practically
minimal

practically
minimal

simply beautiful solutions

for modern living

with 250 color photographs

maggie toy

Thames & Hudson

© 2000 Thames & Hudson Ltd, London

First published in hardcover in the United States of
America in 2000 by Thames & Hudson Inc., 500 Fifth
Avenue, New York, New York 10110

Library of Congress Catalog Card Number 00-101017
ISBN 0-500-51010-5

Printed and bound in Singapore by CS Graphics

contents

new spaces
for new lifestyles

Imagine yourself in a calm, relaxed haven, a room devoid of fuss and clutter, soothing, tranquil and restful, a place you can unwind at the end of a long hard day. The space in your mind is probably cool and simple, sophisticated but without the scores of possessions with which we unthinkingly surround ourselves, an interior

pared down to the essentials. But how could we live in such a place, every day – is it really possible? Poring over the stylish images in glossy magazines, we are beguiled by the Zen notion that to achieve serenity and contentment we must rid ourselves of the extra baggage we accumulate in our daily passage through life. Yet we can't imagine ourselves actually taking the necessary steps to jettison the junk and follow the path to an enlightened minimal existence.

The new requirements of urban space and modern living have redefined our living areas, as in this London house designed by Seth Stein.

What began more than a decade ago as a fashionable style but was characterized by an almost militant aesthetic asceticism has, thankfully, evolved into something richer, deeper and more spiritually fulfilling. Minimalism today allows us to have everything: a livable and flexible environment that can accommodate a gamut of expressions, personalities and activities. Concerned that the term 'minimalism' has become merely a decorative style and has lost the essence of its philosophy, many designers have set out to create ordered yet restful interiors that offer new takes on lifestyles that have changed dramatically since the dawn of the information age.

Simple elegance in interior design has been a constant theme for decades. In his famous 1908 manifesto against applied ornament, Viennese architect Adolf Loos declared that the 'cultural evolution is equivalent to the removal of ornament from articles of daily use'. The influential Swiss designer Le Corbusier was quick to confirm the cultural and social implications of stripping our interiors of ostentatious excess. Quoting from Loos, he affirmed that 'the more cultivated a person becomes the more decoration disappears'. These early reactions to the typically ornate interiors of

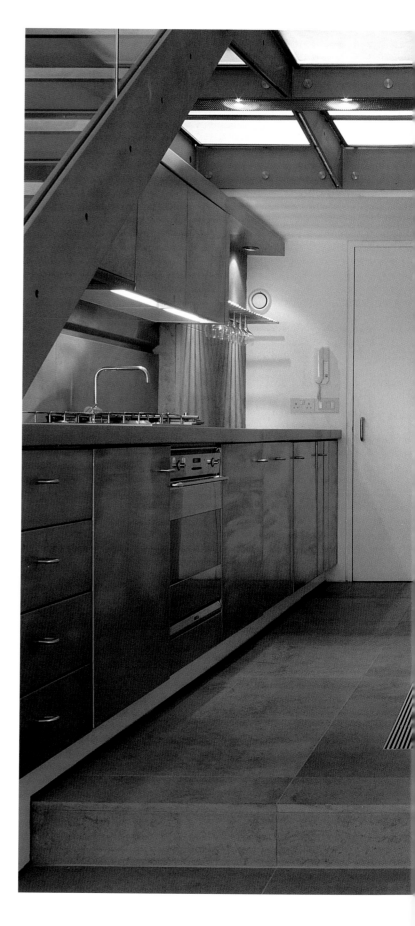

Furniture should express your taste, but allow it to breathe against a neutral backdrop.

In our increasingly eco-conscious world, it is not surprising that materials have begun to play a key role in the minimal space. This heightened awareness has made its way into the house, where materials are no longer seen purely for making up a building's construction – its walls and floors – but for their intrinsic beauty. However pleasing they may still be and despite having become a somewhat clichéd aspect of minimal interiors, white walls and blond woods are slowly being replaced by off-pastel palettes and exotic dark woods, like wenge, which has virtually replaced birch as a minimalist staple.

directly with the water's reflections. This is the message that materials bring: Think beyond use. Think about beauty, tactility, graceful ageing and the tone of your interior will weather the changes in fashion.

A criticism often levelled at essential interiors are their perceived lack of personality. Here too the new minimal space makes fresh allowances. Where any colour other than white was once rejected as non-neutral, nowadays colour – a splash, a wall, a room – can be used boldly and idiosyncratically without disrupting the room's balance or spatial composition; indeed colour can be used quite effectively as an architectural device. Texture, too, was once reviled, but natural patterns can be used to great effect, and even man-made creations

Where any colour other than white was once rejected as non-neutral, nowadays colour – a splash, a wall, a room – can be used boldly and idiosyncratically.

The range of materials available today, whether technologically derived or sourced from far-away places, is staggering. Even a material like granite, which, for example, Swiss architect Peter Zumthor had layered and meticulously hewn for a magnificent spa in Vals, Switzerland, can dazzle the mind and soothe the spirit in entirely unexpected ways. With the granite used in such an unprecedented manner, its true essence emerges to interact

like wallpaper can, used sparingly, provide just the right accent.

Although the interiors presented here are arranged by room, one crucial attribute of the minimal style is flexibility. Features or materials used in the kitchen can often be applied with equal success in the bathroom. And with living rooms being used for more and more activities, they can learn from bedroom or office areas. Whether a

Outdoor spaces are the most fertile opportunity for new ideas, particularly those in the minimal spirit.

studio or a multibedroom house, flexibility of function and use will ensure maximum enjoyment of the space.

Minimalism should be less about strict design tenets and more about an attitude that coincides with our new global, information-rich life. Despite continual and ever more sophisticated preoccupation with finish, detail and well-planned storage systems – allowing the occupier to live freely within the space while maintaining a stark interior appearance – the new minimalism is less a design statement and more of a backdrop against which our quotidian lives are carried out. With a basic awareness of balance and light – and the judicious selection of objects and furniture – it is possible to create an interior that augments the enjoyment of a wide range of activities. The experience of tranquillity and freedom from conventional distractions that the minimal interior makes possible feeds the mind, nourishes the soul and stimulates the variety of life.

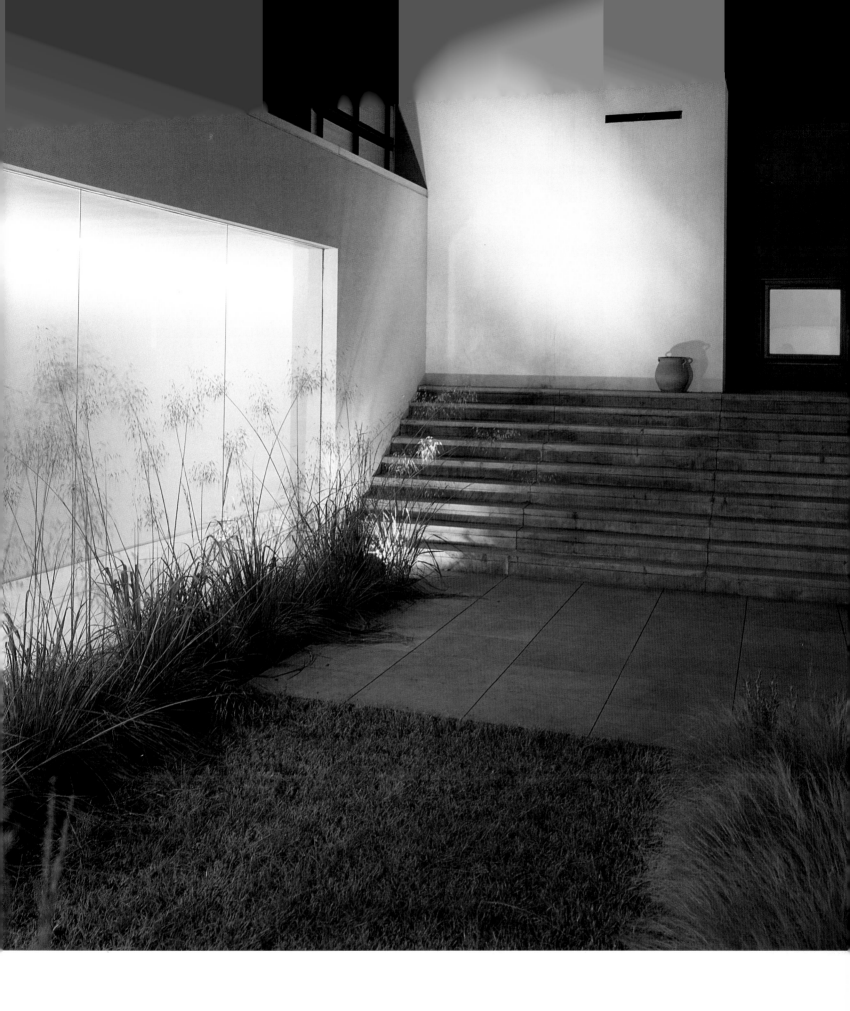

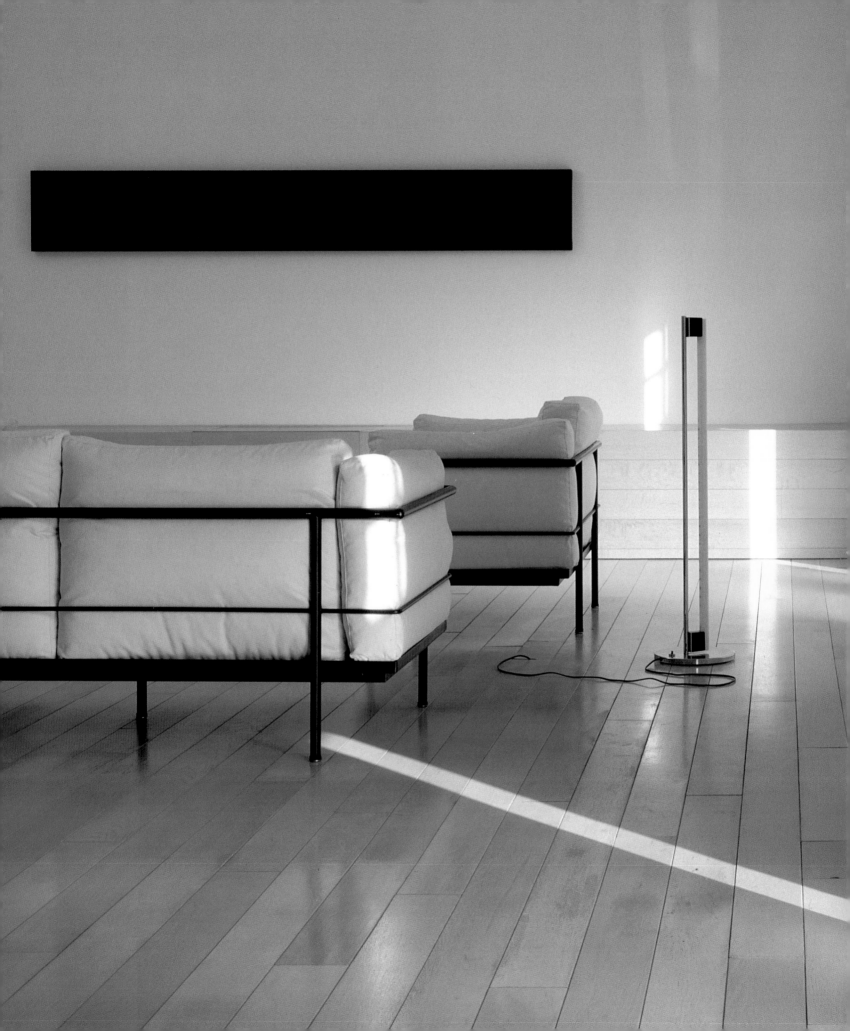

living
and relaxing
the art of form

The minimalist lifestyle is not about self-denial

or abstraction or the elimination of ornament,

but rather the celebration of a space's intrinsic

qualities and a heightened awareness achieved

through material, colour and texture.

In a living environment free from visual distractions, sophisticated simplicity provides a relaxed and calm interior oasis for a wide range of activities, from watching television or listening to music to surfing the net or just hanging out with friends or partners. The stresses of the daily grind, which accumulate and deposit themselves on our everyday lives, can be escaped, at least momentarily, if our interiors are composed with

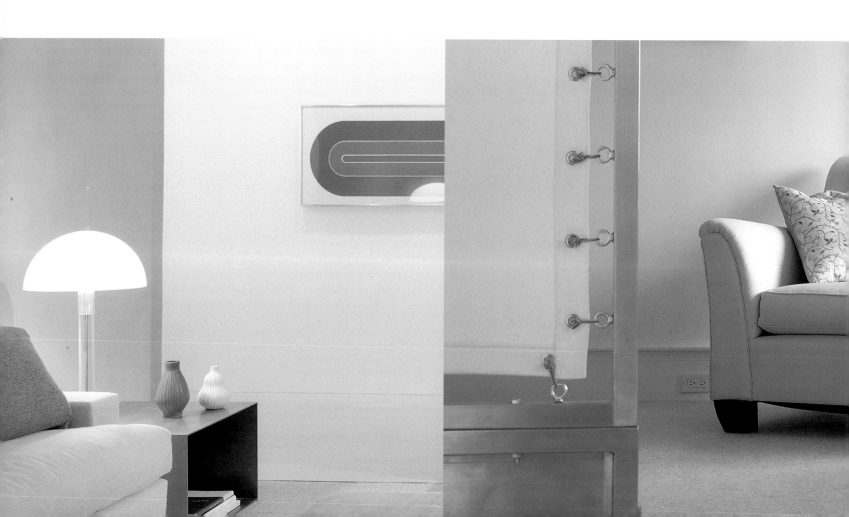

balance and harmony. Although 'minimalism' suggests a method of reduction, the best way to achieve the contemporary look and lifestyle is to start with only walls and floors, adding elements piece by piece, and carefully weighing the effect each piece has on each other and the space. By devising a place for each household item, whether ornamental or functional, we can make the most of the things and people surrounding us.

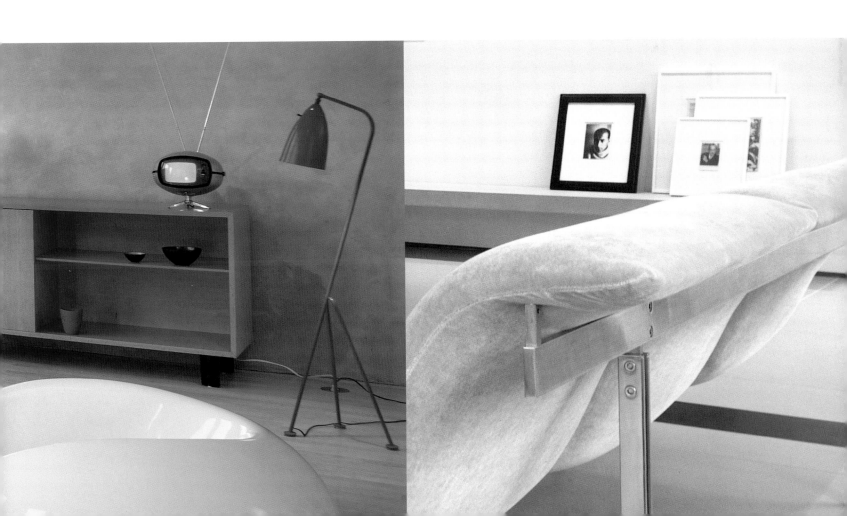

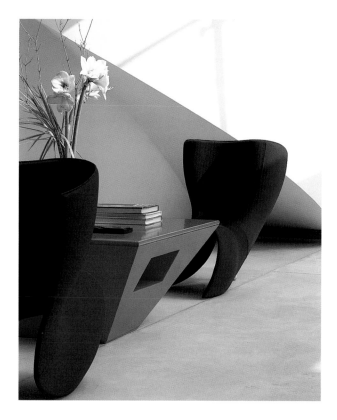

As we enter the third millennium, it is clear that conventional room divisions and domestic hierarchies, which have been in place since the eighteenth century, are less and less suited to the modern lifestyle. The manner in which we spend our leisure time has changed dramatically, particularly in the last five years, rendering sitting or living rooms things of the past. Formal social interaction has been replaced by relaxed gatherings of friends and family in loose spaces, indoors and out.

Nowadays we tend to use the same room for socializing, watching television or using the Internet, and even cooking and eating. It is this variety of activities that offers the greatest challenge to furnishing the central living space cohesively and uniformly. On the one hand it is difficult to achieve spatial purity in a place where so many activities happen and that is the showpiece of our personal style. On the other hand room sizes have grown and open-plan layouts in houses and apartments are increasingly common, making it much easier to establish an ambience of openness, lightness and order.

The first step toward striking a balance is to assess and define your living patterns. Ask yourself, How much time do I spend at home? Where do I prefer to be – in front of the dinner table, preparing food, drinking cocktails with friends, or doing all three simultaneously? Do I like to read, listen to music, watch television or use the computer? Establishing the answers to these questions will help to articulate the living space's zones and optimize the flexibility of the area as a whole.

The patterns of your lifestyle and the understanding of your own distinctions between fun and function are crucial to planning, which will in turn influence the development of interior materials, colours and textures. Altering one or all the surfaces can radically change the room's character and, as we advance into the next century, more and more building materials and finishes from around the world are available to create myriad effects.

Despite the international explosion and ever-widening definition of loft-style living, there are numerous lessons from these spaces that can be applied to just about any kind of interior. Lofts often feature high window-to-wall ratios that encourage the design of open and finely detailed rooms in which the

emphasis on basic living and eliminating clutter is exaggerated by the size of the space. Because the demand for these kinds of spaces have transformed the former low-cost haunts of creative bohemians from New York to London into unaffordable metropol-

behind the chic and streamlined exterior there is a complex system at work.

To achieve the delicate balance of order and flexibility requires foresight, planning and a certain (but not excessive) amount of rigour. Often the idea of the

Spending the extra time beforehand to clarify your needs, routines and desires is the first step to an interior environment that is essential and right for you.

itan oases, some architects have responded by designing the 'new loft style', that is, translating the look and feel of a loft space within a new building.

It is true that to a certain extent to maintain clean living spaces within your own home necessitates a discipline that runs counter to the natural inclination toward relaxing without regimes. Add pets or children to the equation and it seems impossible. Once you have set in place a framework for living that allows you to easily uphold these ideas, however, it is easy to maintain and provides a pure and tranquil setting. The key to this system is storage.

London-based architect Claudio Silvestrin, who designs within the context of the minimal, compares simple architecture to the human body: 'Our human body is in appearance simple, very simple, yet the human skin veils a complicated machine. If we cut a body in half we would immediately realize that behind the simple and easy appearance is a magnificent complexity.' Think of the skin in this case as storage. Silvestrin makes comparisons with Mondrian paintings and Cistercian monasteries to demonstrate that

essential design is misinterpreted as a negative aspect, but that is because people try to impose a regimen on a design, rather than let it evolve from a close awareness of how one lives from day to day.

Sitting area of a Manhattan loft designed by Martin Raffone.

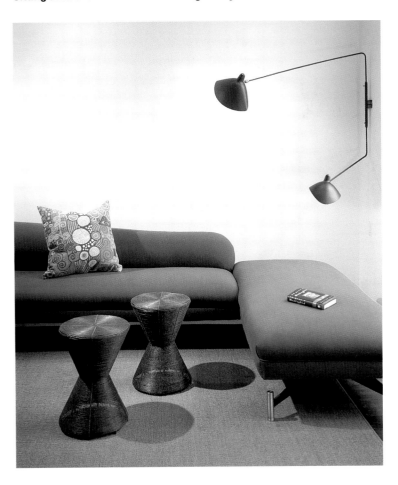

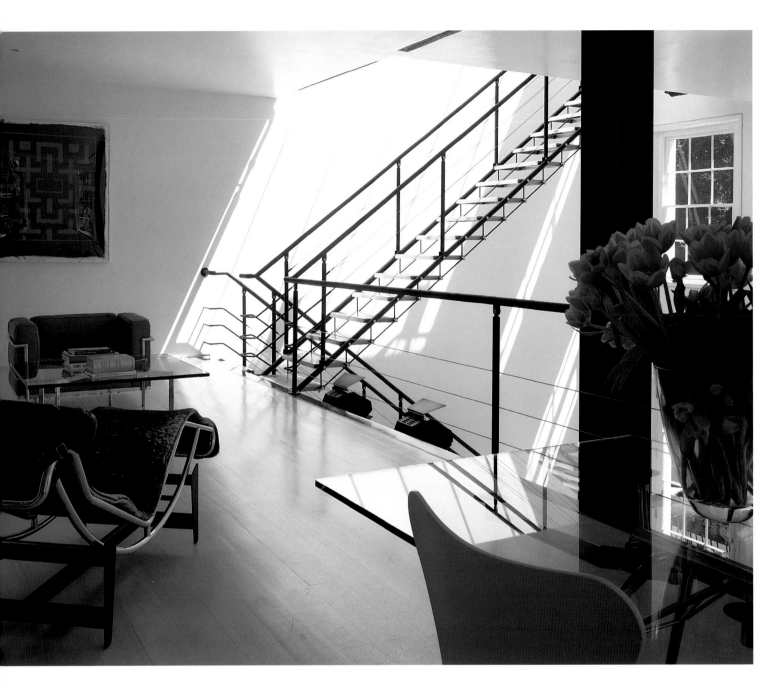

classic precision

As seen in the mezzanine of this London townhouse designed by Richard Rogers, carefully positioned furniture – modern classics like Le Corbusier and Perriand's chaise longue and Mies van der Rohe's Tugendhat table – ensure minimal distraction and maximum freedom of light and space to awaken the occupants' senses. The vast interior space emphasizes sharply defined vertical and diagonal lines in the architecture and furniture with transparent planes that intensify the play of light and human movement.

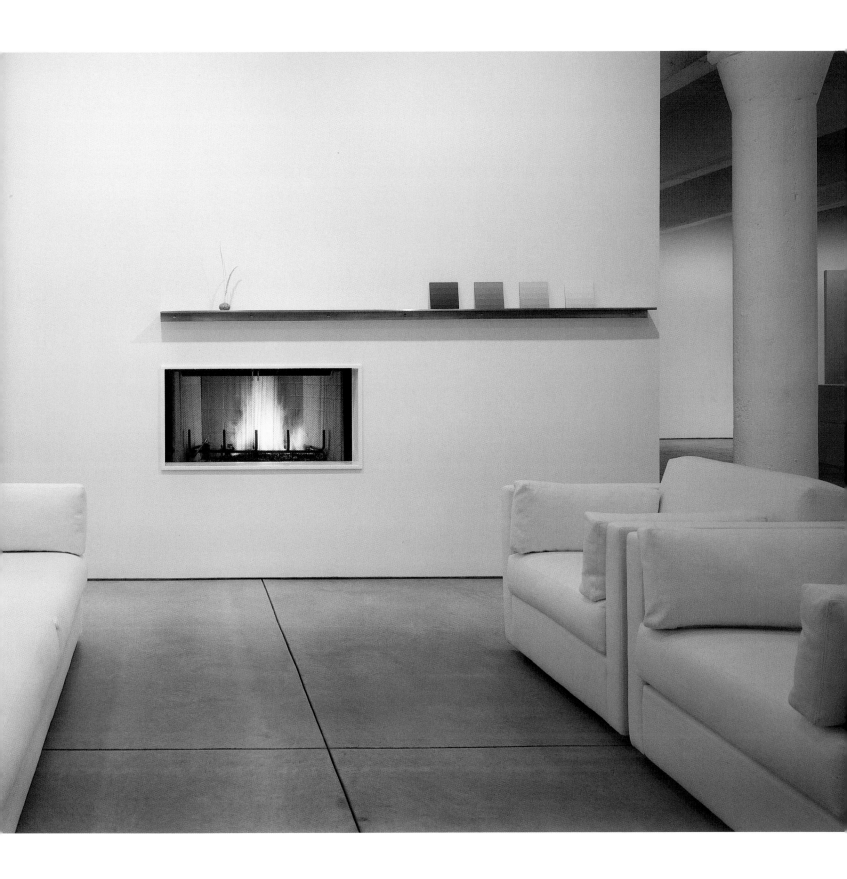

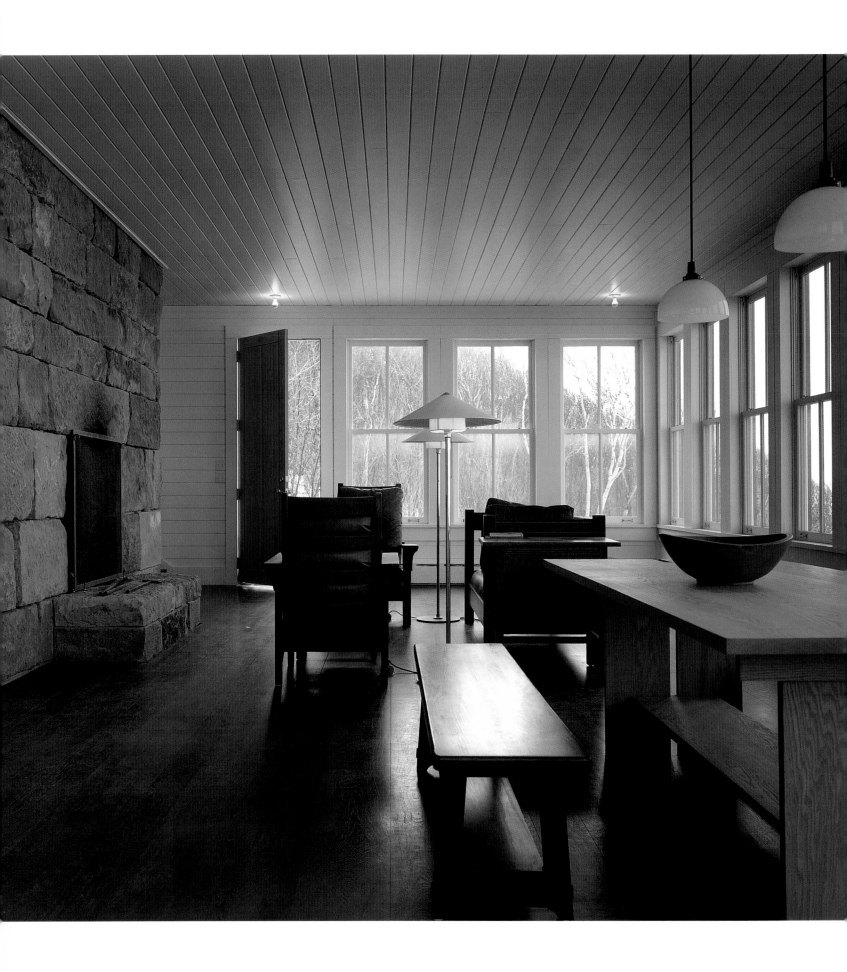

rustic gravitas

Far away from civilization, in the wilds of Nova Scotia, a neo-traditional house created by Richard Gluckman presents solidity and longevity within a pared-down vernacular aesthetic. With massive stones for the fireplace, dark-wood floors and sparingly placed Craftsman furniture, the central living-dining space succeeds in being simultaneously minimal and rustic.

the lightness of living

The dynamism of the open, multilevelled space in this New York loft designed by Hariri & Hariri is achieved through contrasting lightweight elements and solid materials. Steps floating down from the upper level are anchored by a concrete block mediating between levels; a console attached to the wall hovers above the light-wood floor.

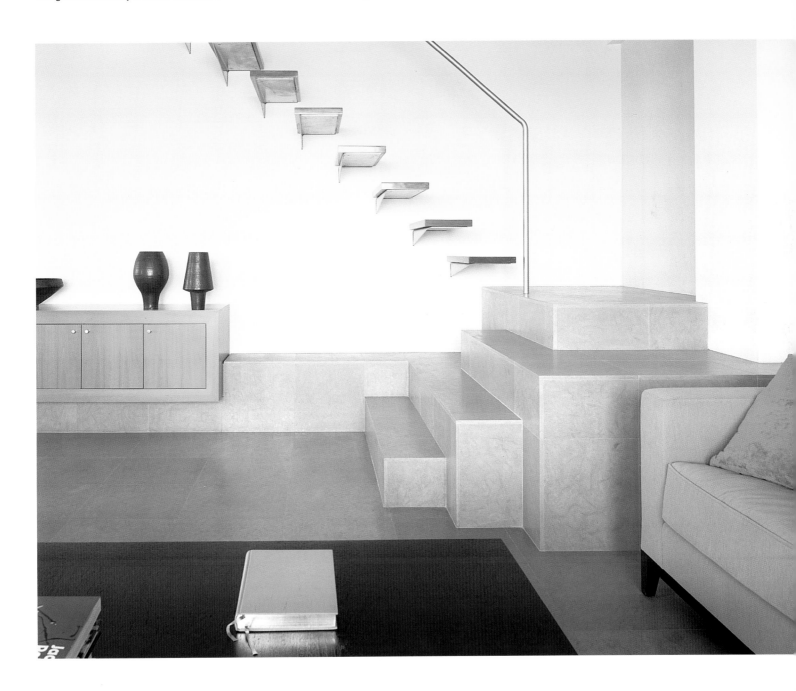

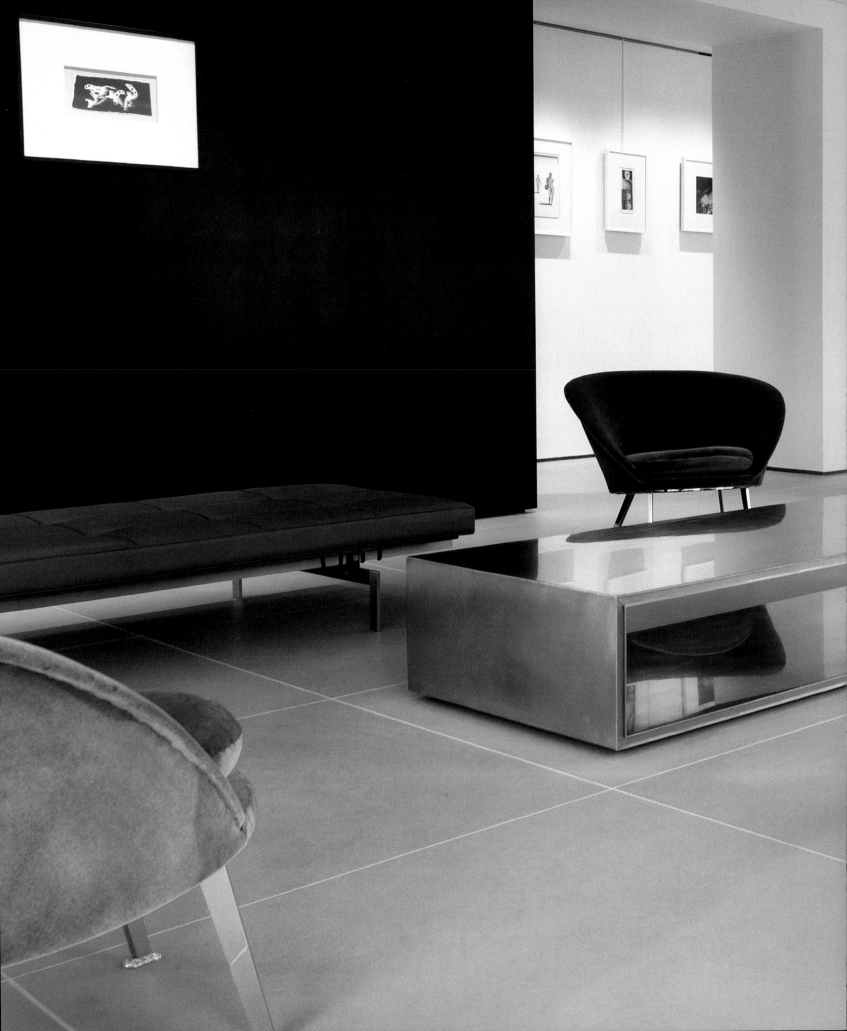

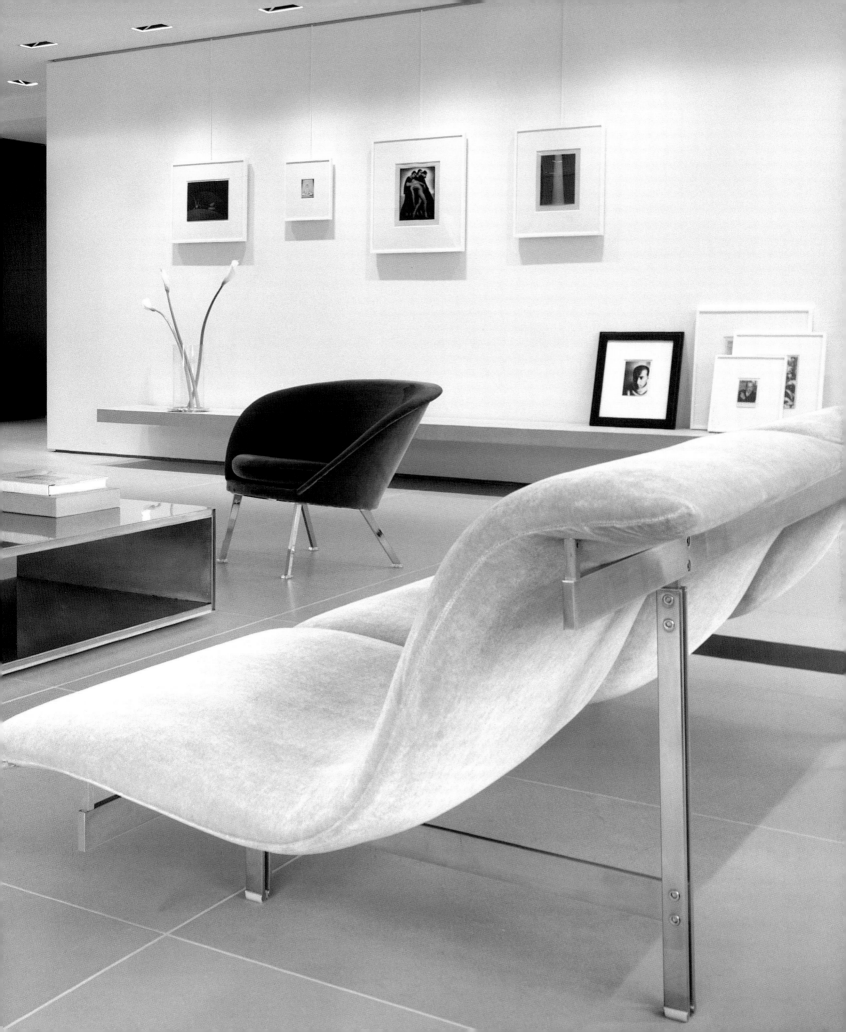

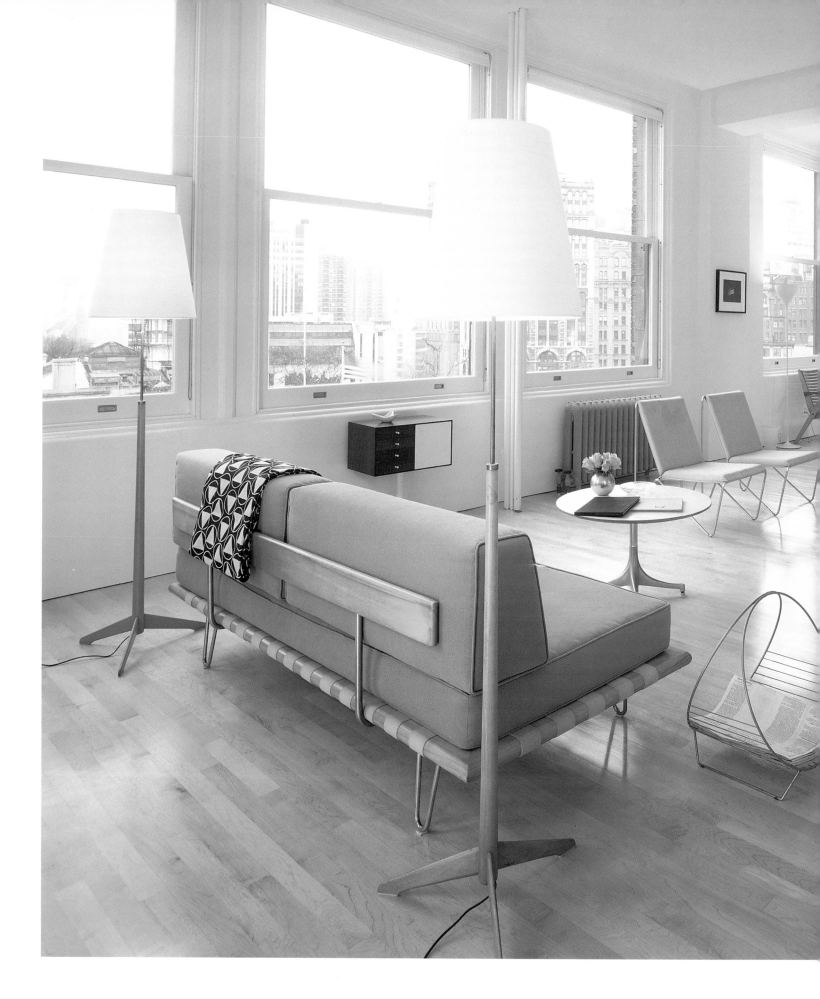

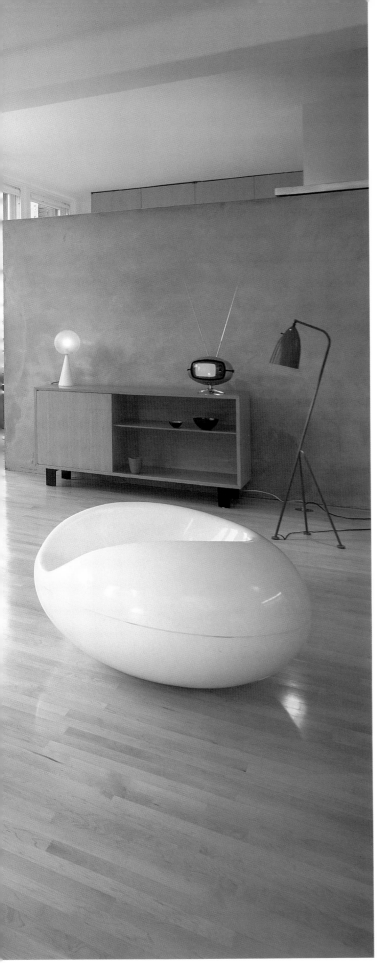

future curves [preceding spread]

The conventional image of minimalism is hard lines, hard surfaces and anonymous colours. This New York apartment by Gabellini reveals a novel take on the idiom. Rich colours – lilac, purple, off-grey – low lines, irregularly sized frames around photographs and sinuous curves add up to a space that is cool, ultramodern and highly desirable.

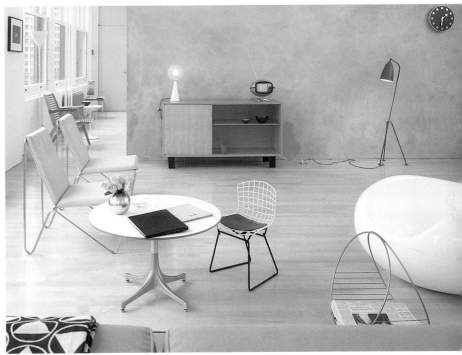

mid-century minimal

The beauty of a pared-down interior is that it can form the perfect background for furniture of character. The owner of this New York apartment designed by Belmont Freeman possesses a fine collection of mid-century modern pieces, which – even more than the architecture – define the open-plan design. Given the careful selection and placement of pieces on the light-wood floor, even a rug to unify the seating area would seem superfluous.

screening technique

In an area with few walls and doors, simple changes in level can articulate a room's uses and add extra dimension to flat spaces. A range of materials can be incorporated to enhance these spatial shifts. For instance, in a New York apartment designed by Pasanella + Klein a beautiful stretched canvas – a softer alternative to the ubiquitous frosted-glass wall – separates the space and allows maximum diffusion of light. One corner of the room features a traditional armchair, which, combined with a heavily grained wood desk, imparts a contemporary feel to the alcove behind the screen.

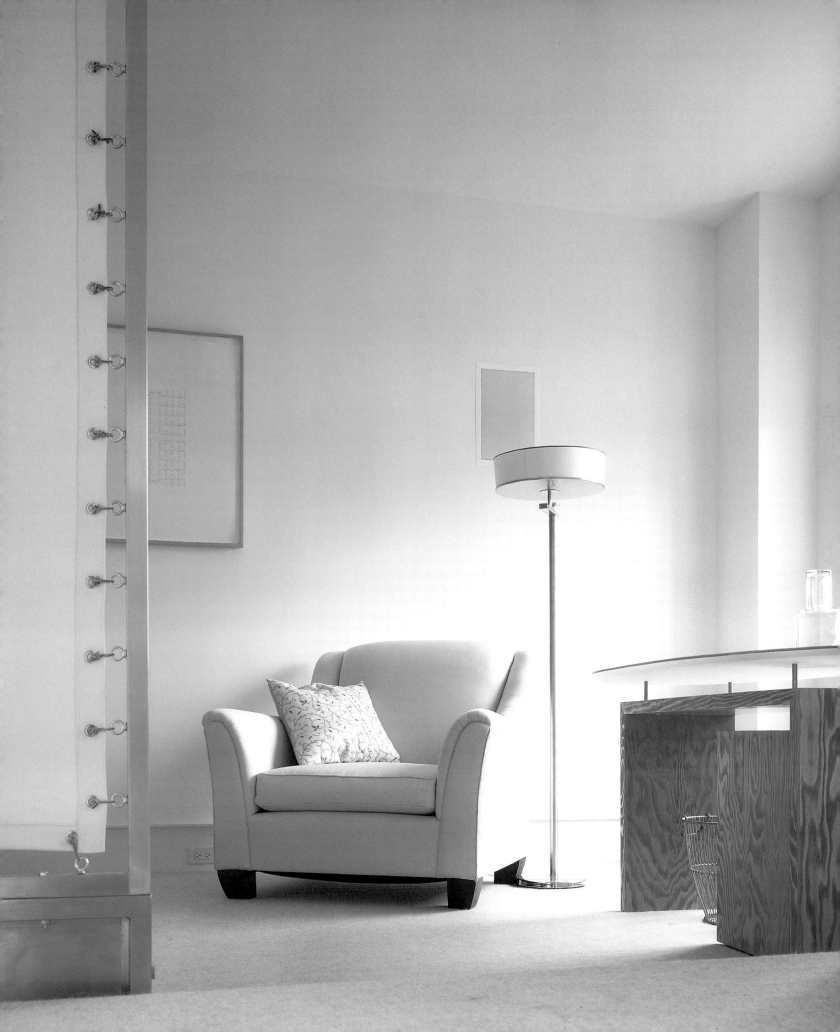

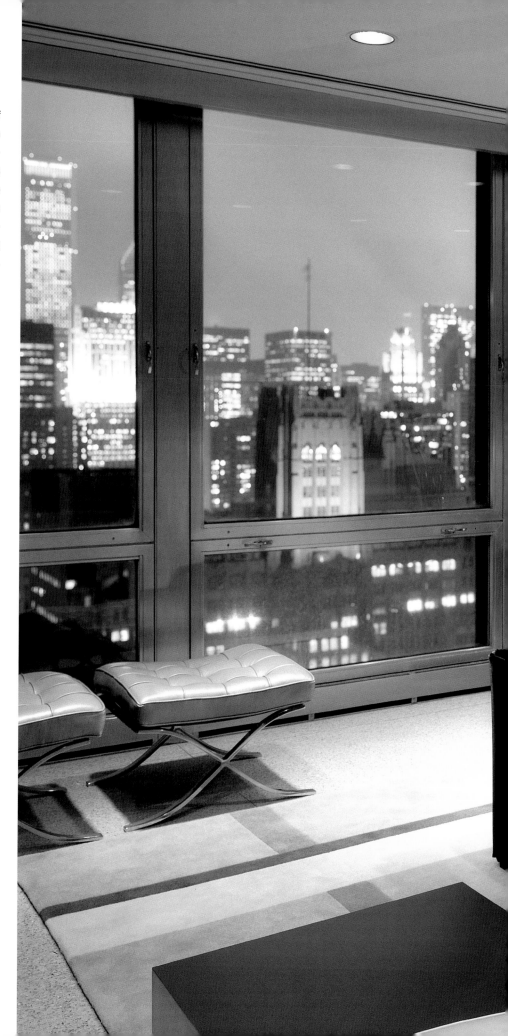

window to the world

Richly reduced to the essential features of the living room – lush leather sofas, plush armchairs, coffee and side tables, the opulence of this New York apartment is heightened by the dramatic view of the cityscape. The vocabulary of the room's pieces are big and boxy, giving the occupant the sense of being in a Hollywood screening room with floor-to-ceiling windows framing the city.

shades of grey [following pages]

The elements of this New York apartment designed by Architecture Project are defined by subtle shifts in grey. Accented by a structural column that has been perfectly rounded to contrast with the stark surfaces, the spatial composition is serene and delicate, a subtle background for objects or art.

white is right

Deborah Berke's design for an artist's loft finds subliminal purity in covering every visible surface with white. The eye is naturally drawn to the artworks that are placed in just the right positions throughout the space.

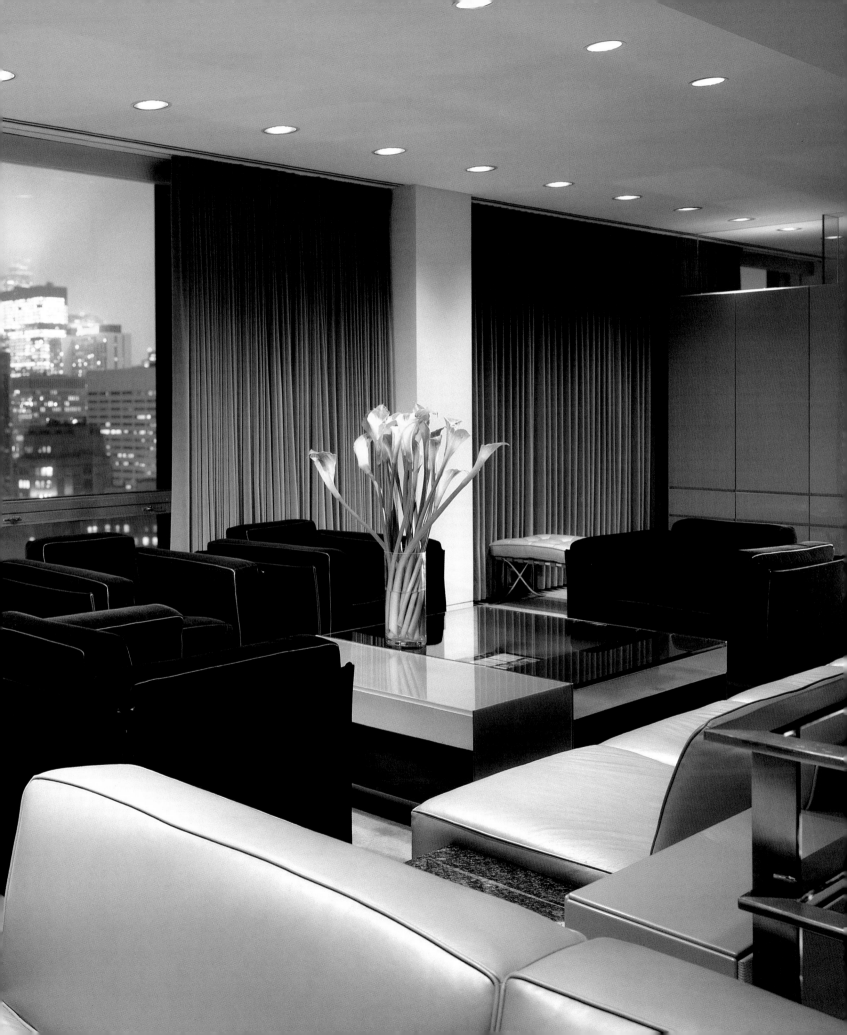

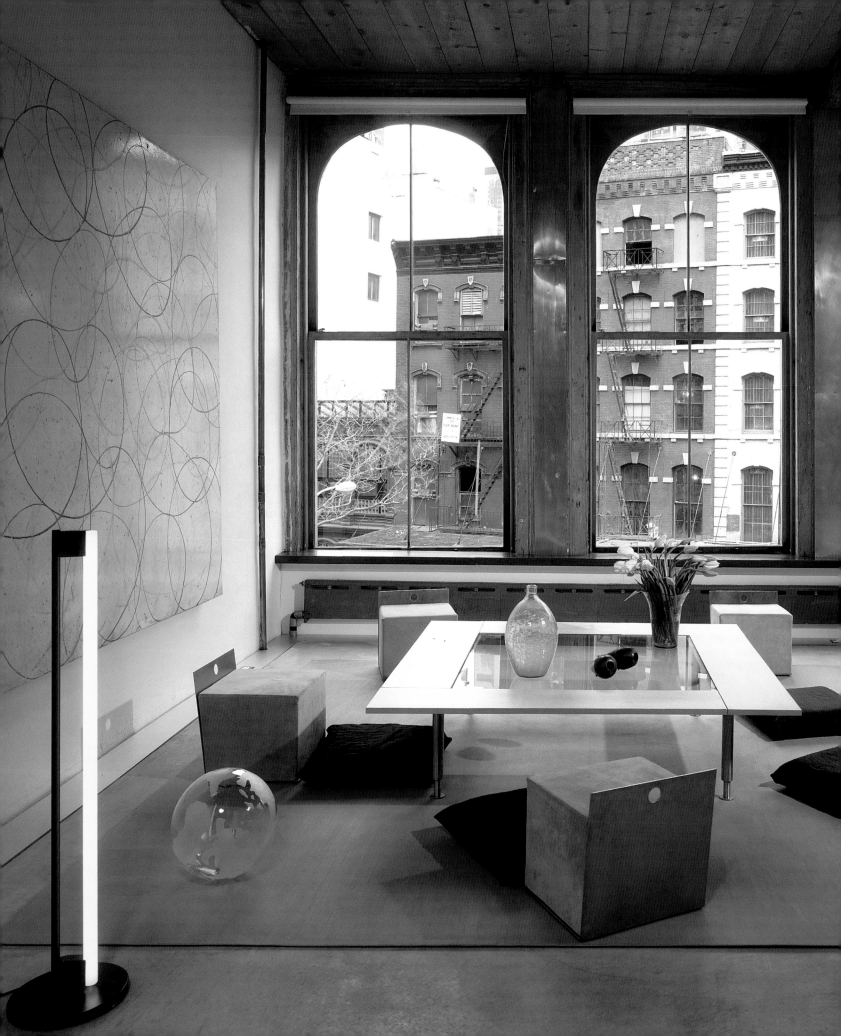

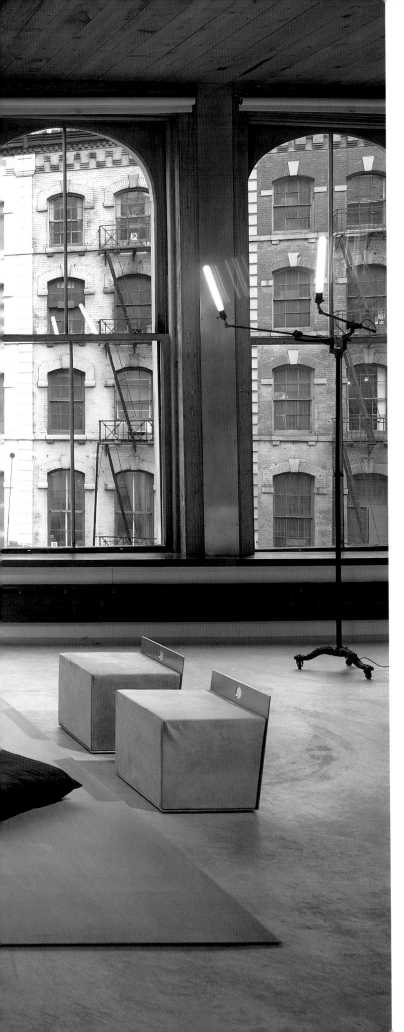

low living

The height of this marvellous loft designed by Morris/Sato Studio in Manhattan's Tribeca is emphasized by the low seating pieces and table. Rather than fixing a living space with sofas and armchairs for conversation, the seating area's variously coloured elemental chairs invite movement and reconfiguration, for sitting, lying down or putting one's feet up to enjoy the view of the sky.

pastel harmony

Large solid-seeming objects can be soft-
ened or even made to appear weightless
with the right colour scheme and illumina-
tion. The reception of London's Hempel
Hotel blends the spatial atmosphere of a
mausoleum with delicate colour and lighting
effect to create a stunning space.

low rider

The central living area of an English country
house designed by David Chipperfield
includes a low concrete piece that extends
almost the entire length of one wall. The
oversize element works masterfully by
being both multifunctional and visually
weighty.

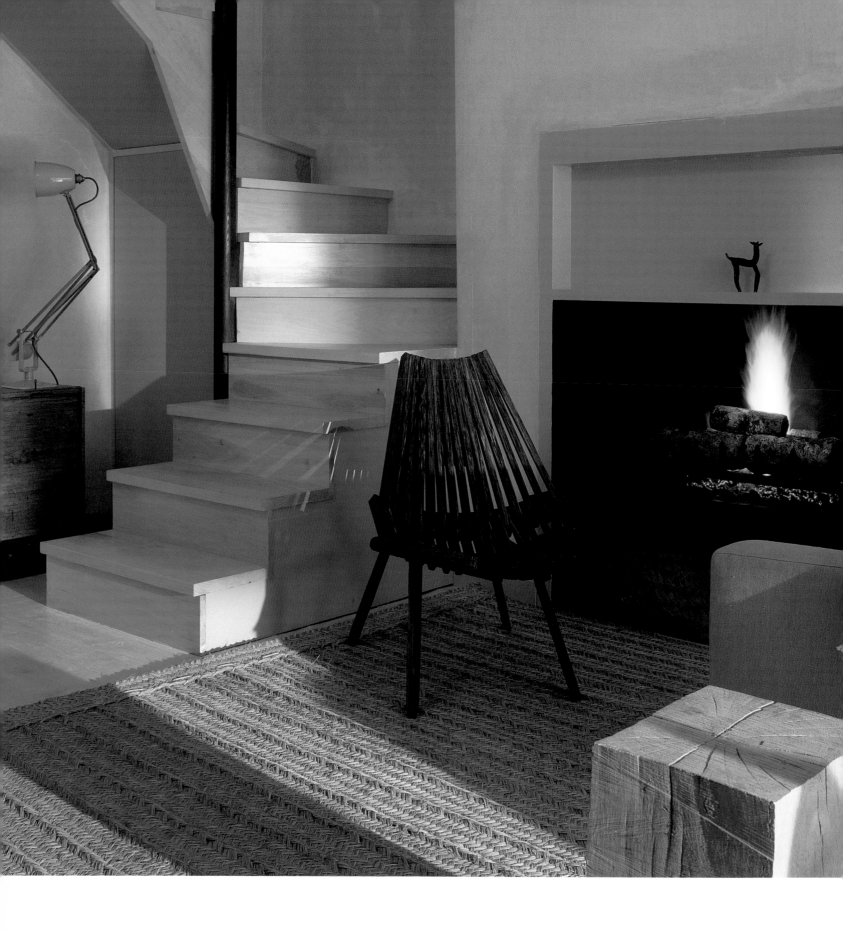

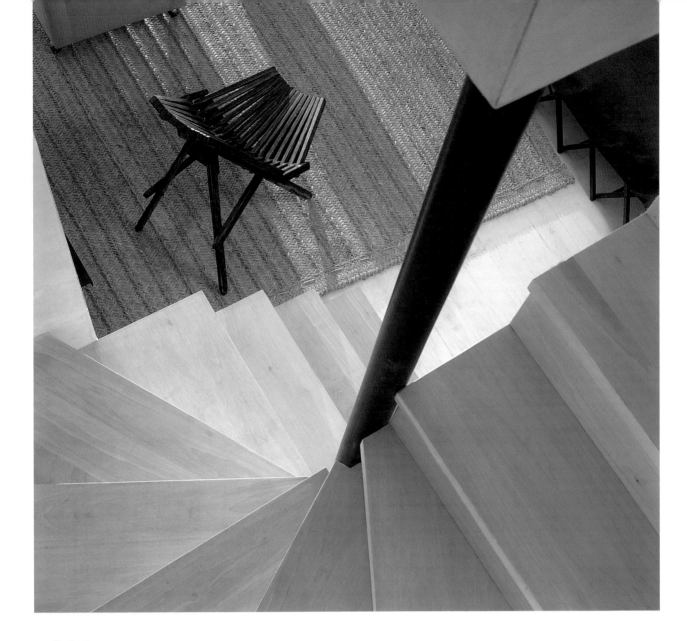

exotic textures

A large amount of room is not a condition for the minimal interior; it is the articulation and distinction of space that is crucial. In this London flat designed by Spencer Fung, natural materials, exotic pieces and a clever use of geometries of scale transform an ordinary living area into a space that is warm, livable, idiosyncratic but modern in spirit. The juxtaposition of the twisting planar staircase and the integrated effect of the dark-wood chair delineate the individuality of each element and induce an overall appreciation of the room's careful composition and order.

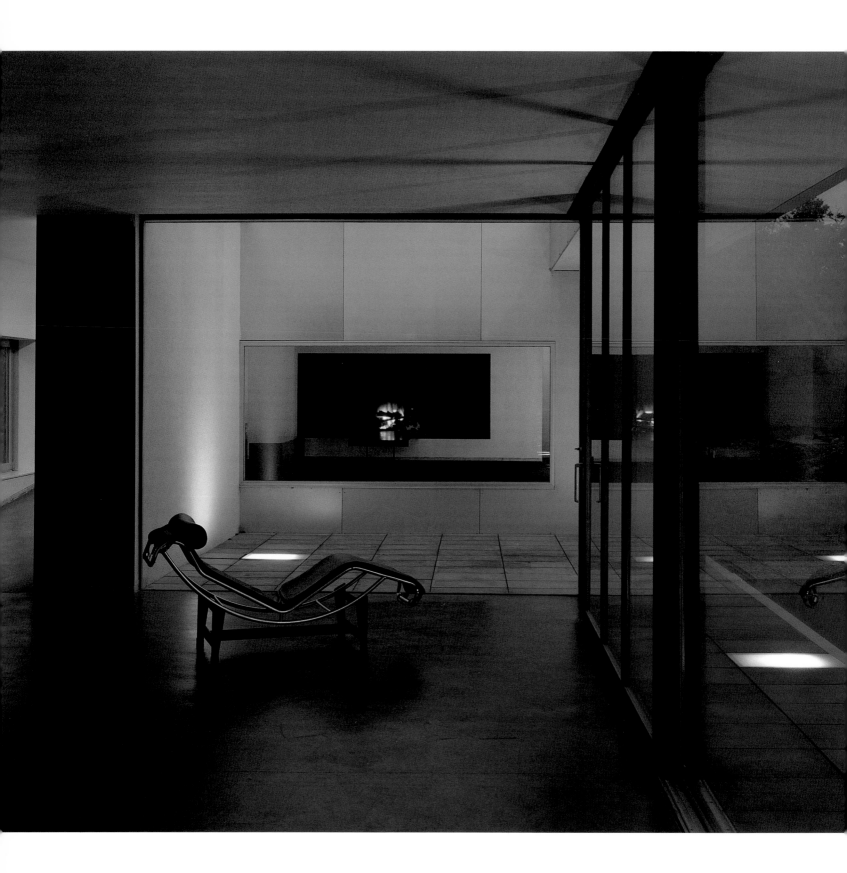

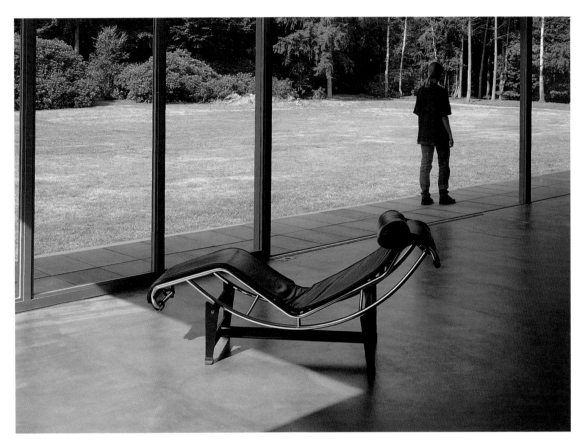

glass box redux

The contemporary interior need not be an entity unto itself; when the possibility of integrating the outdoors arises, it should be maximized. This country house by Stéphane Beel in Belgium dissolves the conventional interior-exterior boundary with stunning full-height sliding-glass windows, but Beel gives the modernist form an extra twist with the incorporation of an old brick wall, underfloor lights and the insertion of a patio – all of which allow daily living to be blurred into a series of unexpected spatial experiences.

fuchsia form

With a touch of inspiration from Mexican modernist Luis Barragán, this London house designed by Seth Stein incorporates a single arresting colour that permeates almost every room in the house with its electric glow. A simple technique that resonates day and night.

cooking
and dining

the essential ingredients

Usually the dwelling's most active and lively

hubs, the kitchen and dining areas are where

the ultimate minimal fusion of function and

fun can be enjoyed around the clock.

The areas set aside to honour the preparation, consumption and appreciation of food need to be the most flexible spaces in the residence. People use their cooking and eating areas very differently, depending on their daily lives and how they enjoy their food. Whether used for grabbing a snack or preparing and eating a large formal dinner, kitchens and dining rooms often serve an even broader social function as inhabitants intersect and congregate for myriad reasons at different times of day. Apart from their obvious functions, therefore, cooking and dining areas should provide a flexible and relaxed backdrop against which to entertain old friends, welcome new acquaintances or interact with family members.

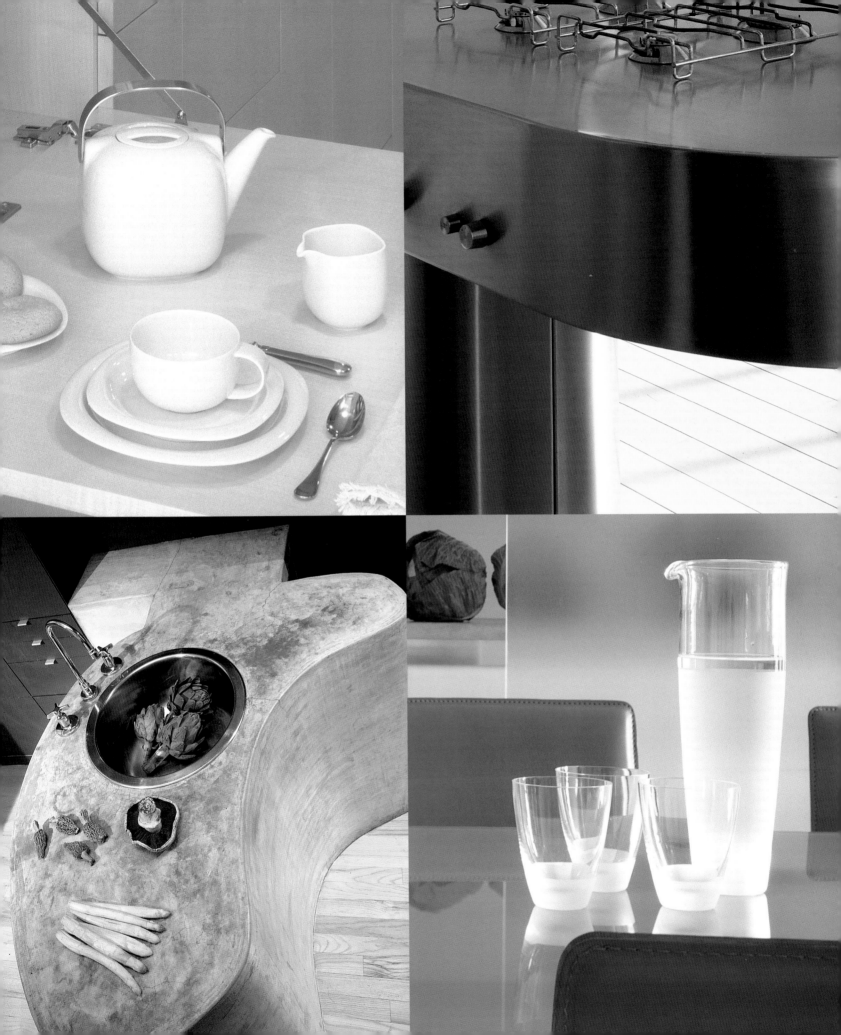

To achieve a minimal but adaptable and multifunctional space, a thorough understanding of routines and variations on those routines is crucial when planning and organizing the space. Some people use the kitchen for little more than breakfast – or maybe only a coffee – in the morning; others spend most of their day there, whether socializing, cooking or even working at home. How important is cooking to you – are you a microwave master or do you aspire to Cordon Bleu standards? Do you like large informal gatherings or small formal affairs? The better you grasp your personal style of cooking, eating and entertaining, the more effectively and regularly you will make use of the space.

Perhaps more than any room, form and function are intertwined in the kitchen and dining areas, so how the kitchen is used will affect how it looks, and vice versa. In addition the kitchen is often where visitors spend a great deal of time, so if it is not part of an open living arrangement, it can make a distinct impression on your friends and acquaintances.

The general layout and look of the space should be determined in the first place by the household cook. For example, the lazy cook isn't as concerned about preparation and display, so counter space can be reduced. The creative cook, on the other hand, needs a combination of large work surfaces, heavy-duty appliances and subdued surroundings to ensure that attention is fixed on the appreciation of food. And there is a combination: for the person who enjoys cooking and entertaining but is less concerned about making an impression, work areas can double as surface areas, allowing people, food and conversation to intermingle.

A constant feature in all these scenarios is, of course, storage. Because cabinets and pantries are usually the most visible aspects of the kitchen, they offer an excellent opportunity to introduce colour, texture, geometry, even sculpture, over a large area. While some people aspire to a tough industrial atmosphere that exudes professional standards of cooking with tools on display, others prefer a soft approach that is more comfortable for drinking tea or a glass of wine around a table. Storage space can go a long way towards determining the character of a room, so don't just think about how much space you need (there is never enough – the number of must-

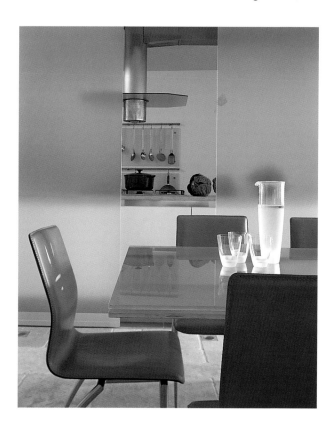

Kitchen/dining area of a London house by D'Soto Architects.

have kitchen gadgets doesn't get any smaller) to hide cooking utensils and food supplies, consider how you can add a level of design sophistication with cabinets. If the kitchen and dining areas are separate, the cabinets can create a pleasing unity to the design; if they are a single space, an overall scheme for storage allows greater flexibility and optimum usage.

The relationship between the kitchen and dining areas is essential in determining the character of the space. Although often how the areas for these rooms are used is predetermined by the architecture, there are a number of ways to open up or separate the spaces according to the desired effect. Apart from establishing a greater feeling of spaciousness, unifying the areas allows for more informal interaction, as well as the transfer and presentation of food. Distinct spaces generally don't permit as much free movement between people and activities, but conceived

Countertop in a London kitchen designed by Malin Iovino.

possibilities for innovative interpretations – table as continuation of work surface, table as island, table as wall furniture. Dining chairs are probably the easiest way to make a simple design statement, provided the

Subtle contrasts are crucial and can be manipulated to offset bold statements made elsewhere.

cleverly, a separate dining room can double as a home office. The fewer the obvious signs that the room is used for formal dining occasions, the more ways it can be adapted for other purposes.

Regardless of how the kitchen and dining room are connected, the focal point – even when cooking is going on in the background – is the table. Inevitably used for a broad variety of activities solitary and communal – eating, homework, games – it exerts a gravitational pull. But the table need not be a conventional piece of furniture. There are numerous

table and environment in which they are placed gives them centre stage. Like the Arne Jacobsen–designed 'Ant' chair, they can be effectively employed to soften the hard lines of cabinets and appliances.

Apart from the 'hard' aspects of the kitchen, there are 'softer' elements – lighting, textiles, seating – that enhance the space's ambience. Orchestrated carefully and judiciously with the kitchen and dining areas' other elements, it is these special soft touches that will ultimately make the space the inviting and resilient centrepiece of the interior.

long island

There are an endless number of configurations designed to accommodate the multiple functions of the kitchen. This airy cooking and dining area in a London house designed by Malin Iovino makes optimum use of a long space to create an island that not only acts as the central work and dining unit, but also helps to visually elongate the space. The design also maximizes circulation to ensure that dinner guests or lazy early-morning breakfast eaters move around easily between work and seating places.

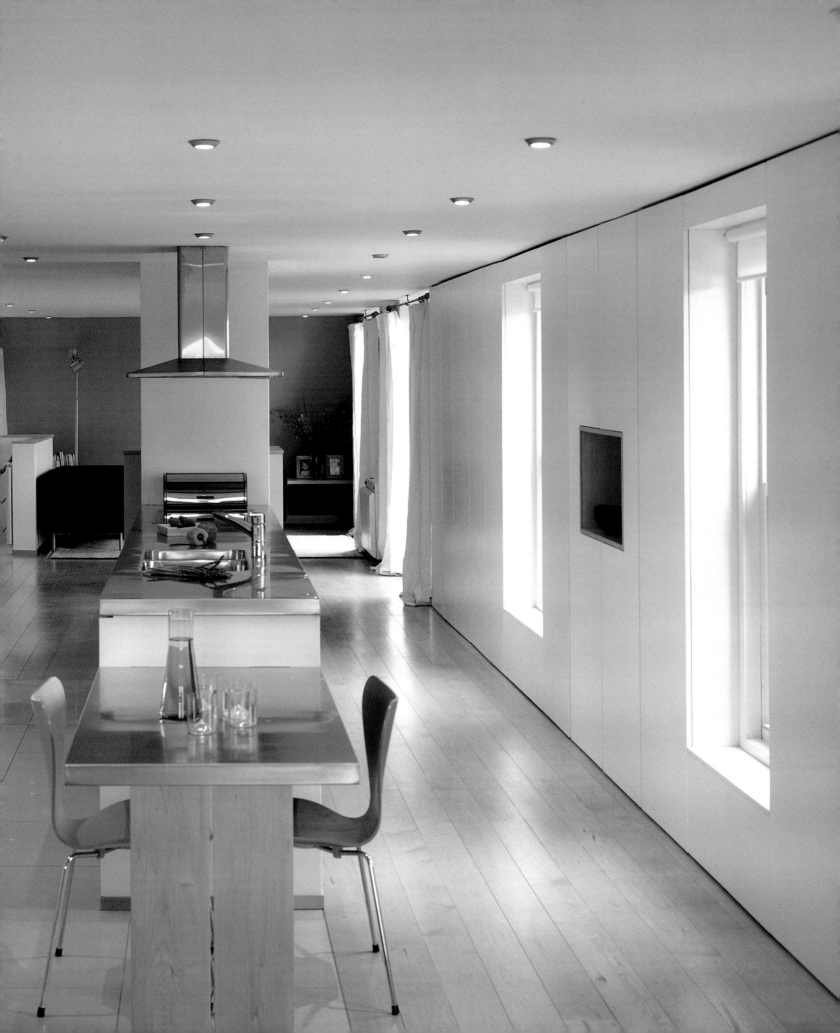

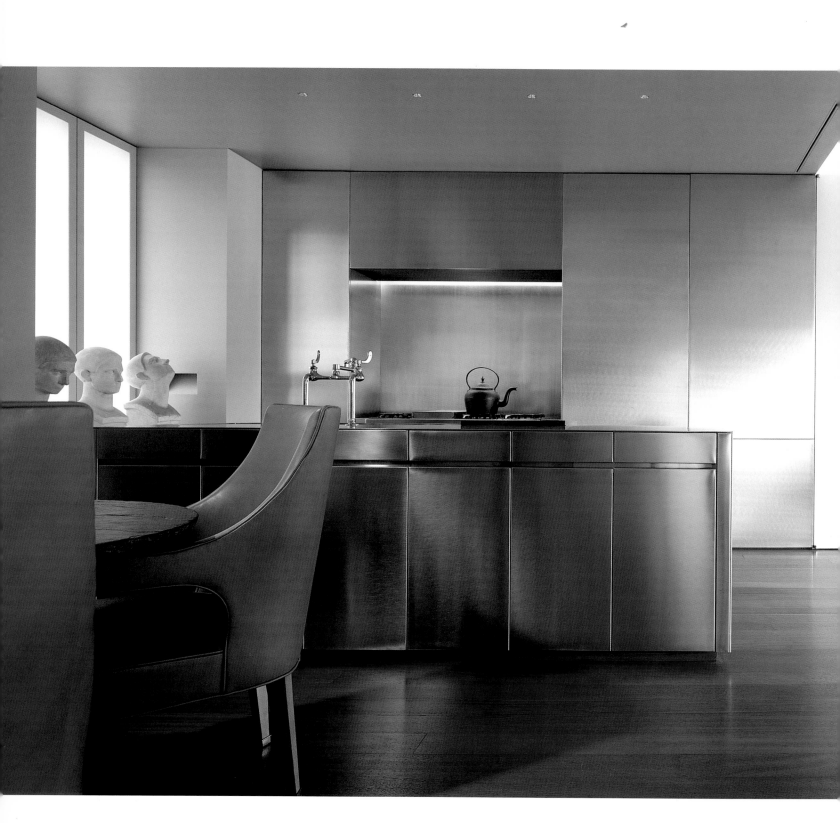

machine for cooking

Stainless steel dominates the surfaces of the London townhouse of architect Richard Rogers, whose wife, Ruth, is a chef of international renown. Rather than using the standard floor and wall cabinets, full-height storage and a precisely detailed cooking island provide the ultimate professional access and look. The size of the units also ensures that all utilitarian implements can be hidden away.

the art of steel [opposite]

The striking stainless-steel aspect of this lush New York apartment designed by Tsao & McKown is unexpectedly offset by three busts that humanize and enliven the space.

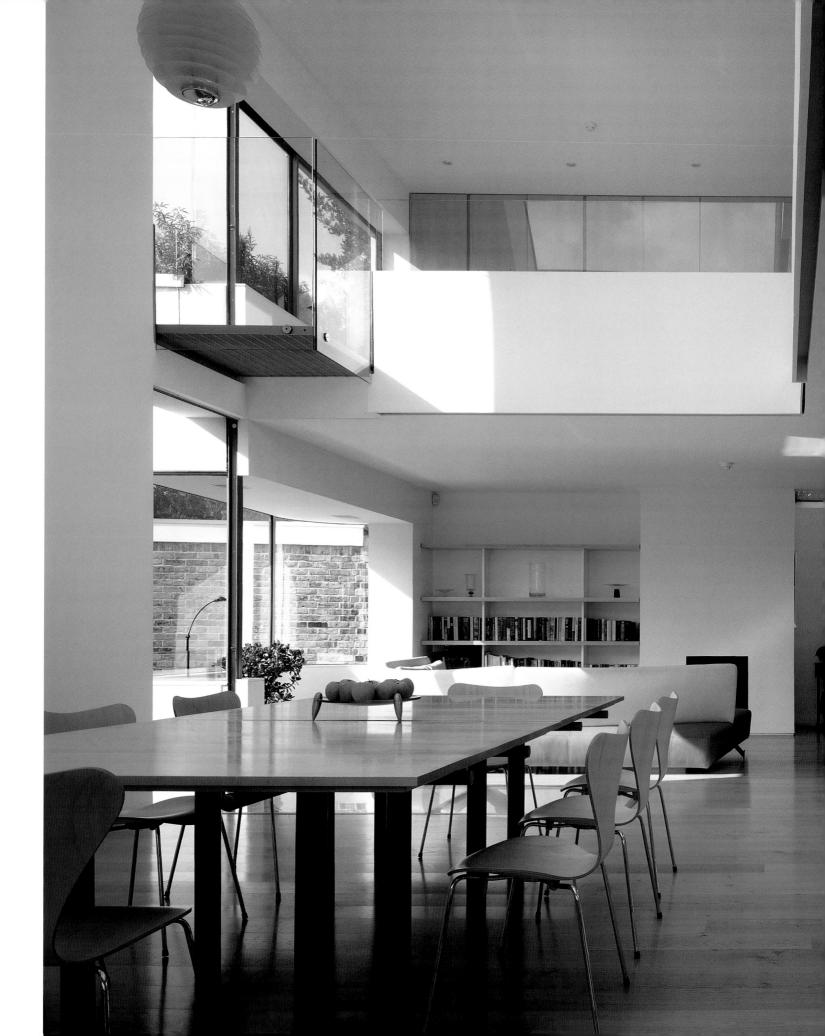

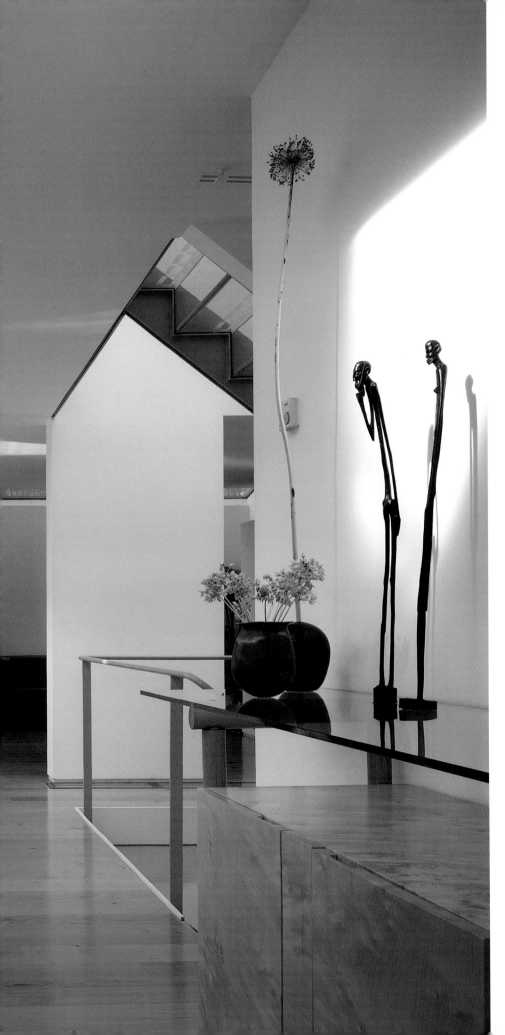

the centrepiece

Simplicity of visual orientation allows an interior to be quickly read and appreciated. In a minimal house designed by Rick Mather in London, the play of white, light and glass animates open areas that are carefully defined by furniture and selected artworks. The dramatic dining area, set beneath a galleried, double-height space, is flooded with light and space – a perfect atmosphere for a lazy brunch.

extension table [following pages]

Rather than using a table to divide a room, it can slice through two spaces, as seen in the dining area of London's Hempel Hotel. This innovative built-in table offers the possibility of using the surfaces in different ways at different times. The only unifying concept is the sublime frosted-glass wall that diffuses light through the space.

eastern style

The dining area – or any other living area for that matter – need not only be defined by standard tables and chairs. The sunken seating area in the lobby of London's Hempel Hotel, adorned only with Japanese-style low tables, is both intimate and open, informal and flexible.

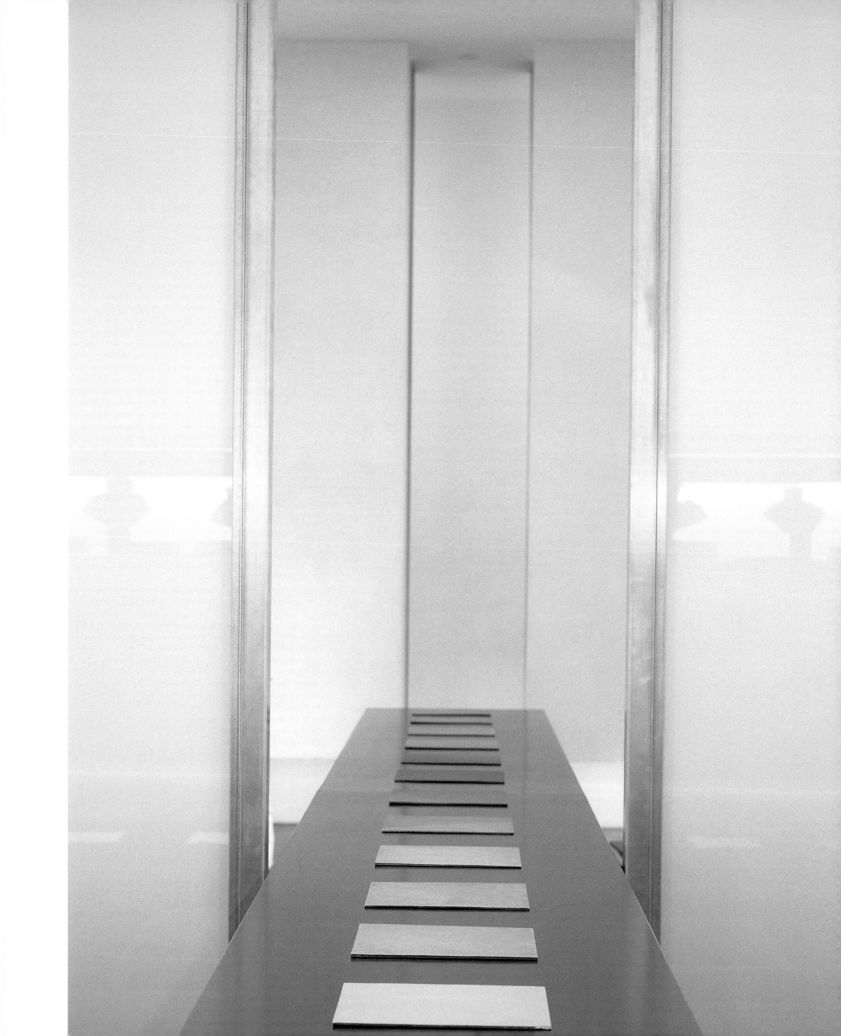

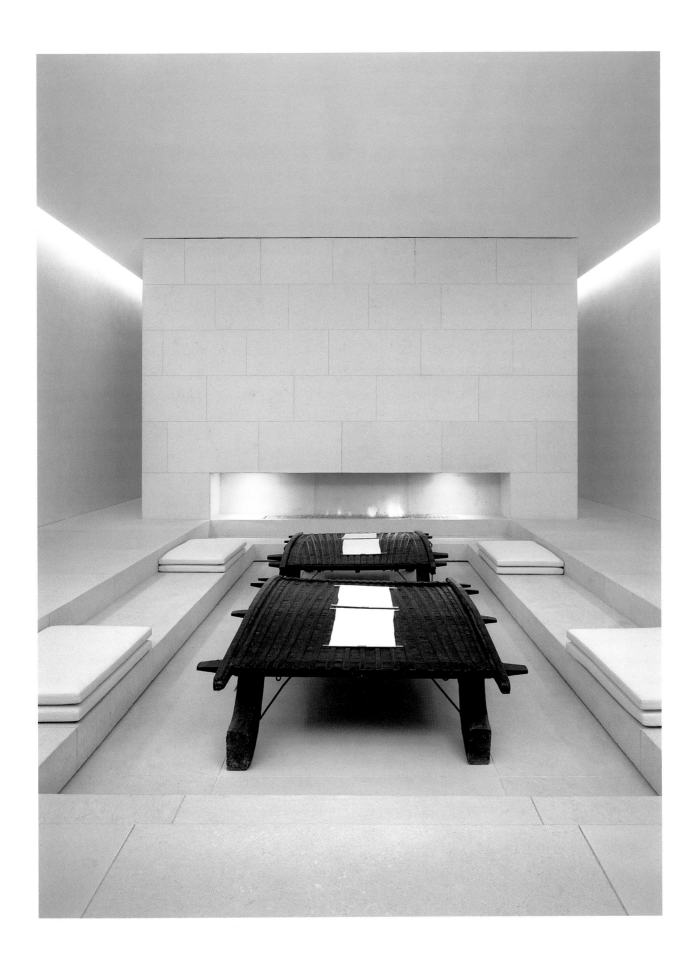

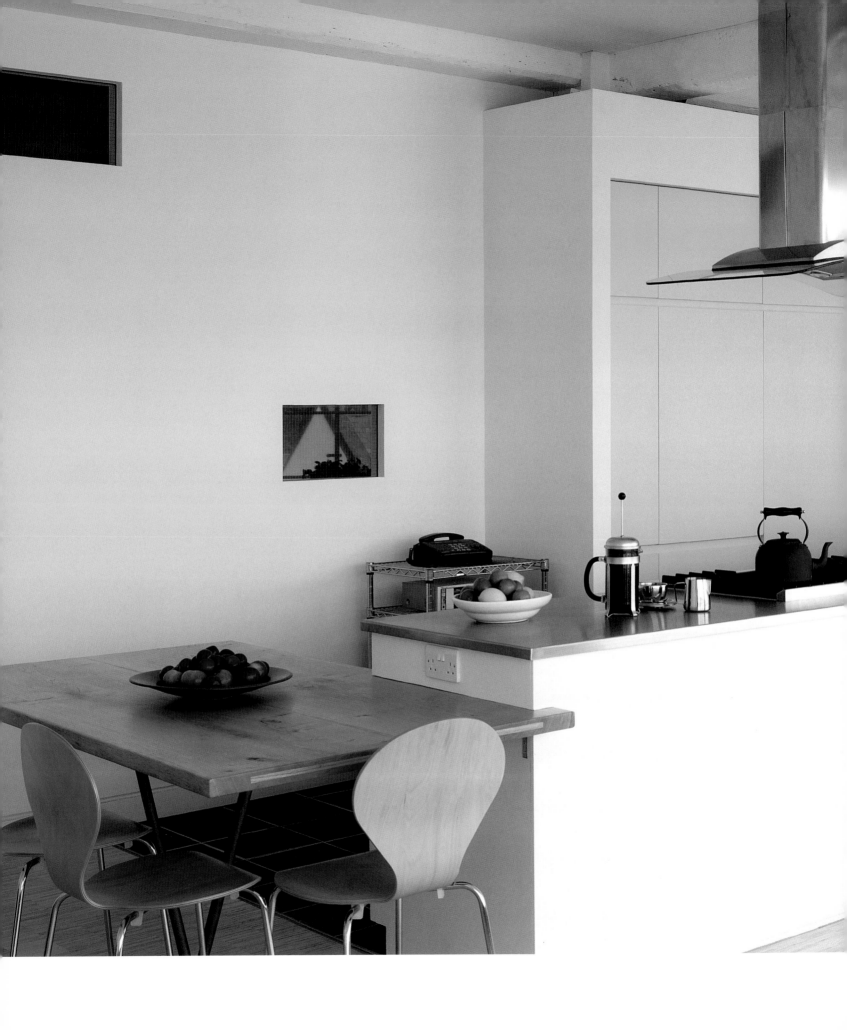

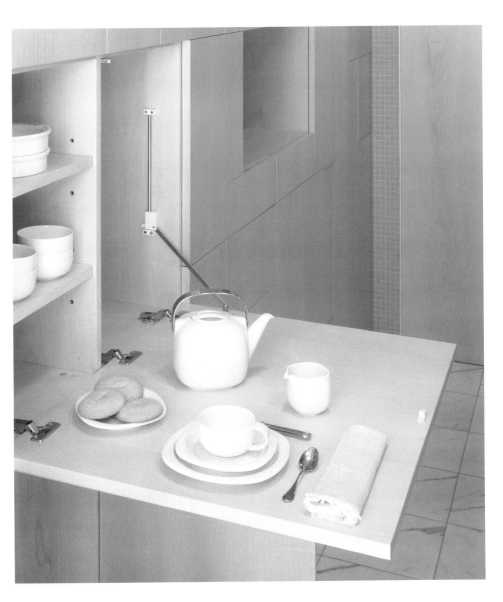

light preparation

Drawing on Scandinavian style, architects and designers have long used blond woods – ash, maple, birch – to create light and airy interiors. Today, there are countless innovative uses and effects to be created from inexpensive plywood veneers that can be easily customized. Wood features on practically every unit in an apartment in San Remo, Italy, designed by Marco Romanelli, where its warmth and strong geometries are modern, convenient and inviting. A fold-down cupboard is perfect for a small eating surface in the compact kitchen.

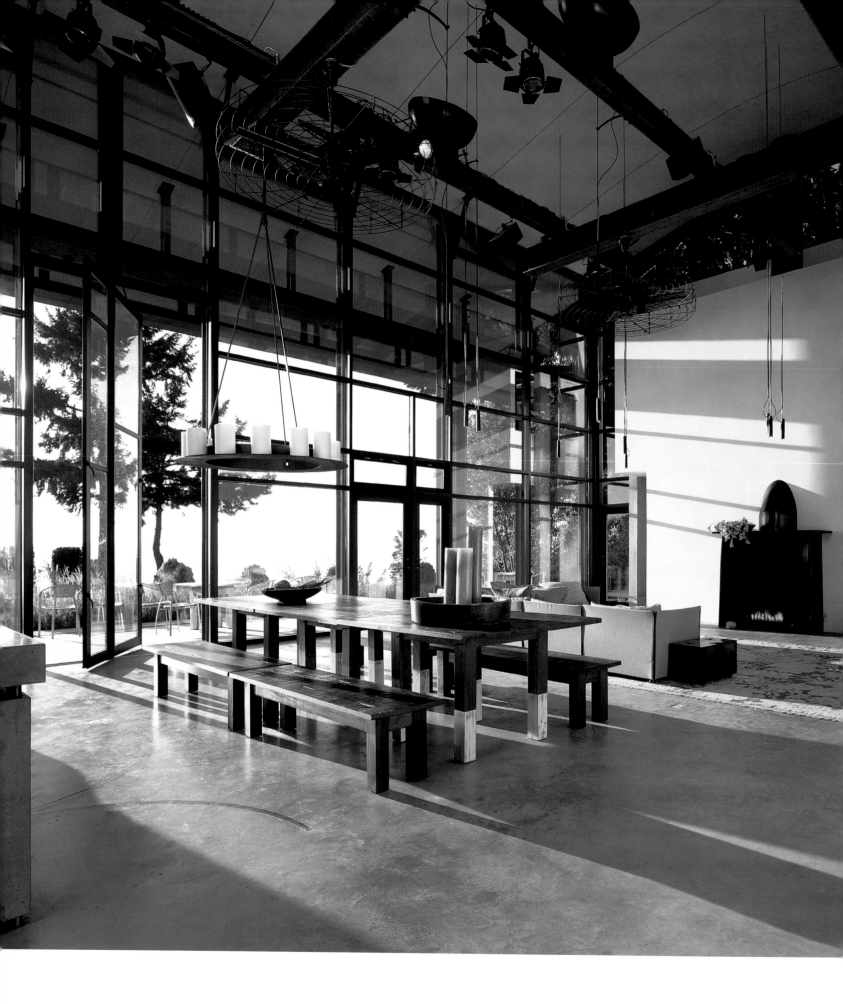

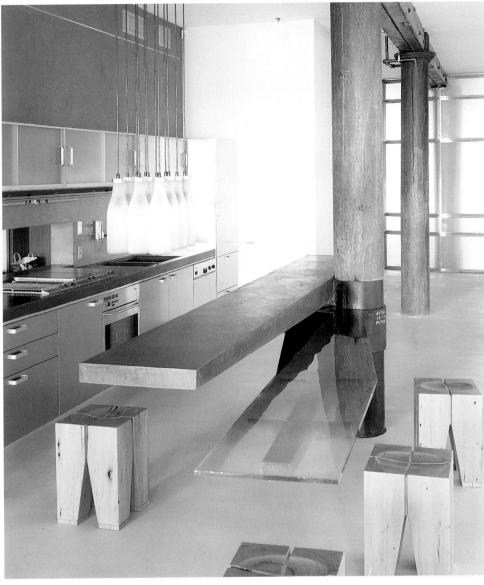

medieval modern [left]

Like an old baronial dining hall, the vastness of this living-dining space in a house near Seattle designed by Olson Sundberg is augmented by the spare use of simple but robust furniture pieces. Elements suspended from the ceiling, however, give the room the modern-day feel of a stage set.

inviting industry

Found and industrial objects and materials characterize the kitchen-dining area of this New York loft created by Winka Dubbeldam. Rough-hewn solid wood pieces, echoing the heavy-duty columns, contrast with the ready-made chandelier and metal fixings.

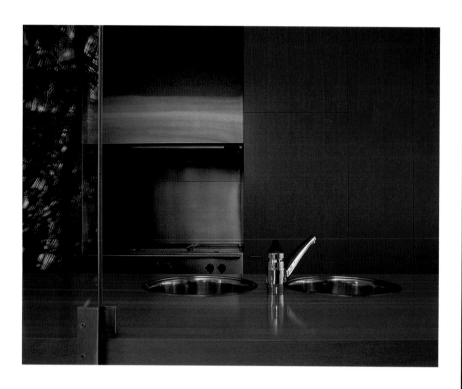

dynamic projection

Sleek and exotic, the kitchen-dining-outdoor area of this modern Sydney terrace house designed by Andrew Nolan blends streamlined forms with strong materials. The space's centrepiece, the long polished wood surface, has a host of uses – from functional to social – and visually leads the eye to the pool outside. Dark stone tiling, a rich palette of surface colours and a long skylight ensure that the nature of the space changes dramatically over the course of the day.

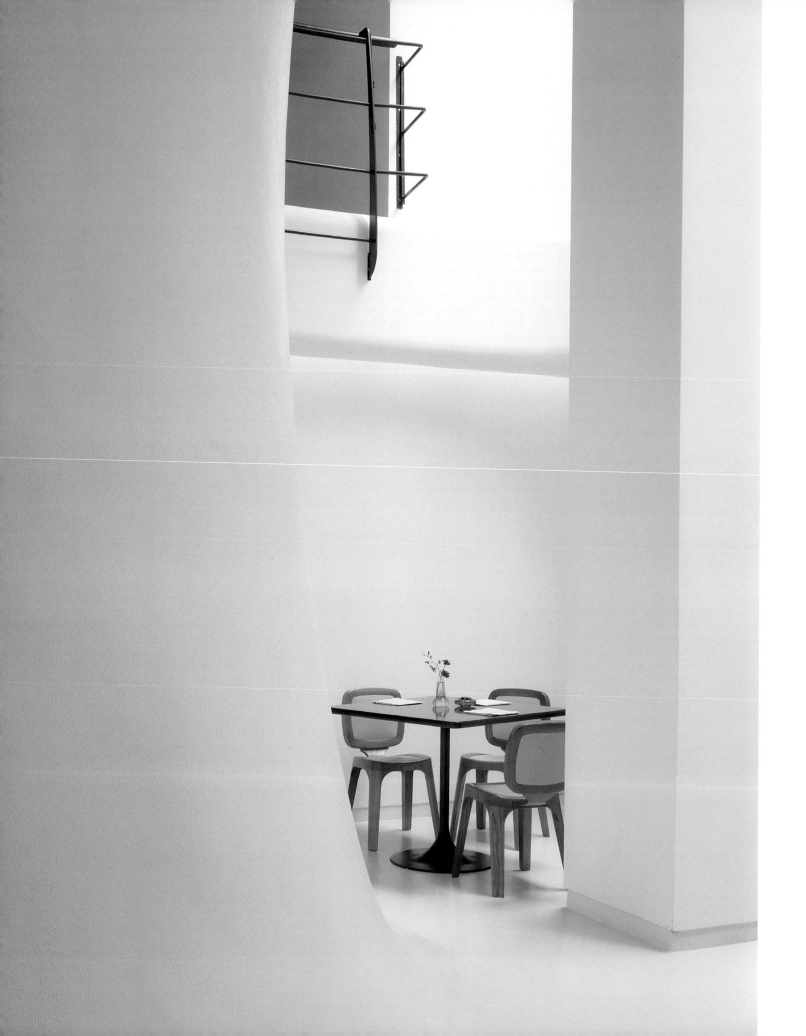

high drama [left]

At one of London's liveliest restaurants, designed by Marc Newson, it is not only the double-height interior that distinguishes the space: gently curving white walls ensure that diners have a sense of enclosure, despite the large volume.

horizontal hub

A large, open horizontal space, like this one designed by Seth Stein for a London house, with a table at its focal point, has many uses. Apart from informal interaction, such a set-up fosters a broad range of social events and can accommodate the activities of small children.

down the middle [following pages]

Although the kitchen and dining room in this London house designed by Arthur Collin are separated by a divider, they are unified by the fine detailing carried through both spaces. Even though the objects and functions in each room are different, the handleless cabinets, white surfaces and wood flooring tie the space together.

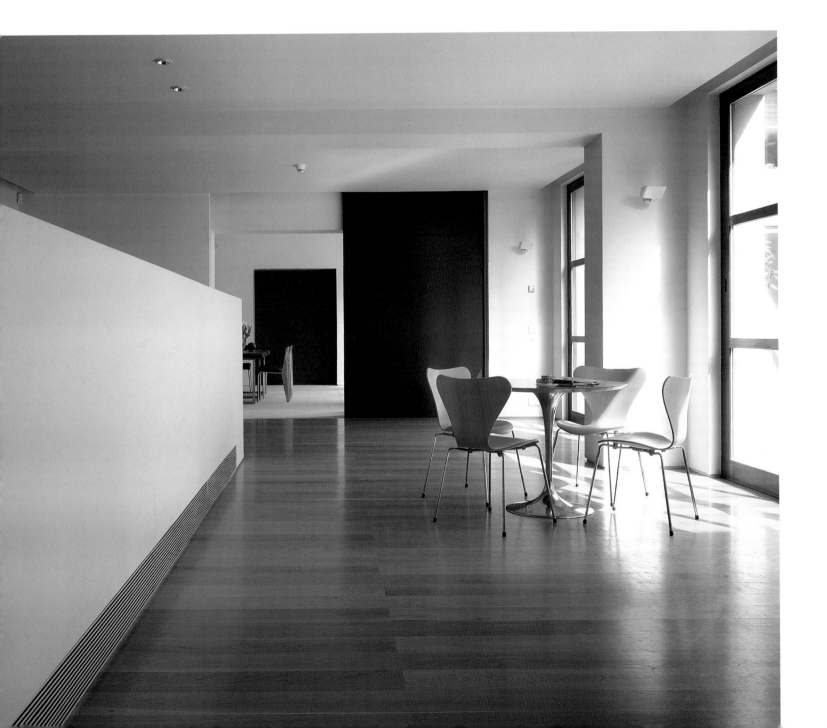

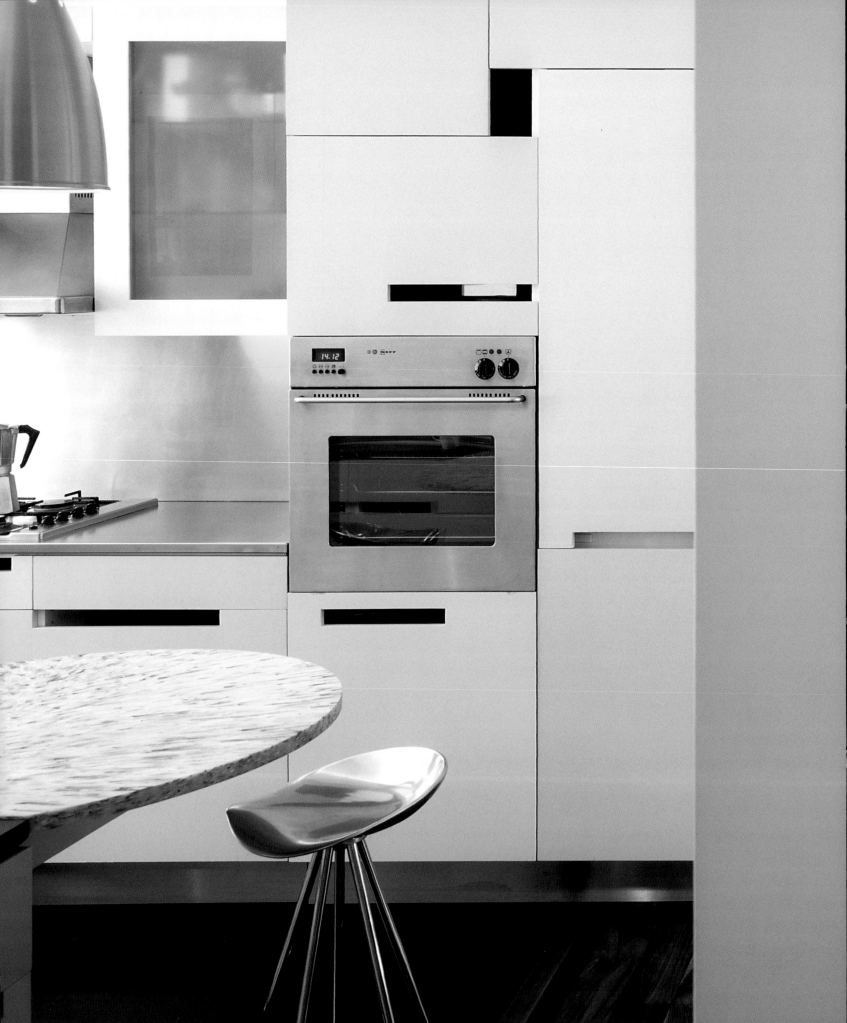

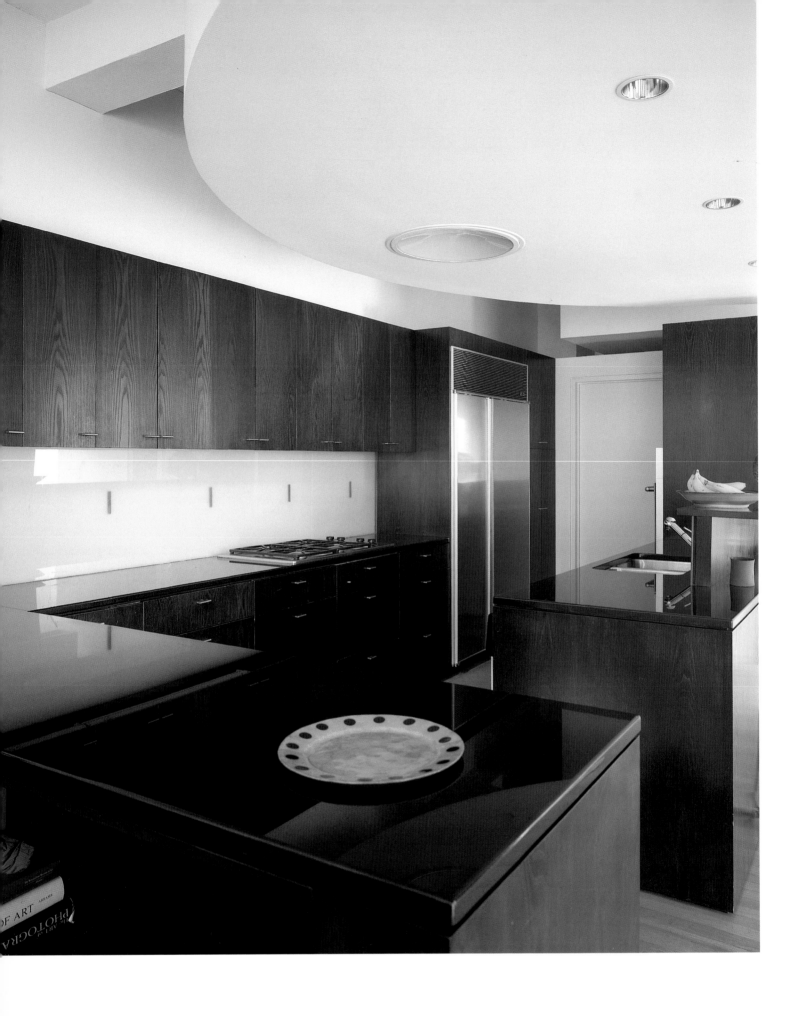

material world [left]

The traditionally configured kitchen can be rendered more contemporary by use of an inventive finish. The effect of the stained wood on the floor and wall cabinets in this New York loft designed by Fairbanks and Marble is more prominent because of the regularity of the components.

magnetic attraction

With its metallic surfaces this otherwise conventional kitchen island created for a house in London by Buschow Henley Architecture assumes a striking form, a modern monolith in the open-plan room. On its own, it conceals the accoutrements of cooking; in the space as a whole, it exerts a gravitational pull on the inhabitants.

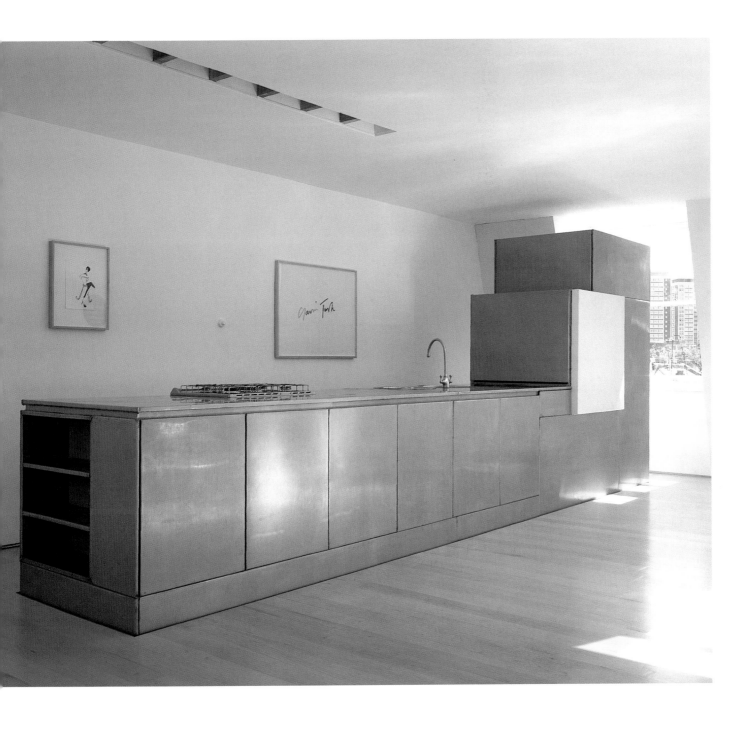

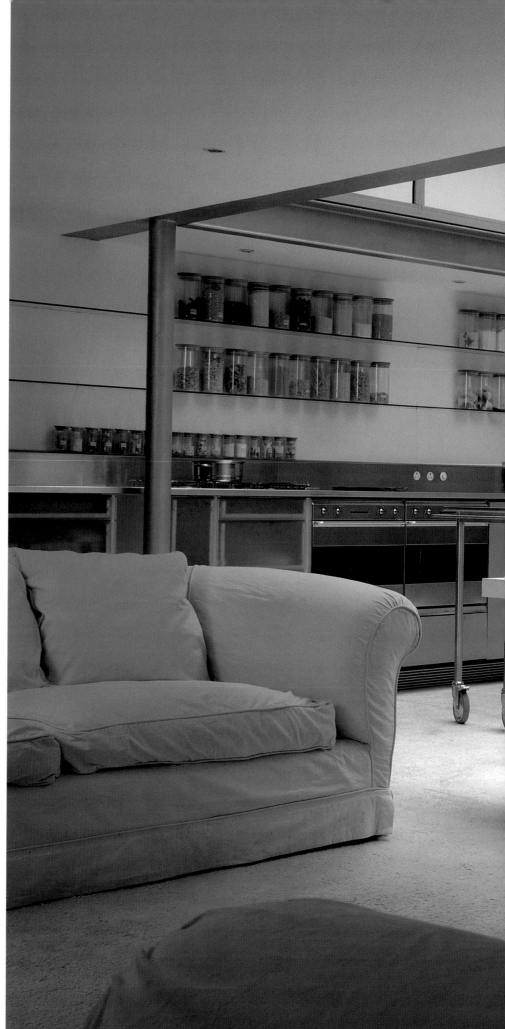

al fresco indoors

The simple inversion of conventional room arrangements can inject fresh perspectives to an interior space. The central dining court of this dramatic London townhouse designed by Paxton Locher allows the kitchen and seating areas to be configured at the periphery to ensure that activity is focused on the house's most social zone.

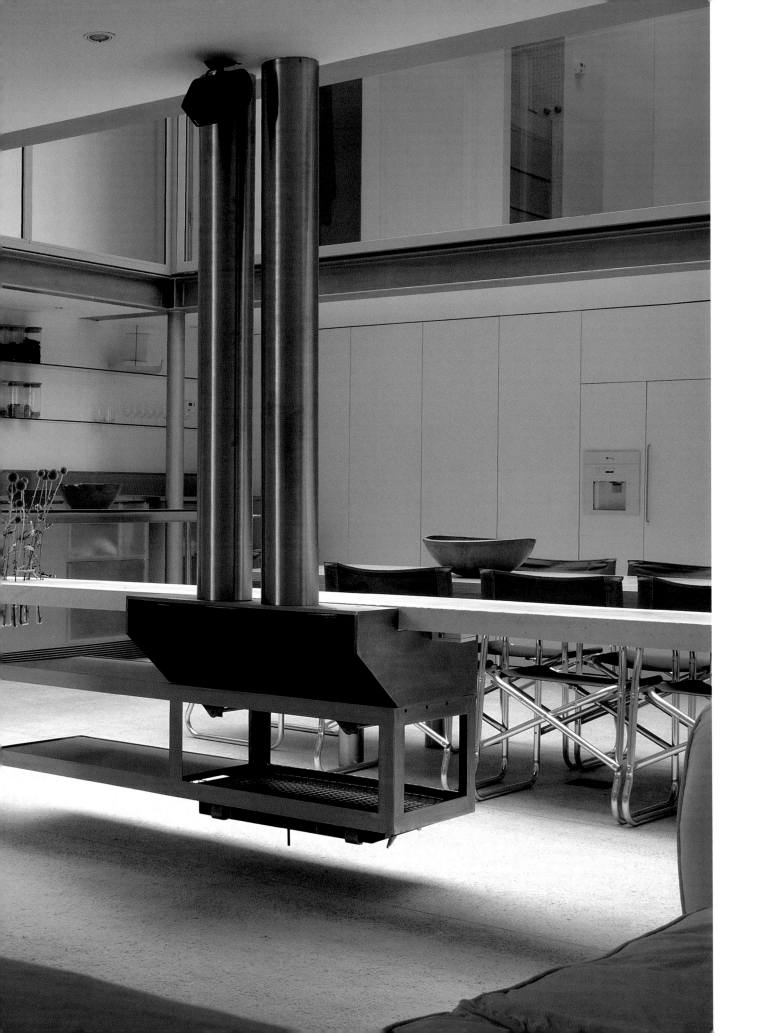

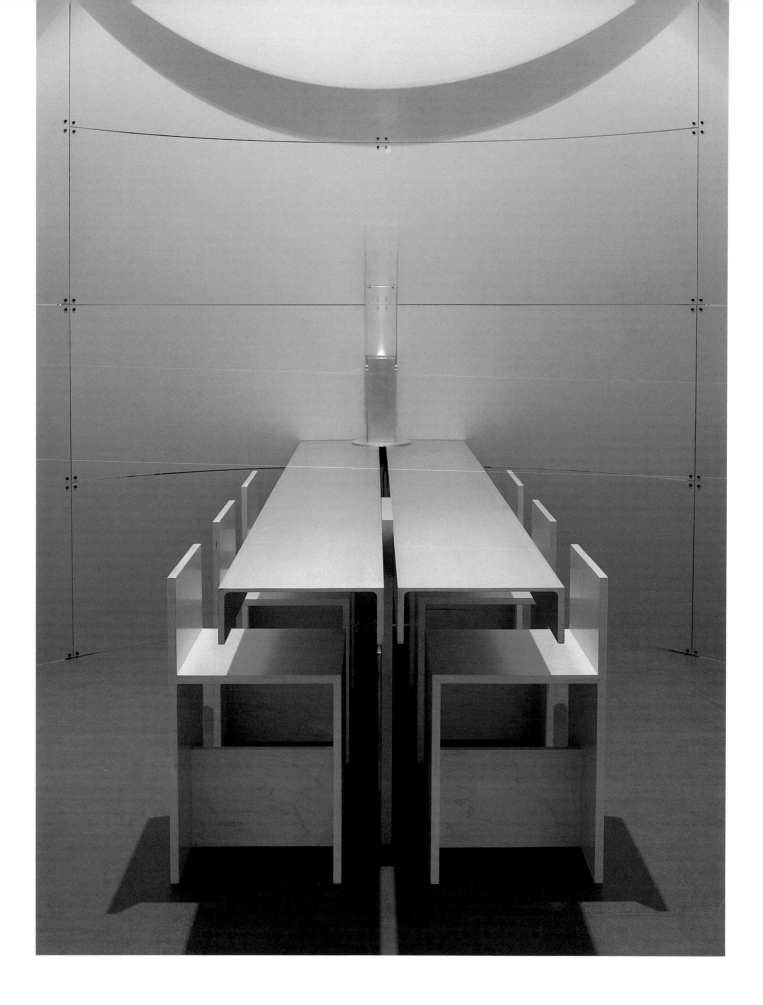

room within a room

Within a large open-plan environment – like a loft – a convenient and flexible way to create a surprisingly intimate space is a free-standing unit. This one, created as a conference room for the office of San Francisco architect Jim Jennings, uses curved steel to envelop a space whose ambience can be carefully modulated by lighting effects. Remove the table, and the enclosure could be used as a private meditation chamber.

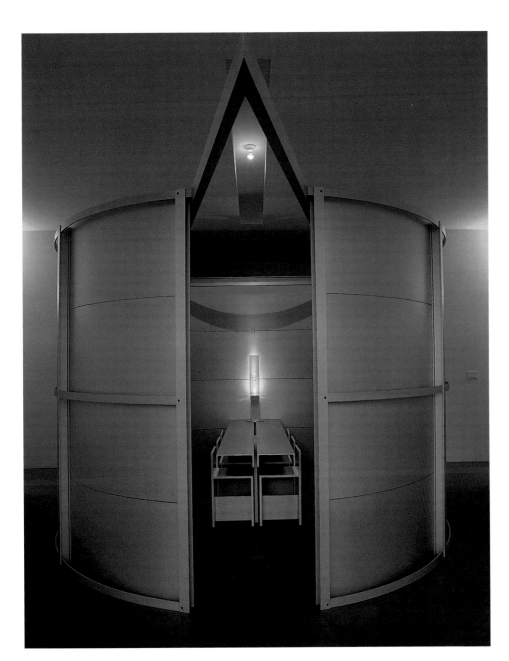

pastel palette [following pages]

A classic light-hued colour scheme, as opposed to heavy rich tones, makes any room seem larger. In this New York loft by Belmont Freeman pastel-hued furniture and lighting are balanced pleasingly against stainless-steel accents, such as furniture legs and kitchen appliances.

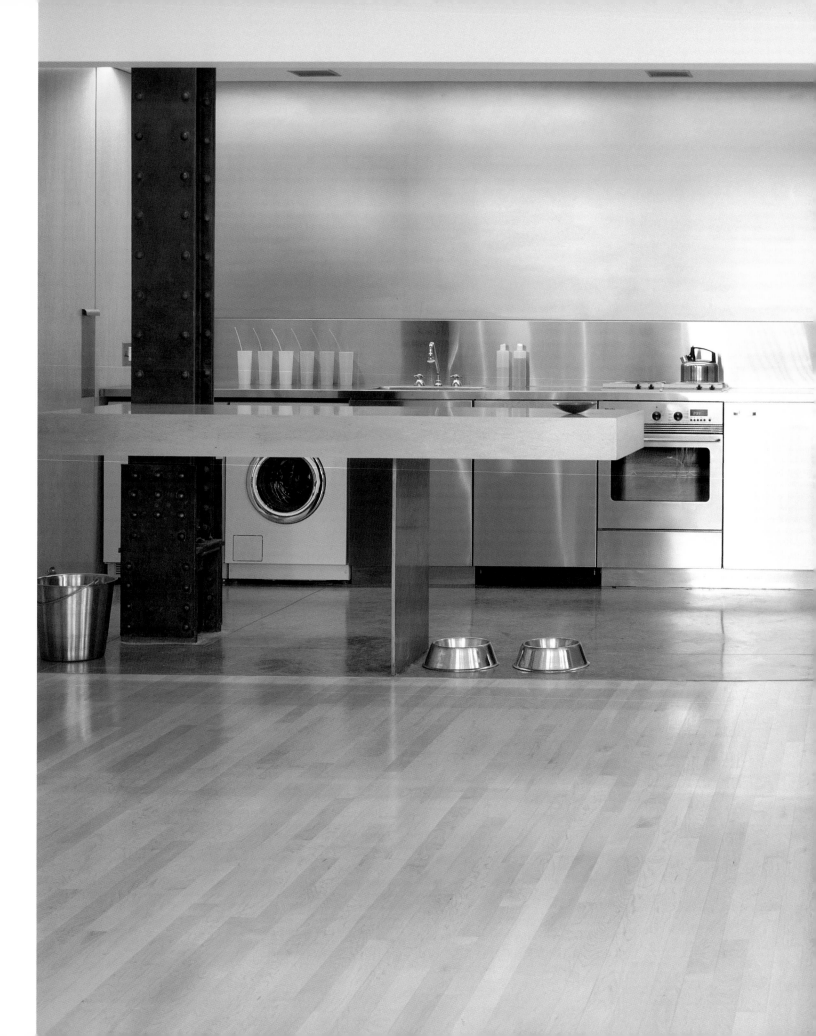

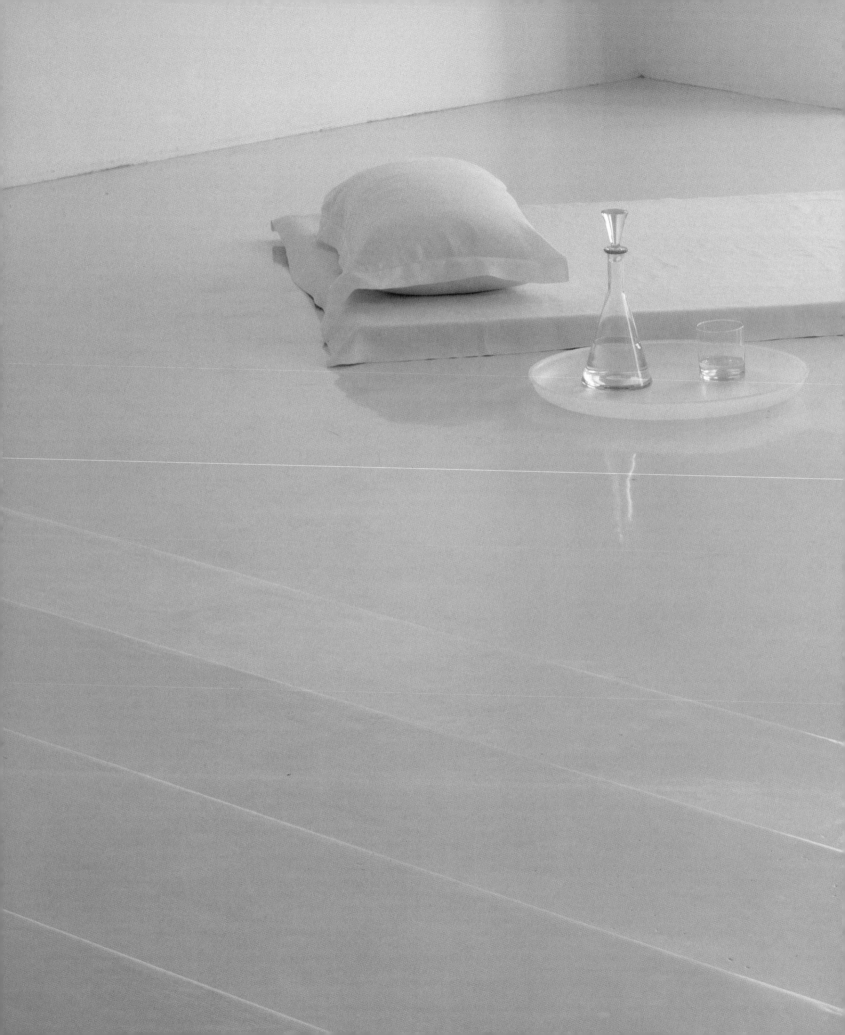

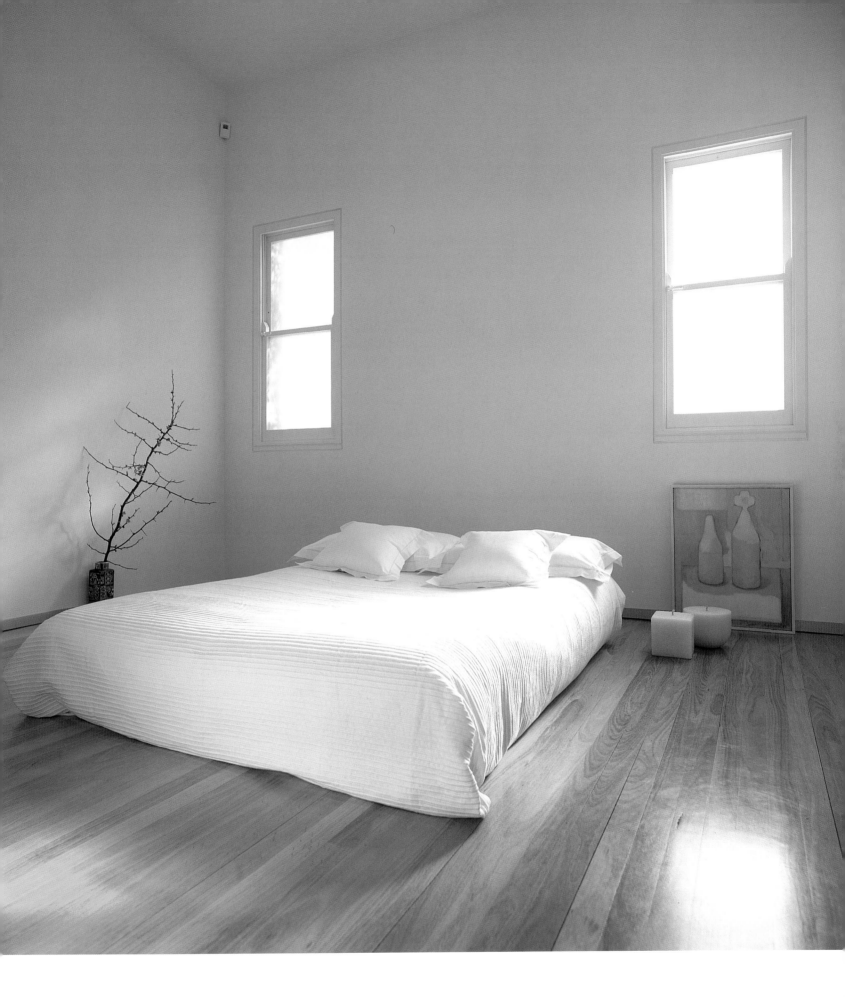

colour harmonies

Occasionally inspiration turns up in unexpected places. This low bed in the Calvin Klein store in Paris, which was designed by Claudio Silvestrin, demonstrates the effectiveness of how similar colour tones operating across hard and soft materials can establish an inviting contrast.

lord's lair [right]

Richly textured mid-tone wood walls, a deep heavy green curtain and an animal rug on the floor are the only components in the bedroom. The loft, designed by Winka Dubbeldam, possesses an atmosphere that conveys a country-house air while being unapologetically minimal.

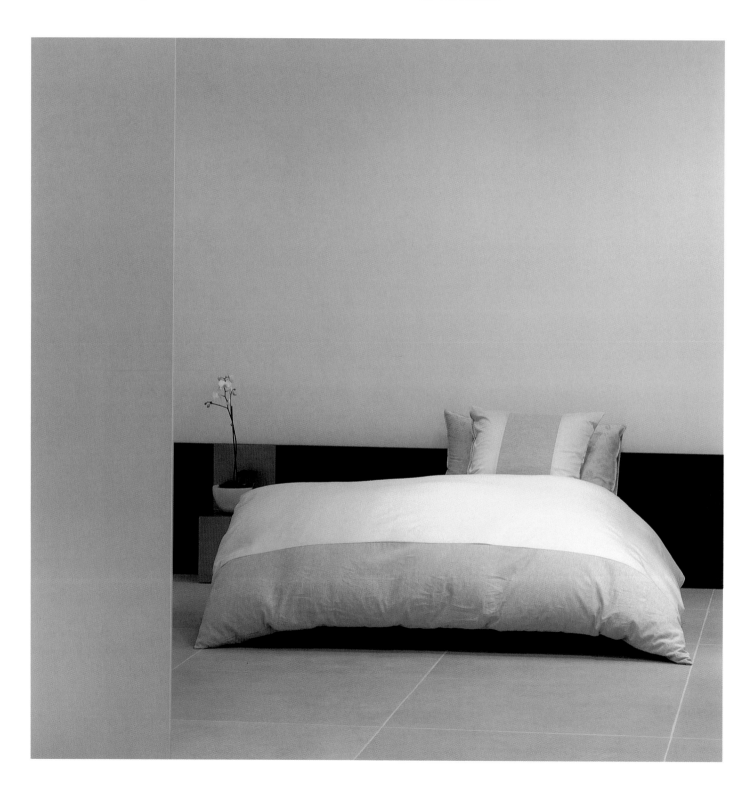

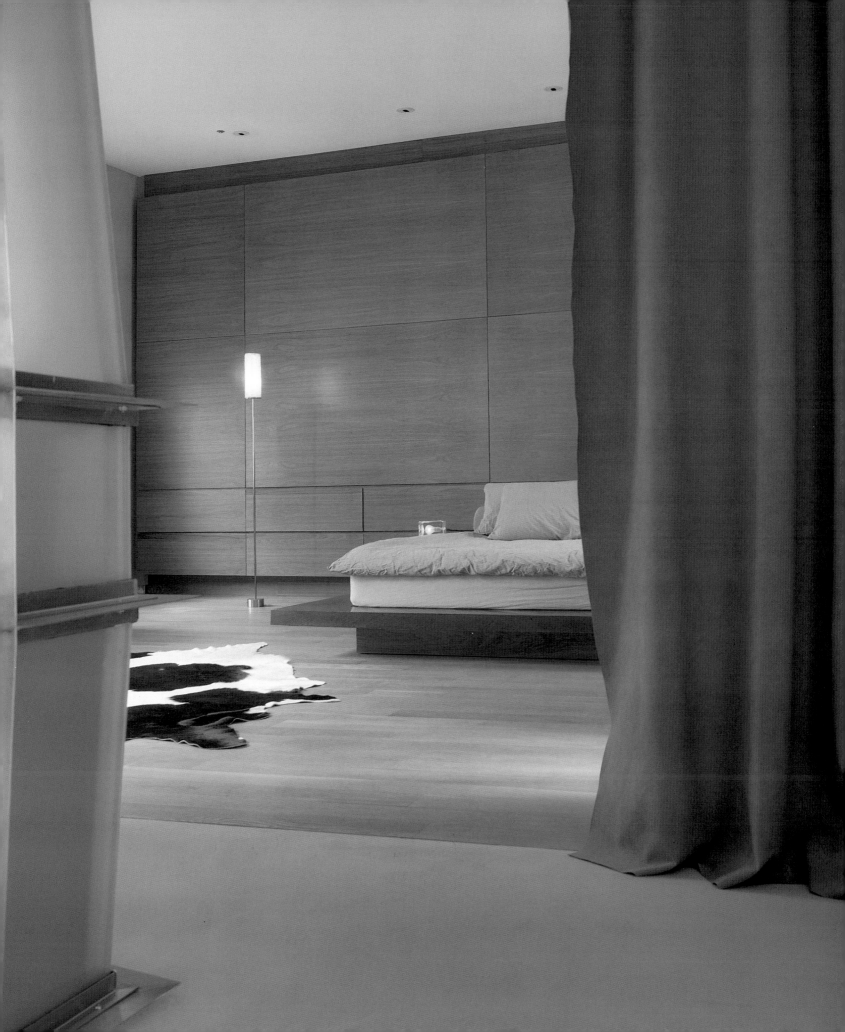

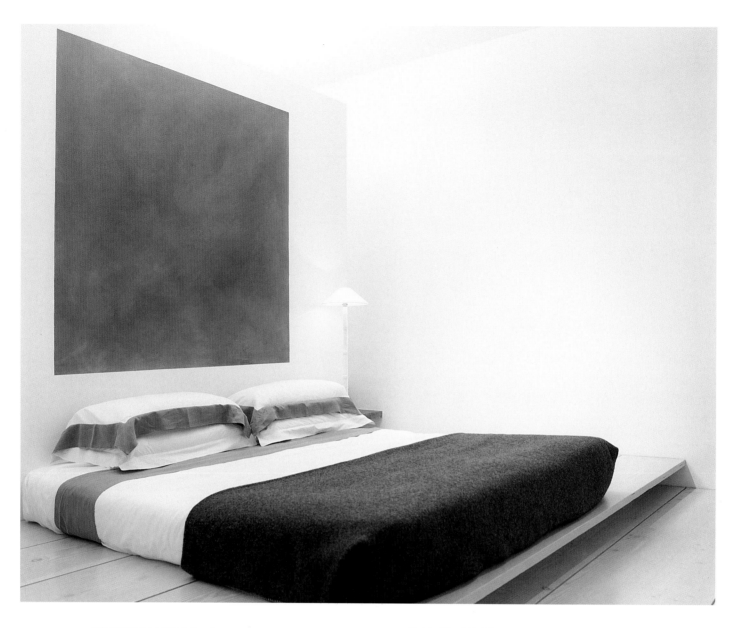

raising the comfort level

In a room in London's Hempel Hotel, the clever insertion of a low wide-plank platform makes the room seem taller and can act as a large area for storage. Like the carefully considered grey painting, the platform articulates the space's planar aspects so that the bed's soft, hovering form is that much more inviting.

light effect [right]

This Manhattan bedroom designed by Morris/Sato Studio uses a reverse trick: a sense of height is achieved in a small space through the placement of uplights that draw the eye upward, while the bed's dark coverings keep it firmly anchored to the ground.

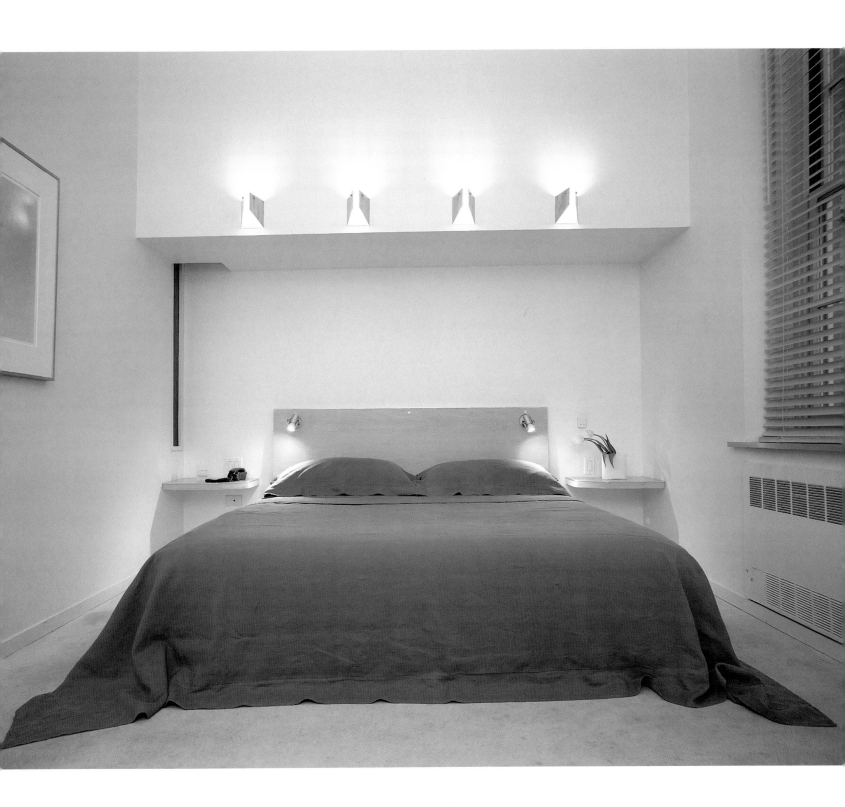

The all-white bedroom of a Greenwich Village loft designed by Deborah Berke makes the most of artwork by the artist-owner. Although the arrangement of furniture is symmetrical, a row of four small paintings seeming to miss one detracts from the space's classicism. Irregularity, used sparingly, creates intriguing effect.

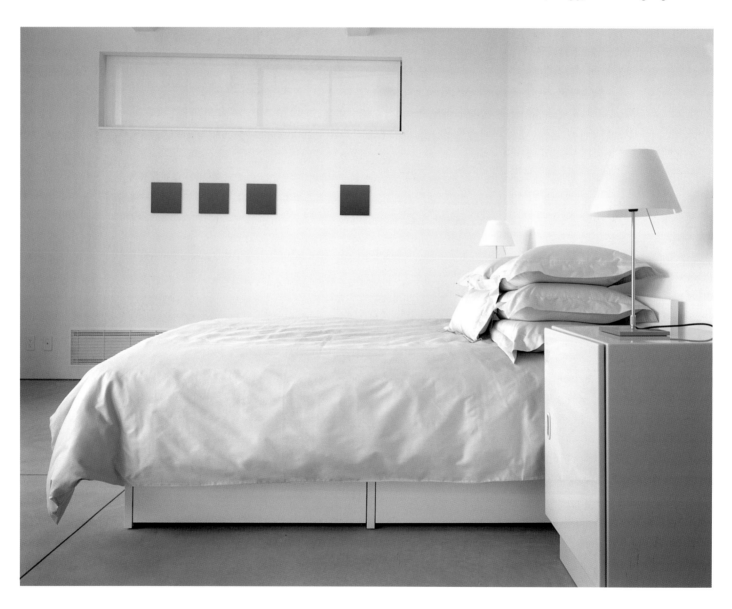

light refraction

Some may argue that frosted or etched glass has become a cliché of the contemporary interior – but not when used in multiple layers. To optimize the play of illumination in this London flat, architect John Pawson employed a series of glass divisions that dramatically blur the precious English commodity of natural light.

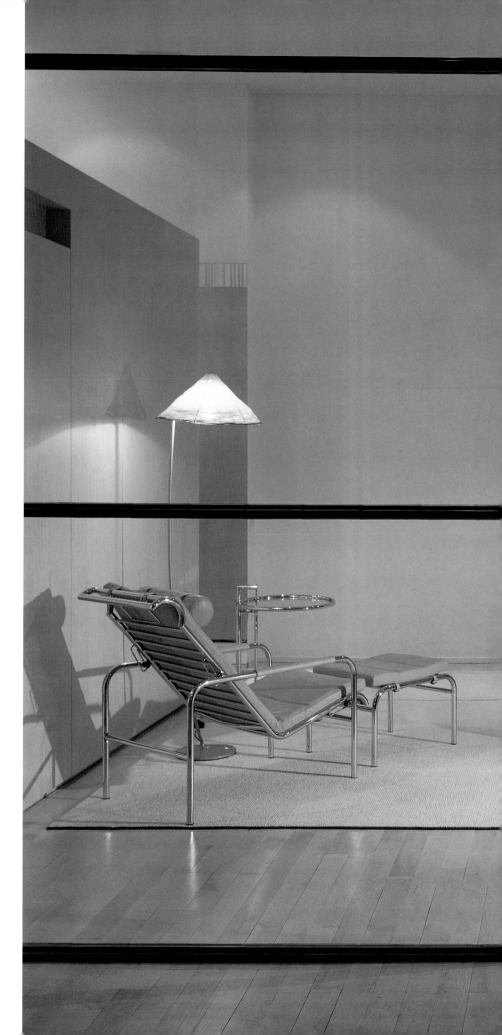

inverting the glass box

Playing on the ambiguities of public versus private space, Hanrahan Meyers Architects found an innovative solution in setting off a bedroom in a Manhattan loft with a glass wall, which provides acoustic and when necessary visual separation from the main living space. Movable and fixed glass planes permit the space to be open or complex – depending on the mood, time of day or social function – while the loft space as a whole remains open and light. The curtains of the bedroom can be drawn to ensure privacy and a sense of enclosure – a room within a room.

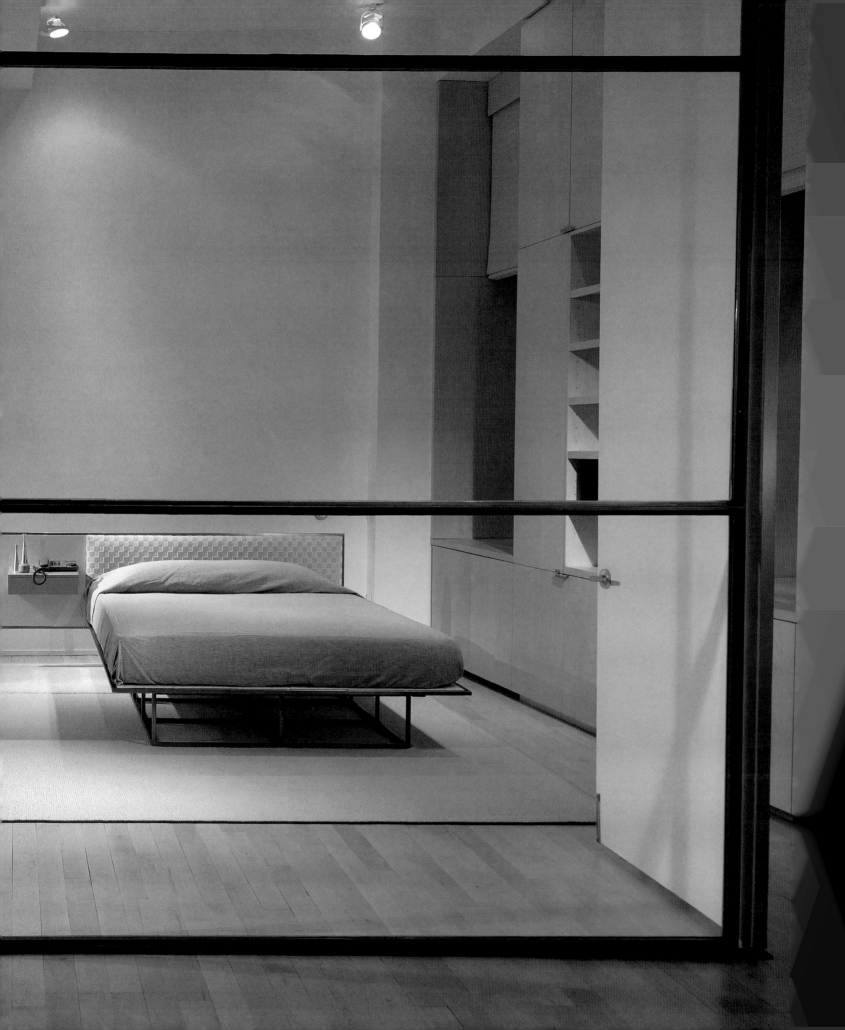

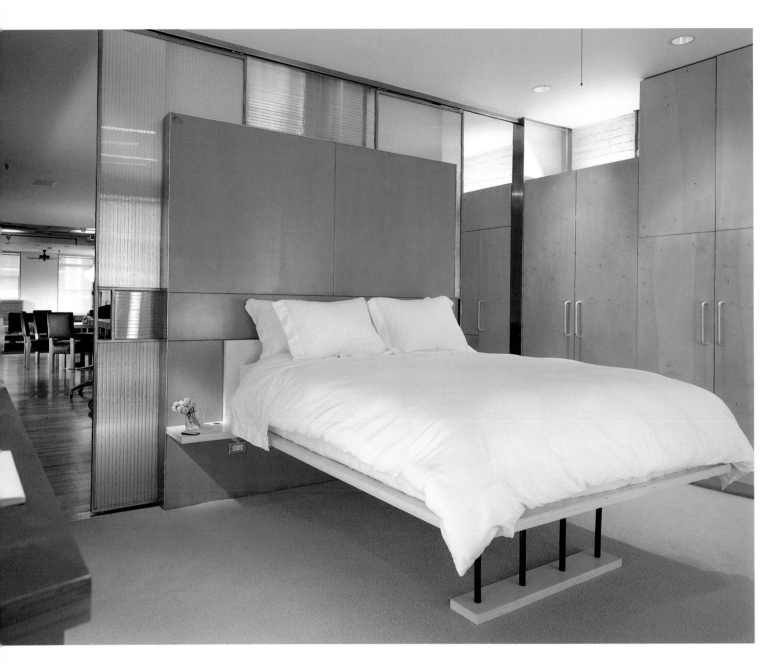

a platform for sleeping

Using a hybrid of translucency and solidity, a studio called Resolution 4 Architecture used sliding and fixed bevelled glass panels to surround the wooden headboard in this Tribeca loft bedroom. Light into the room is maximized and animated by the glass.

the comfort of gravity [right]

Gravity and our natural inclination to lie down are exaggerated in a New York apartment. Artworks appear to be about to drip onto the bed, which is supported by a chunky wood frame. In their comparative lightness, thin cloth curtains provide an ethereal contrast.

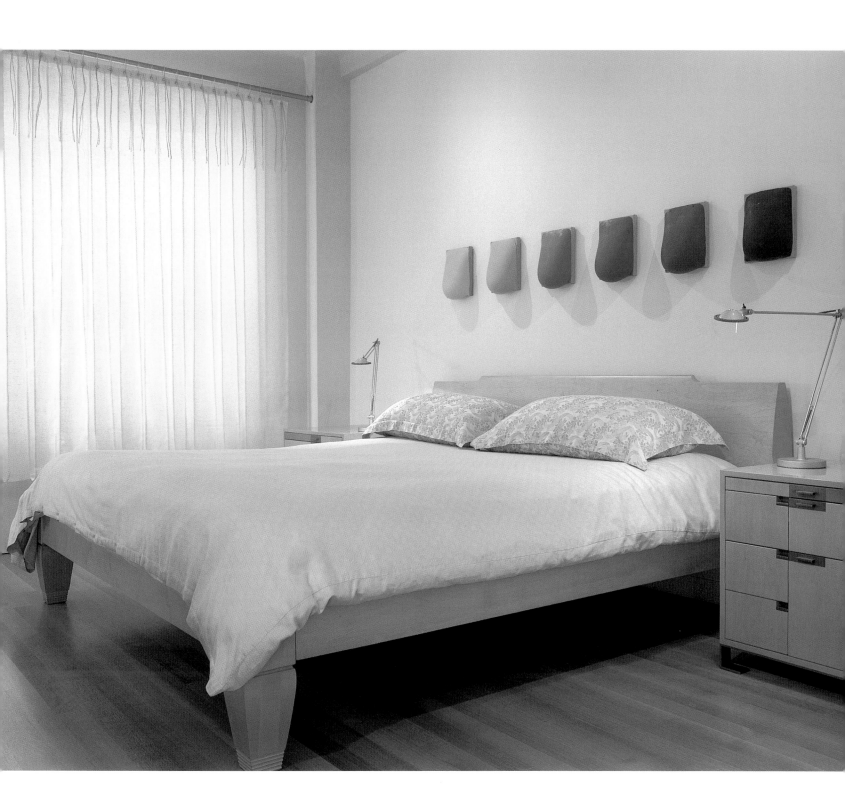

movable sleep

A robust aesthetic, complete with a bed on castors, characterizes this dynamic bedroom space, designed by Smith-Miller + Hawkinson for a loft in Manhattan, which overlooks a double-height studio.

black and white [right]

Anchored visually by a flat black wall, the bed in this New York apartment designed by Gabellini floats over the all-white space. A collection of photographs complement the room.

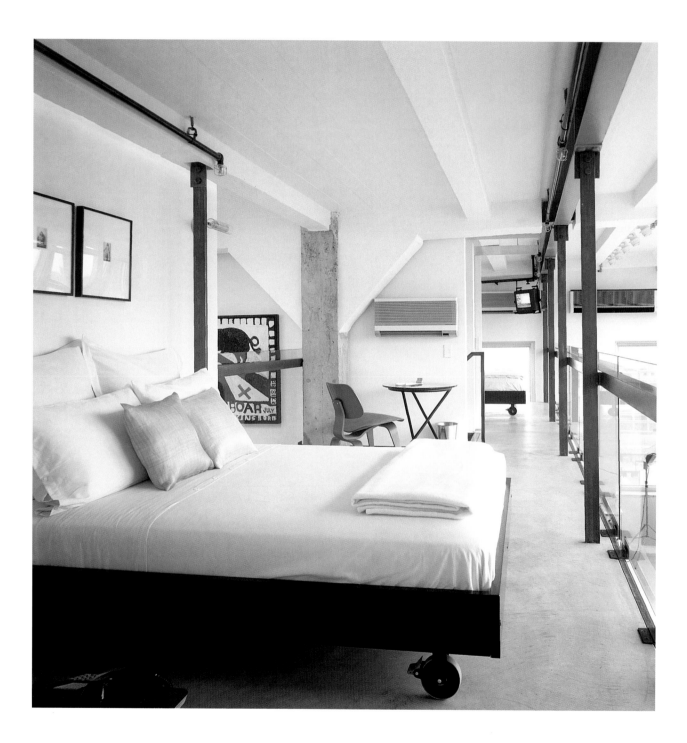

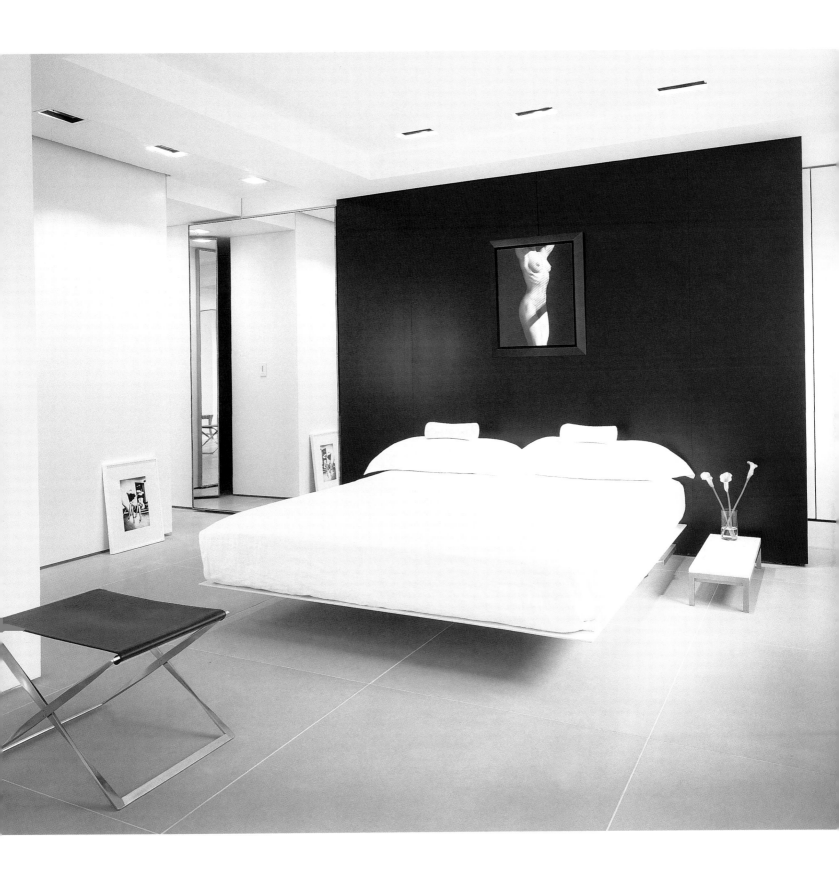

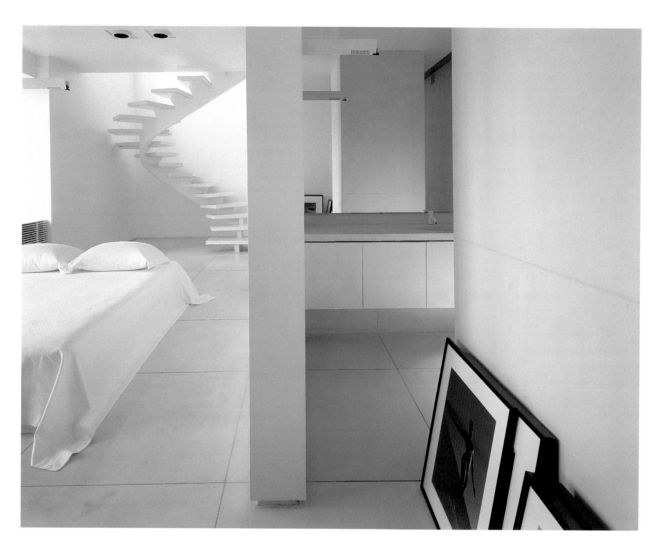

heaven underground

Most people prefer their beds to have some form of attachment to a wall, usually in the form of a headboard. In this extraordinary Manhattan space designed by Jay Smith, however, everything floats: stairs step lightly down to the bedroom, which confidently exploits its central position. Enshrouded in white, dreamers can imagine they are hovering above – rather than below – the house.

spatial exactitude [right]

Carefully set next to a well-ordered pebble garden, this private sleeping haven created by Mark Guard within a London townhouse ensures that slumber and meditation are one. Imagine the sensation of waking up, peering out over the quiet garden and taking a contemplative stroll with pebbles crunching underfoot – all before breakfast.

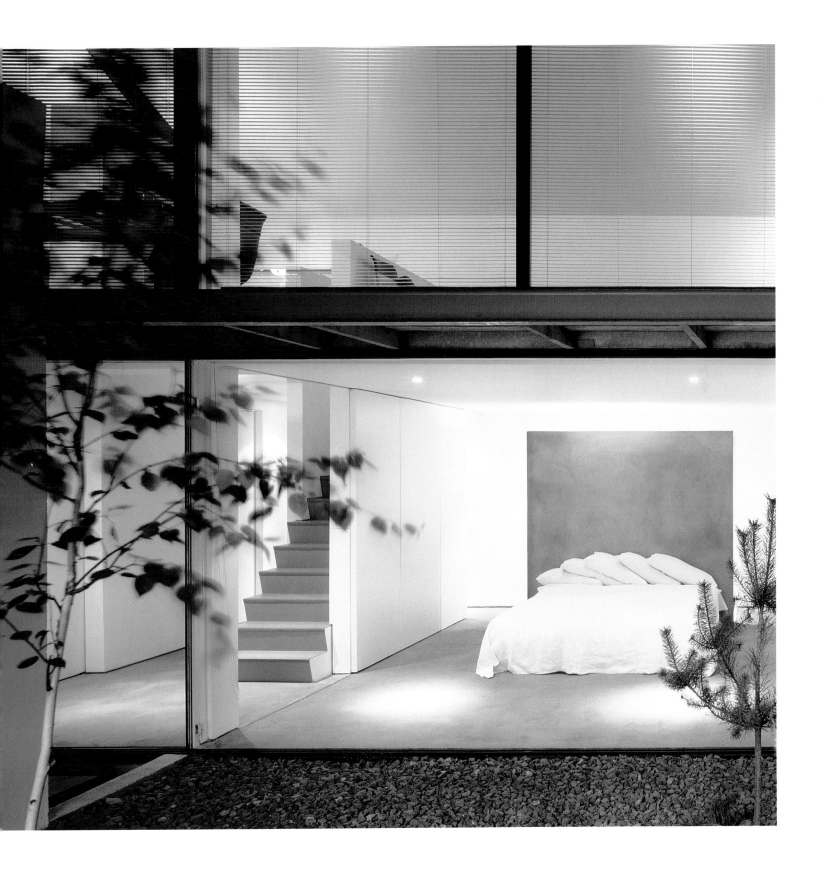

bathing

liquid rituals

Cleanliness and the process of
ablution take place daily, so
why not enhance the experience
with a harmonious space that
can energize the body and still
the mind?

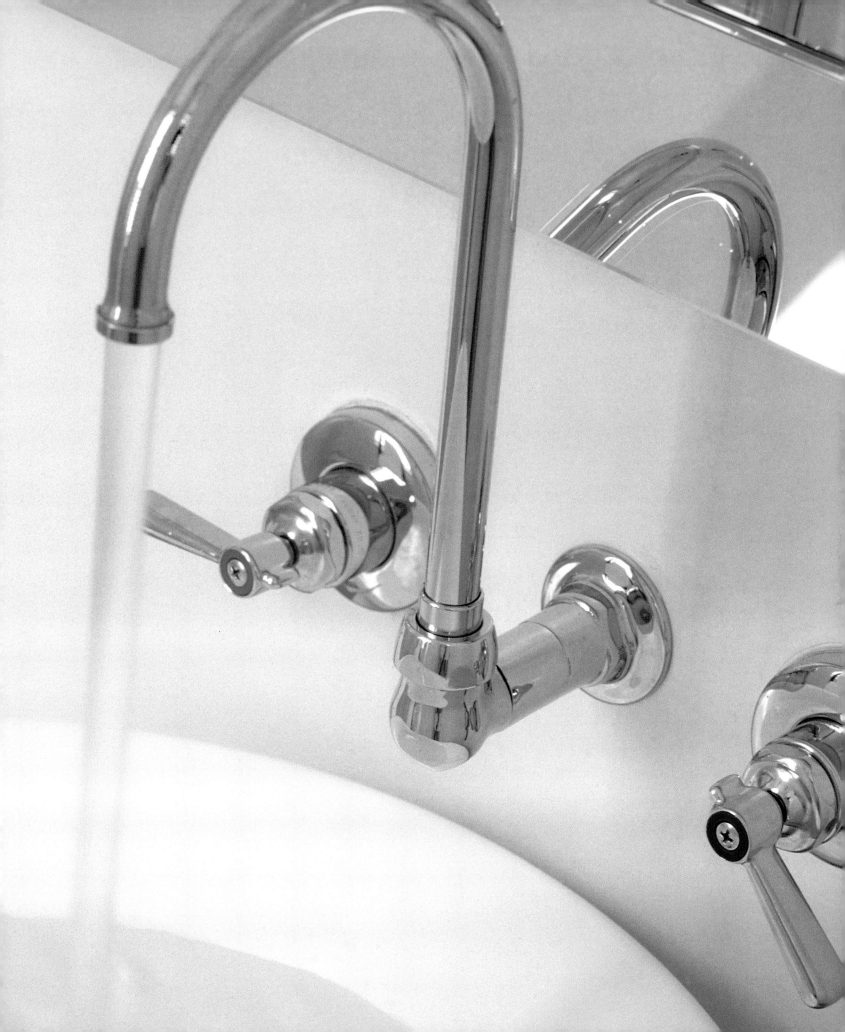

Although the Egyptians, Greeks and Romans attached great importance to bathing, their recreational and spiritual attitudes toward water have over time and with modern life been lost in favour of a purely utilitarian, hygienic and rather puritanical use of the bathroom. With retreats from daily life becoming more and more scarce, however, the bathroom has become a sacred

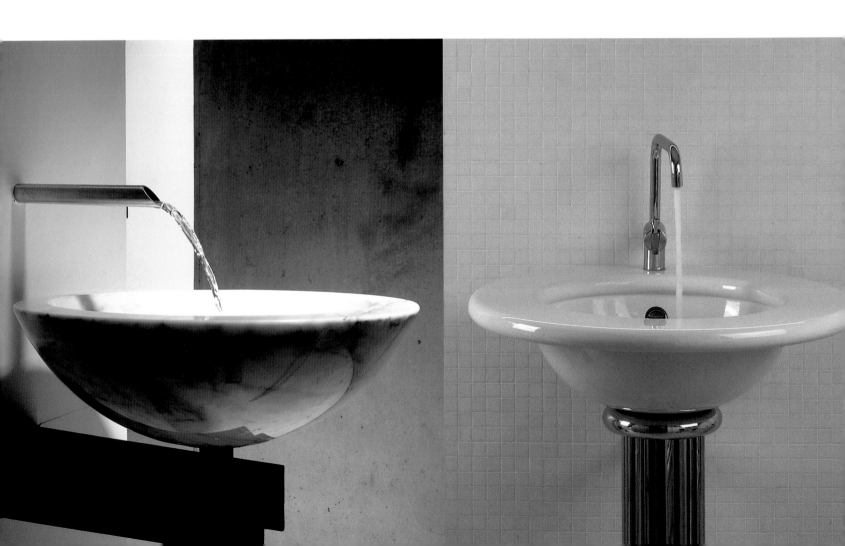

space in which to perform daily functions and to relax. To create an environment that is both useful and calm, the clever manipulation of space, surface and light are vital. With the right combination, the space can become the perfect place to meditate – perhaps with the aid of aromatherapy – while your consciousness lingers over the soothing sound of water.

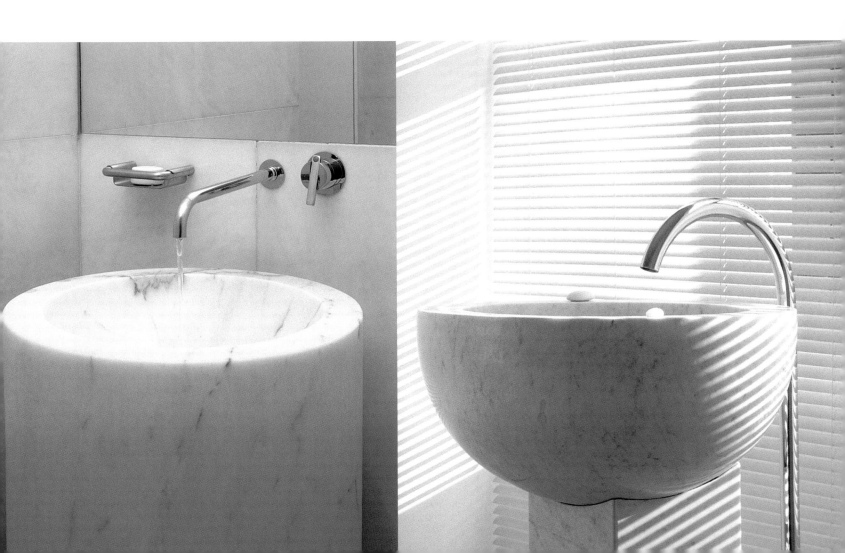

Let materials speak for themselves in a manner that induces contemplation of their intrinsic nature and are wonderful to the touch.

Today's bathroom is primarily a functional necessity and people rarely take enough time to think about what could make it the most special room in the house. Traditionally, the bathroom has been one of the smaller rooms in the home. Add to that the network of pipes needed to bring in water and take out waste, traps and plugs and other plumbing

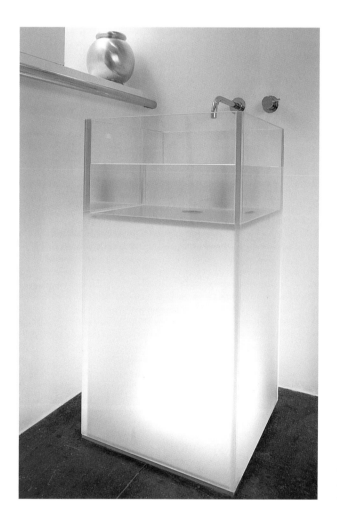

details, and the possibility of creating an essential space seems remote. Of all the rooms in the dwelling the bathroom is the one area where privacy is a genuine necessity and not just a preference. And more than other rooms, bathrooms have to withstand substantial wear and tear from the extremes of temperature, steam and moisture. Any surface decoration needs to be tough, waterproof and easy to clean.

These issues do not preclude achieving a serene space, but all need careful consideration. The hard and clinical look often attributed to the minimal style naturally suits the necessities of the bathroom. Yet, the aim is to achieve a relaxed and spacious feel – despite the actual size available – in which the occupant can do everything from taking a brisk invigorating wake-up shower to relaxing in a comforting tub with a good book at the end of an enervating day.

As the following examples show, there are a variety of ways to confront the difficulties posed by the bathroom, from innovative spatial configurations to high-tech materials, from lighting effects to tactile surfaces. In recent years a number of designers and architects have begun to use sophisticated technologies and materials in new and surprising ways,

Sink at the Hempel Hotel in London [left].
All-glass sink designed by John Lautner for a house in Los Angeles [opposite].

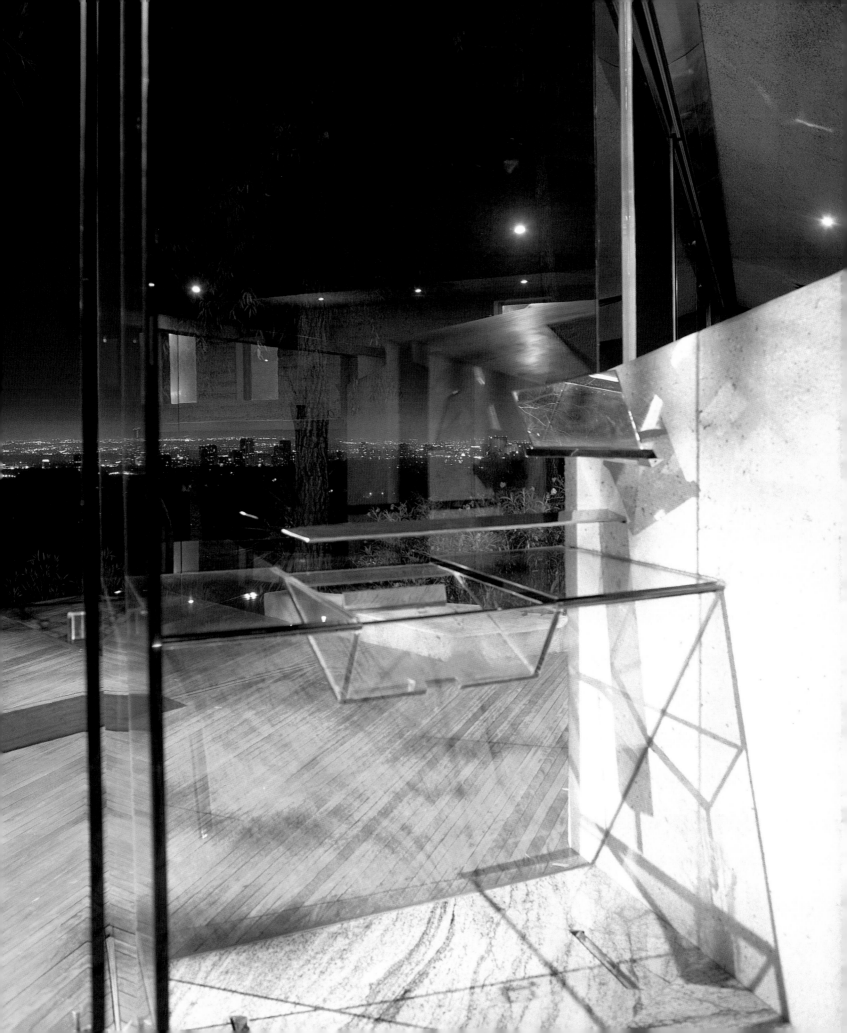

particularly in the bathroom. For example, where privacy is necessary but space and light are limited, what better than a wall of sheet glass that at first sight appears transparent but can be transformed by the flick of a switch into an illuminated milky-white screen concealing everything behind it (in either direction). When the wall is not in use, the room appears to be an extension of another room and yet when in use provides privacy on one side and a spectacular lighting effect on the other.

New and improved sealants mean that it is possible today to successfully join pieces of glass so that they can be incorporated into basins and baths. Similarly, magnificent slabs of marble can form baths that are monumentally minimal. In some examples, baths are hewn from a single piece of rock – a sculpture that induces the bather to contemplate the ageless beauty of a solid piece of the earth. Thanks to advanced surface sealing systems, such porous rock as limestone can be used as flooring without fear of staining.

The combination and contrast of materials is vitally important to establish the desired look. For instance, stainless steel against marble is one successful solution that is both functional and beautiful. Other classic combinations include glass and limestone, cast iron and wood. The important factor in a minimal space is not to use materials merely in an honest way – to let them speak for themselves – but in a manner that induces contemplation of their inherent qualities and is wonderful to the touch. By reducing the number of materials used the relationship among them is heightened.

Bathtub in London house designed by Pawson and Silvestrin.

There is nothing worse than underestimating storage needs, particularly in the bathroom, where space is at a premium. In addition to the amount of storage, one must consider location: bottles and lotions need to be within easy reach of the shower, bath, basin or lavatory.

One of the most constraining features of the bathroom is that the 'furniture' is fixed and cannot be changed at a later date without considerable inconvenience and expense. Here, too, advance planning and careful consideration of every detail and fixture are critical before finalizing the design. For obvious reasons, the elements of the bathroom are ergonomically designed, but because of the human body's variable size and shape there is a broad range of

products that cater to different needs and tastes.

The last and undoubtedly the most defining

The aim of bathroom design, therefore, is to balance the needs of the everyday with an allowance

We ourselves are largely made of water, so it is natural for us to spend time in contemplation and in reverence of it.

aspect of the bathroom is water: the reason for the room. As with all the components of the room, water must not be taken for granted. It must be celebrated, respected and, increasingly, used sparingly. The design of the space, therefore, must take water seriously – as a material in itself. Water is universal, yet every culture assigns its own meanings to it and each has its own way of designing in relation to it. Ultimately, though, our experience of water is personal, intimate and private; the bathroom should be a temple to water and its use in maintaining our well-being. We ourselves are largely made of water, so it is only natural for us to spend some time in contemplation and perhaps in reverence of it.

Most bathroom lighting is harsh, designed more to ensure that we can see and clean every pore than for atmosphere. Clearly there needs to be strong, focused lights for certain functions, but one should also make an allowance for those moments when peace and quiet are desired. Candles are the most obvious alternatives, but wonderful atmospheres can be created with backlighting behind glass, or pinpoint spotlights in the right places. Always think of the space as a whole, but usable in parts.

Marble bathtub in London house designed by John Pawson.

for those rare occasions when pampering is needed. There is no better place than the bathroom for making yourself feel good in mind and spirit, so explore new territory, discover the nature of things, but most of all, relax.

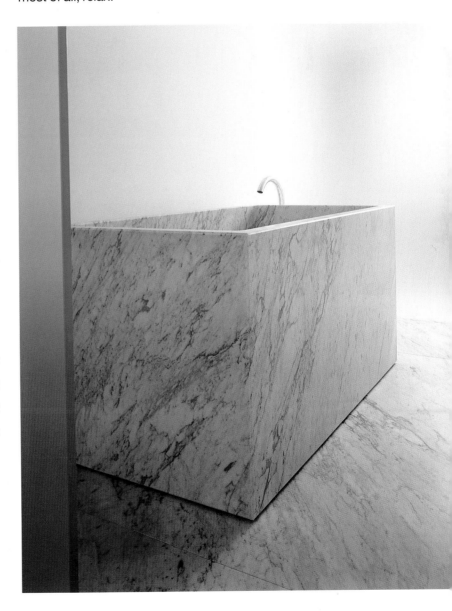

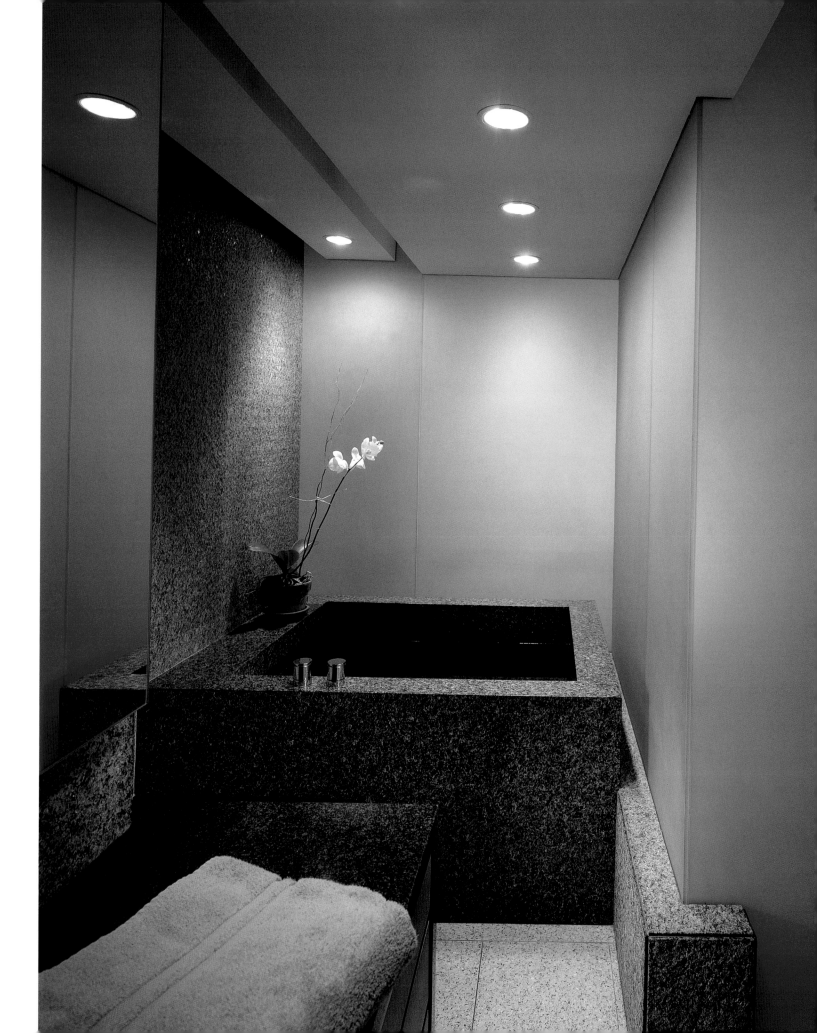

sheer pleasure

Most conventional bathrooms feature pieces that suggest some connection to the body's irregular and curved shapes. In this New York apartment, unexpected strong rectangular forms offer comfort and solidity to the user.

direct from nature

Despite our requirement for optimum cleanliness and functionality, many elements of the bathroom are needlessly clinical. Stone underscores the naturalness of our daily bathing ritual. This Belgian house designed by Vincent van Duysen, for example, features a grey sink seemingly hewn from a single piece of rock.

return to luxury

Stunning cobalt and a 1940s-feel impart a sense of hotel grandeur to this glass-walled bathroom in a New York loft designed by Winka Dubbeldam. The minimal bathroom looks best when the materials are few and artfully contrasted; gold-effect tiling is the pièce de résistance.

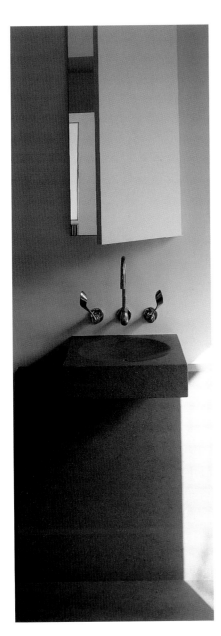
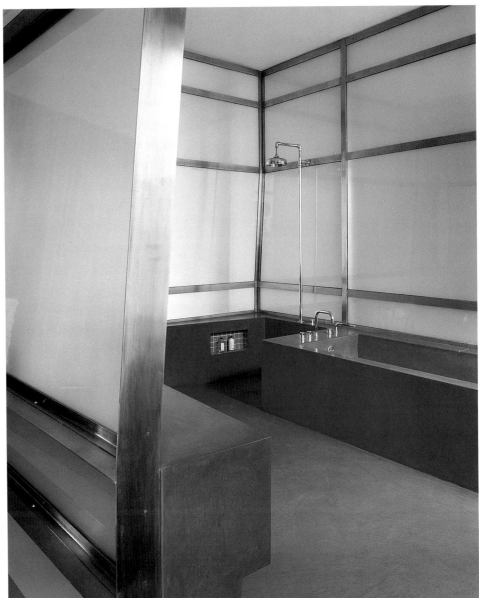

refreshing tradition

The purity and simplicity of white in the bathroom are almost as old as plumbing itself. Optimal for hygiene and a bright way to begin the day, white is always right. For the Delano Hotel in Miami, designed by Philippe Starck, a round basin with traditional fittings is the perfect start to a sun-filled day.

rightful order

Although it shares its whiteness with the Delano, this serene bathroom in London's Hempel Hotel works behind the townhouse's Victorian exterior, which the bather can glimpse while soaking in the tub. Privacy is assured by the careful placement of pots and plants, rendering frosted glass unnecessary.

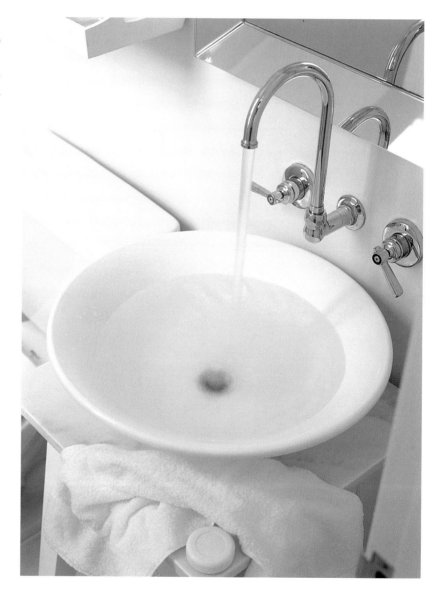

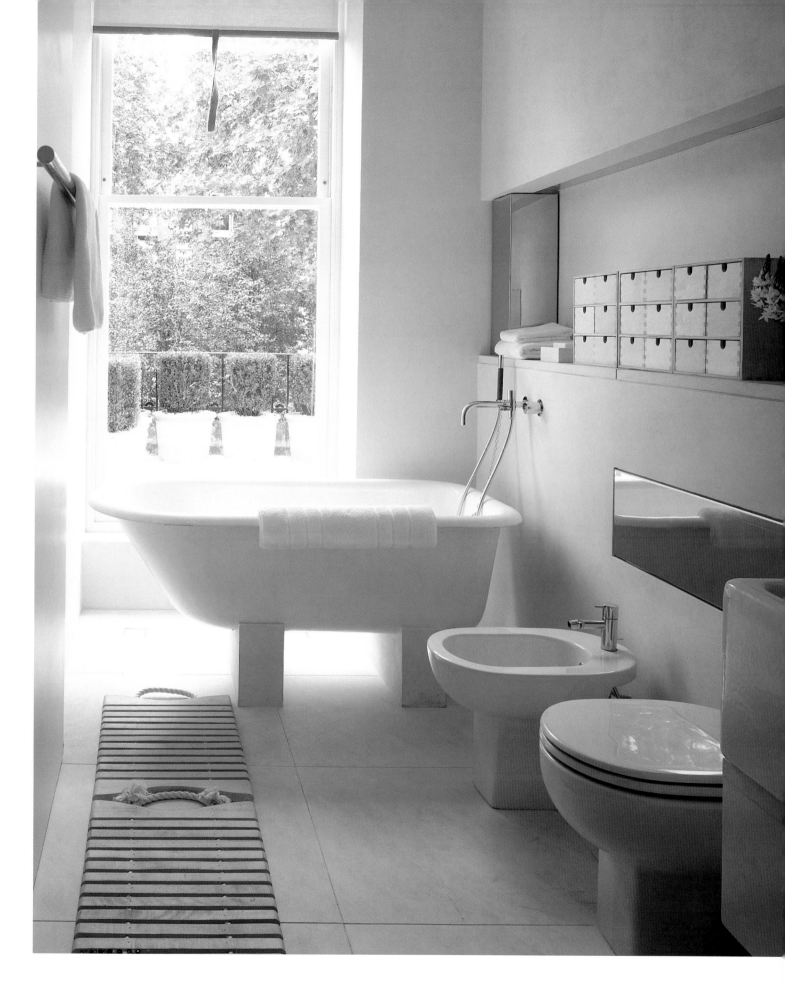

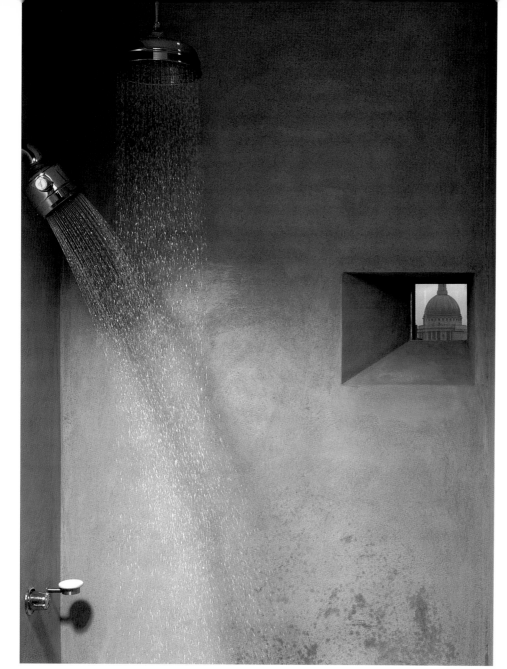

shower with a view

Showers are usually designed for their utilitarian function, with often no more than a soap dish and a spout. Taking advantage of a terrific, almost whimsical, view of London's St Paul's Cathedral, early-morning bathers in this flat designed by Seth Stein can consider the day ahead – and the world outside – from a unique vantage point.

translucent drapery

A shower curtain is frequently an after-thought, but in this New York apartment by Morris/Sato Studio, it determines the design. As a free-standing circular unit luxu-riously surrounded by acres of curtain and suspended from concealed rails, the shower projects an air of drama – a place for enjoyment not just cleansing.

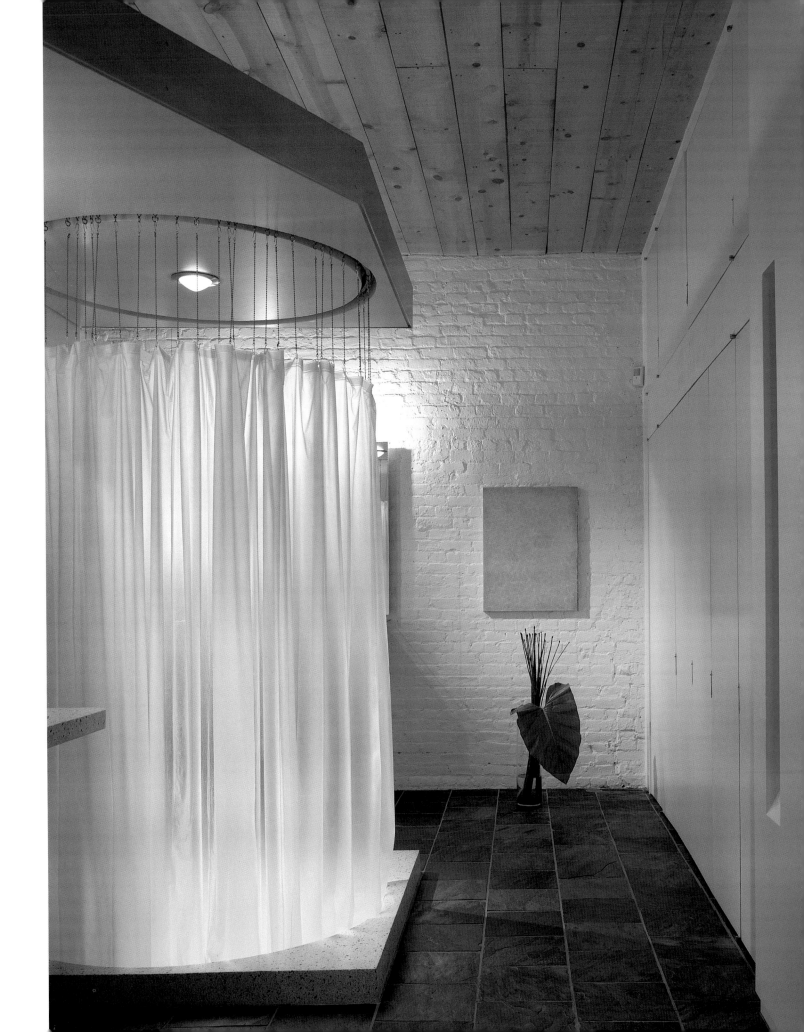

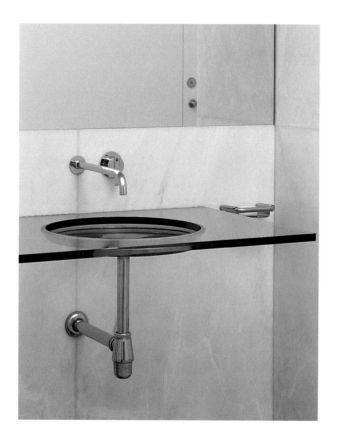

plane water

The bathroom of Pousada de Santa Maria, a former monastery in Portugal converted into a hotel by Eduardo Souto de Moura, features a thin glass basin that has the appearance of water itself. Against marble walls and classic minimal fixtures, the movement and containment of water become the focus of attention.

tiled geometries [right]

Covering practically every surface, the light-blue tiles of the bathroom in this Milan apartment designed by Luigi Farrario create a magically pure space that is somehow reminiscent of a Roman bath – except for a wittily selected and fully waterproof inflatable *poltrona*.

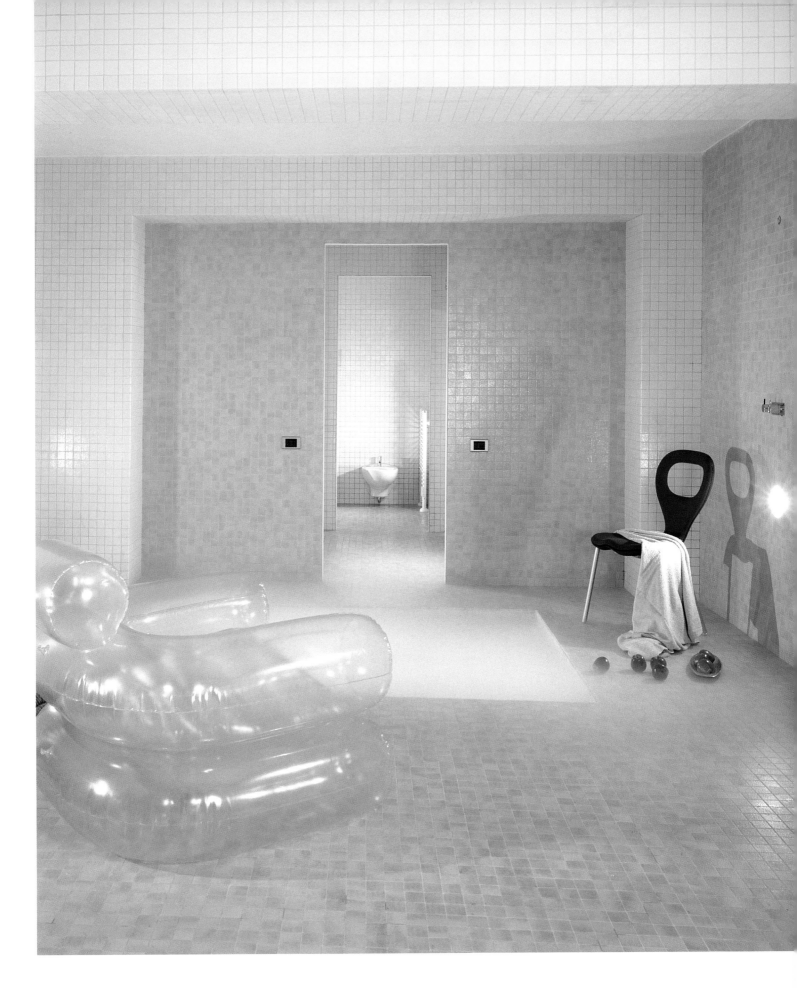

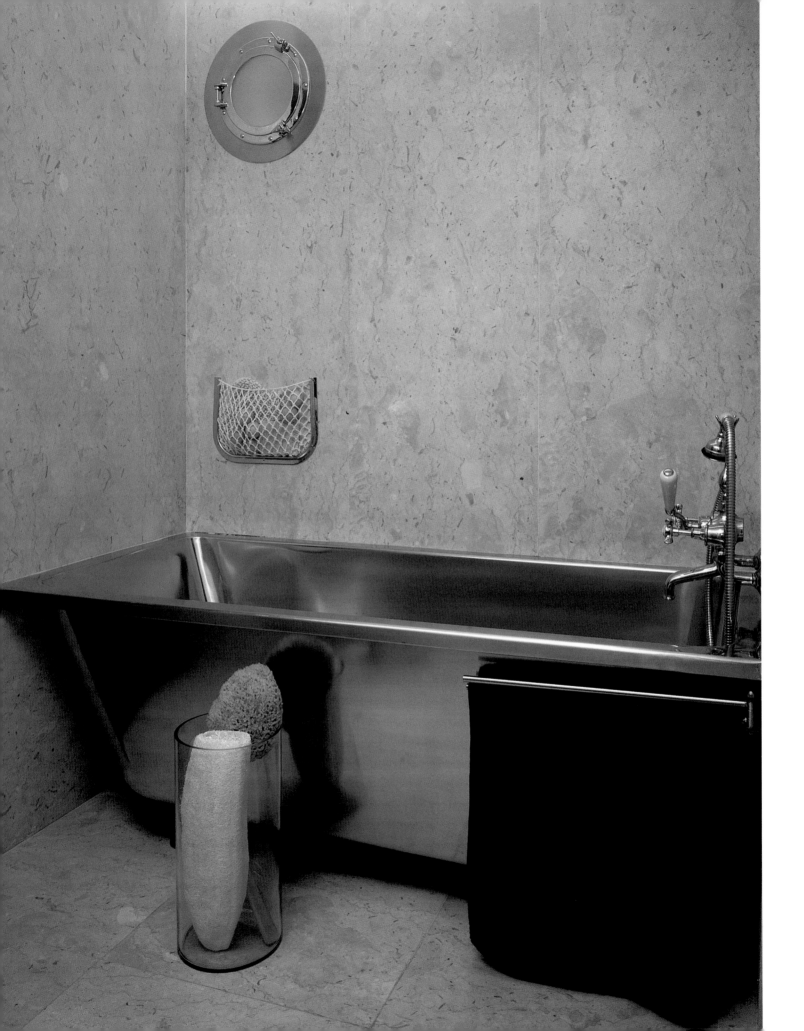

sail away [left]

Used on a single item, particularly in a bathroom, a strong material can evoke a variety of associations. Here, a slightly shorter than usual stainless-steel tub and porthole evoke a nautical feel in a London bathroom designed by Eva Jiricna.

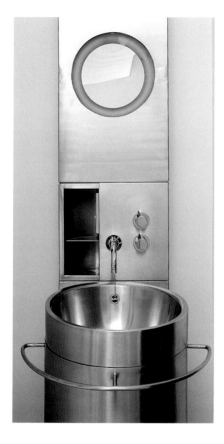

the beauty of function

Although not to everyone's taste, no one can deny the hygienic and utilitarian beauty of stainless steel – or its capacity to change the nature of a room. In one room, it might function as a high-precision water dispenser [above]; in another context [right], it might even be whimsical.

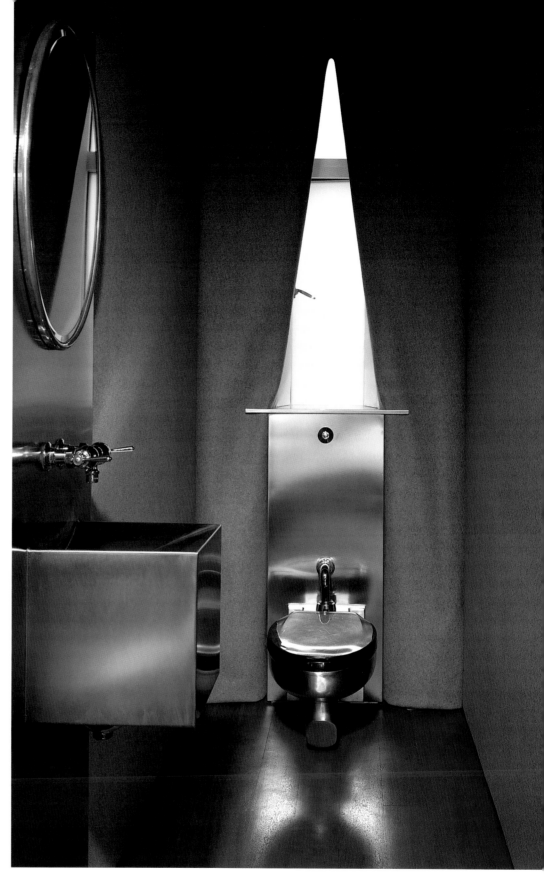

disappearing act

It can be difficult to carve up a large loftlike space to form private rooms like the bathroom, but glass technology offers interesting new variations. By passing electric currents through glass, the walls around an enclosed space can be transformed from a suggestive veil to an luminescent plane that offers complete privacy, as in this Michael Gabellini–designed apartment in New York.

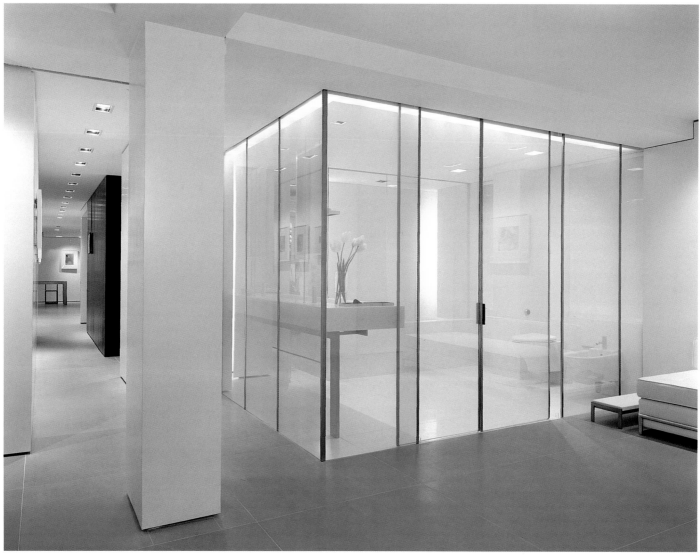

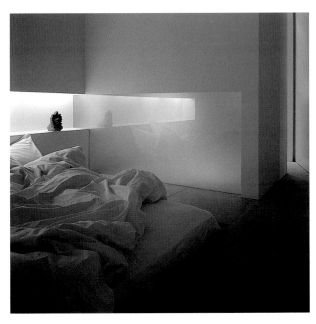

interior oasis

Enclosing the bath within the bedroom of this London flat designed by Seth Stein, the glass allows the water to be ornamental as the play of reflections bounce off its surfaces. In private mode, the glass offers the bather a pure and intimate space for contemplation.

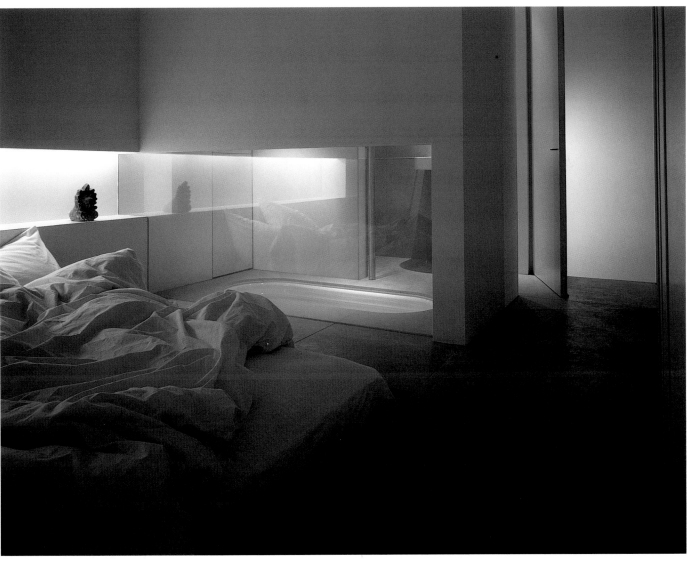

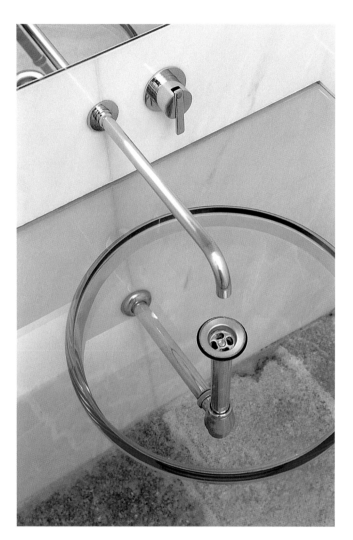

circles and squares

The bathroom's shapes are governed by typically ergonomic considerations. Reducing as many fixtures as possible to their Platonic volumes reinforces the elemental nature of water and our primitive attachment to it.

glass house [opposite]

Off-square lines serve to exaggerate the stunning effects of glass in the bathroom of this Sydney house designed by Stephen Varady. Hard lines are softened by a frosted-glass floor, an unusual and highly effective alternative to standard materials.

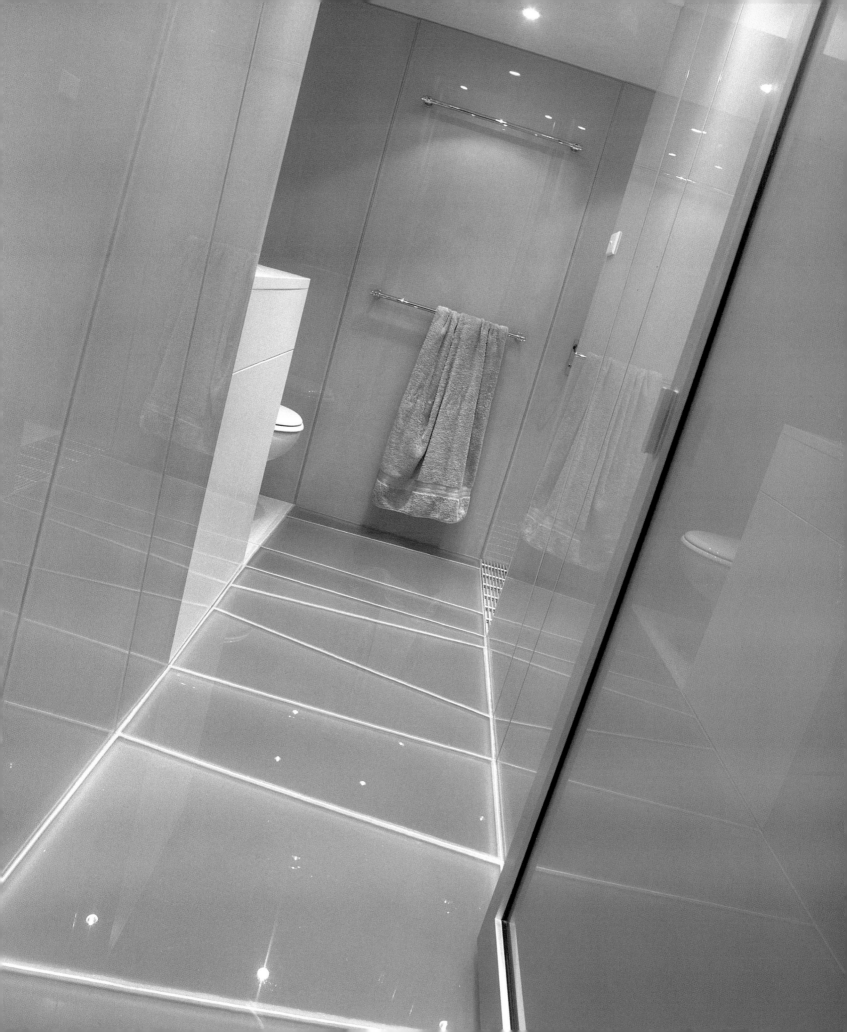

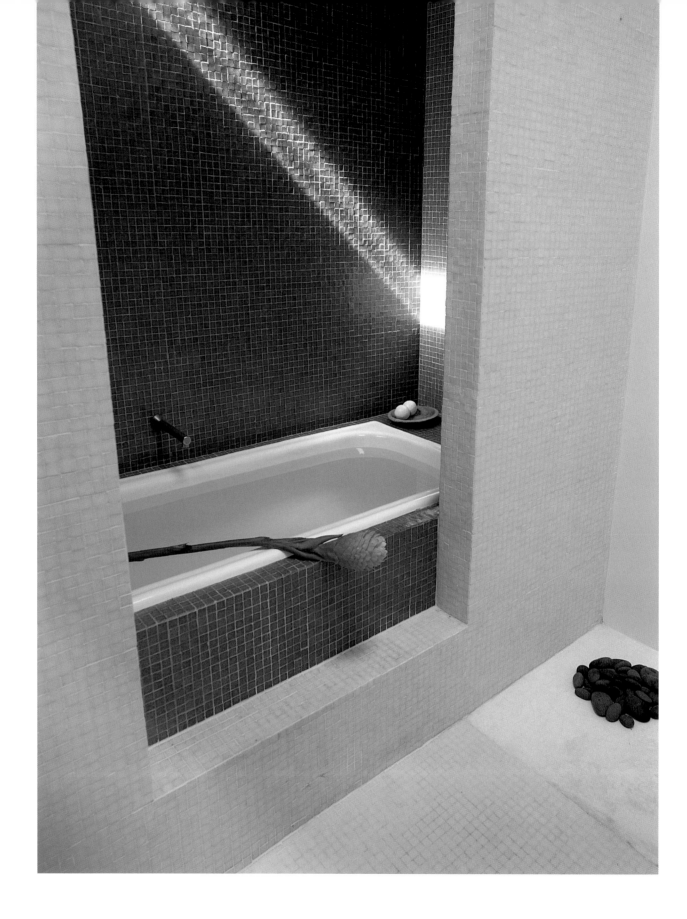

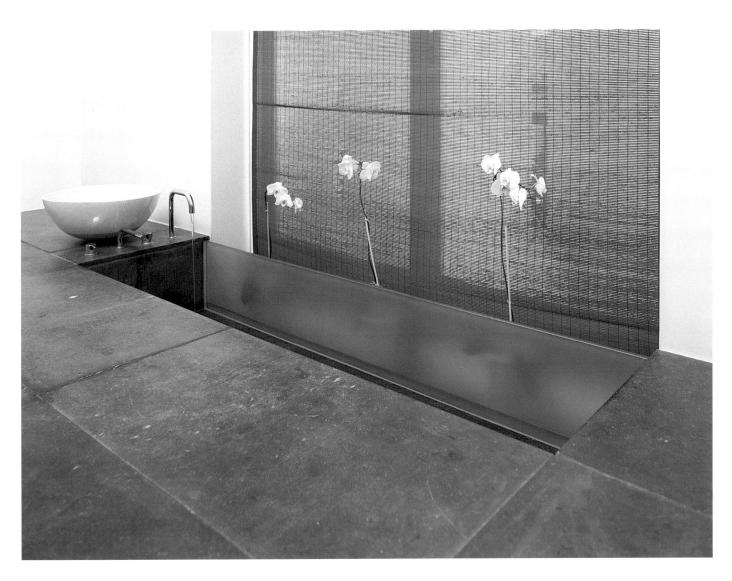

light penetration [left]

The clean lines of this bathtub created by Christina Markham for a house in Sydney are enriched by mosaic tiles. Added dimension is achieved by the thin shaft of light that penetrates the space. Walls have been positioned to provide the feeling of a room within a room, further articulated by the dark-blue tiles enclosing the bathtub.

full immersion

A decidedly Eastern aesthetic permeates this sunken bath, which has been specially designed to take advantage of the windows in London's Hempel Hotel. Large slate floor tiles give the impression that the tub has been hewn from rock, heightening the bather's sense of communion with nature.

outdoor spaces
rooms beyond rooms

Today's domestic space needs to move outside. Extend the interior and multiply the variety in your life by colonizing new territories for outdoor living.

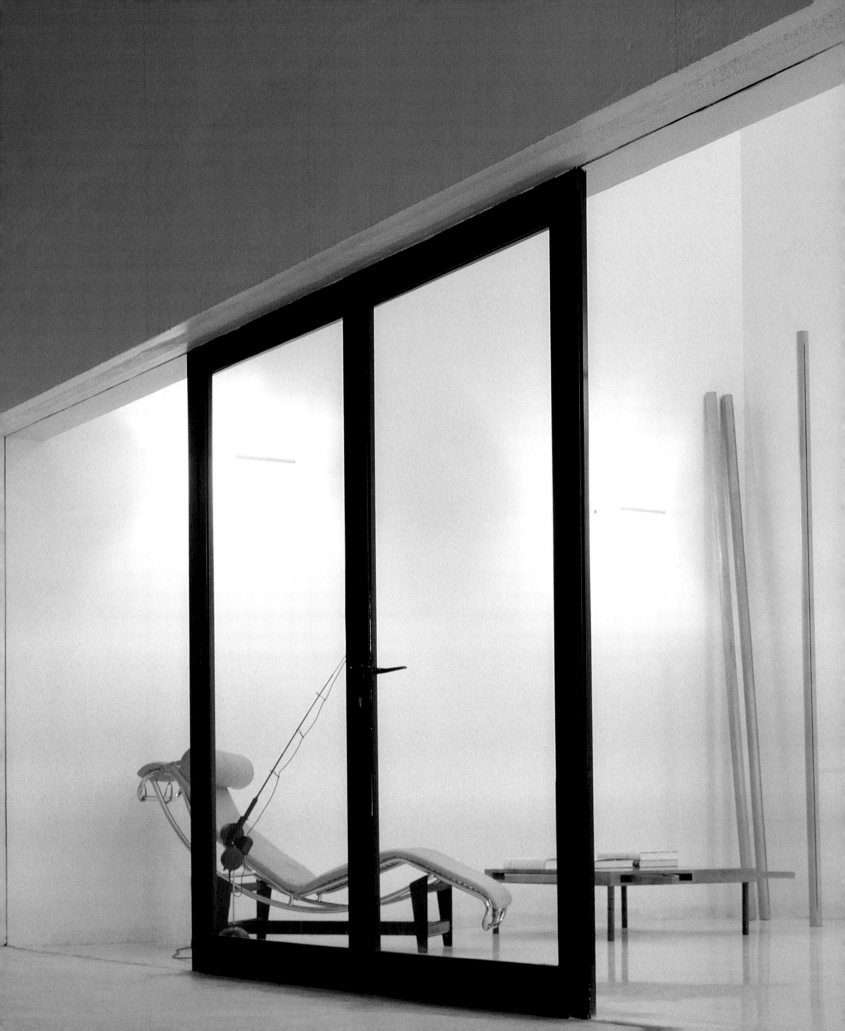

In recent years the simplicity of minimalist interior design has slowly been moving outside. As the notion of an outdoor 'room' enjoys broader and more innovative interpretations, it presents an ideal opportunity to extend space – or at least the perception of space. A room that emanates from the interior offers the possibility of continuing a style in to a different context or a contrasting space that still offsets the inside. Many devices – ancient and modern – are employed to create compatible exterior designs. One classic and perennially pleasing example is the pool, whether used for light reflection, fitness or pure beauty. The minimal outdoor space is the perfect backdrop for new takes on the garden, small or large.

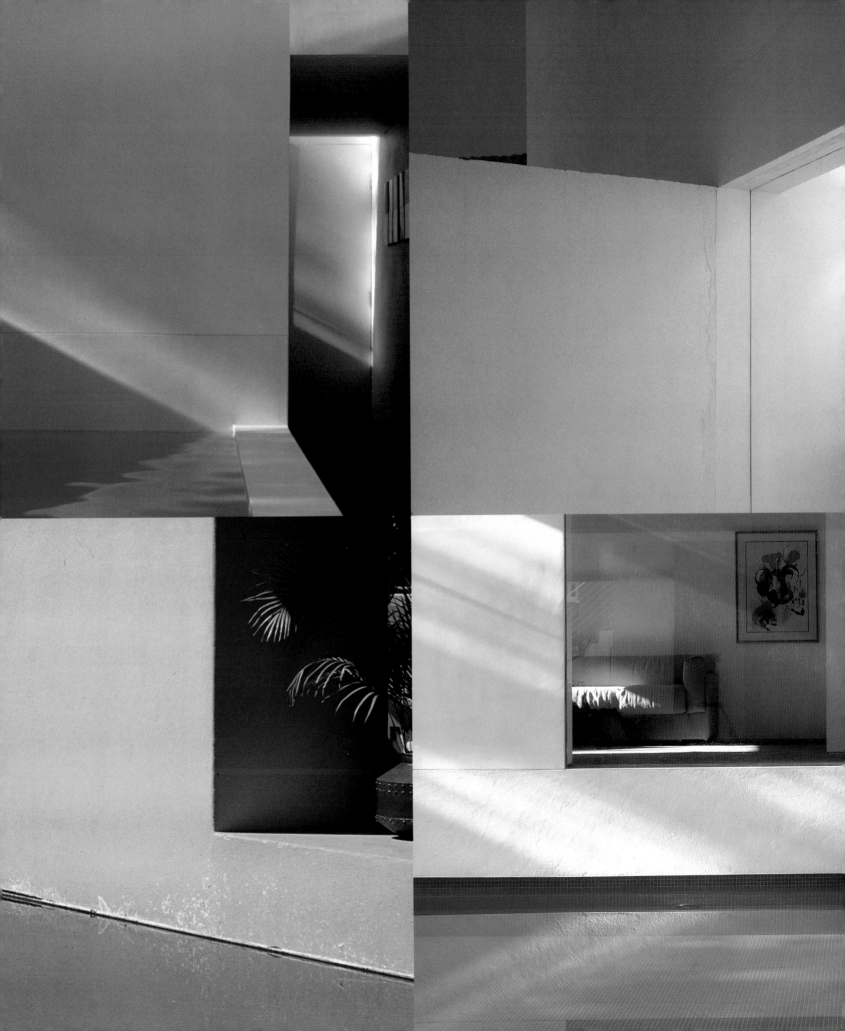

With ecological awareness increasing on a global level, outdoor spaces have become the hot area of design. No longer considered an idle pursuit for people with too much time on their hands, gardening and garden design have taken unexpected new turns in recent years. These new trends, in concert with the minimal attitude, have influenced exquisite indoor-outdoor spaces around the world. While few climates offer year-round outdoor living, the mere visual integration of the outside with domestic interiors can keep life fresh 365 days a year, regardless of weather.

Many people are aware that today's brand of minimalism was foreshadowed by Japanese design. The ancient concept of *ma,* the space and balance between objects, is extremely influential. From the fifteenth century to today, Japanese raked-gravel courtyards have inspired meditative outdoor scenes.

As interior design styles have developed, so have comparable garden styles: Victorians had a distinctive mode of decoration that complemented their ornate architectural design; Arts and Crafts houses had beautiful garden designs; and the modernist pioneers created planar exterior spaces that effectively lengthened their open-plan interiors. Thus, as minimalism in all its varieties has developed internationally, the garden space has also grown. Using the same ideas as the interior – purity, texture, abstraction – the garden has become a serene extension of the interior, a room *beyond* the room.

The key to a successful outdoor space is that it be considered integral to the interior. Conventionally, the garden has been treated as a separate entity, usually at the back or side of a house, with a completely different set of aesthetic, design and practical considerations and only enjoyed during clement times of the year. The convergence of environmental awareness and outside living with greater design sophistication has led to exciting spaces that seamlessly merge indoors and outdoors.

There is no reason why exterior spaces cannot be designed with exactly the same precision as the interior, using the same or a contrasting palette of materials, textures, colours and objects. And there is no reason why an outdoor, or outdoorlike, space cannot be used for the same activities as for those that take place indoors. The traditional boundary between the 'garden' and the 'house' should be blurred – this is what brings about the most appealing designs.

Creating a workable interaction between the natural world and domestic constraints is one of the designer's greatest challenges. On a basic level, it is

about striking a balance between order and chaos. While control can be exerted over most building elements and materials used in the construction, the garden's character is determined by nature's laws.

wood planks or textured stone tiles, a courtyard can become a refuge for contemplation or, surrounded by candles, an ideal setting for al-fresco dining.

There are a number of interventions to existing

One of the glories of the minimal outdoor space is that carefully devised spaces can look great with little care.

The designer need not have a specialized horticultural knowledge to create a successful indoor-outdoor zone, but familiarity with plant forms, their needs for light and shade and their growing cycles, will clearly lead to richer space. One advantage offered by a collection of potted plants, for example, is that they won't take years to mature. Choosing the most effective – and, if desired, low-maintenance – plants, however, takes care and sensitivity. For most busy people one of the glories of the minimal outdoor space is that it can look great with little care.

The new outdoor room can take many forms. The most obvious is a private space behind the house. Rather than resort to appending a traditional conservatory on the back, however, the architectural form of the house should be perceived as a natural extension of the interior. If, for instance, a kitchen is next to the garden, extend the central work island or banquette into the outdoor space, an effect that will enlarge the feel and use of both spaces. Another immensely pleasing indoor-outdoor space is the courtyard, which is ideal for restricted spaces. Whether using exotic hard-

arrangements that can enhance the indoor-outdoor relationship: using changes in levels creates interlocking roomlike spaces; extending such outdoor elements as paths, paving, planting into the indoor strengthens the bond. Glass, which can take myriad forms, should be used wherever as possible. The bottom line is that the house and garden are one, and should be treated as such.

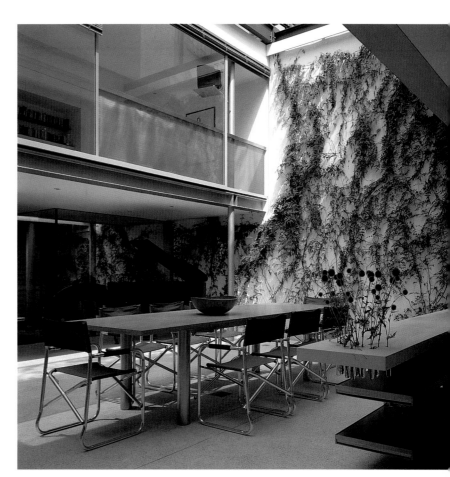

Interior dining court in a London townhouse by Paxton Locher.

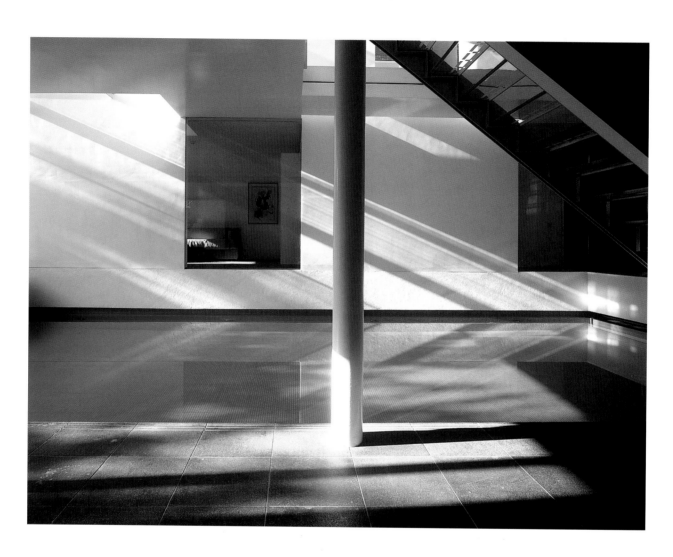

outside in

Indoors or out? Architect David Chipperfield devised an interior swimming pool in an atrium as the focal point of this London house, and in the process inverted the conventional placement of the pool. Reflections from the pool animate the entire interior of the residence, including a bedroom that overlooks the water. A glass staircase ensures that light suffuses every corner of the house.

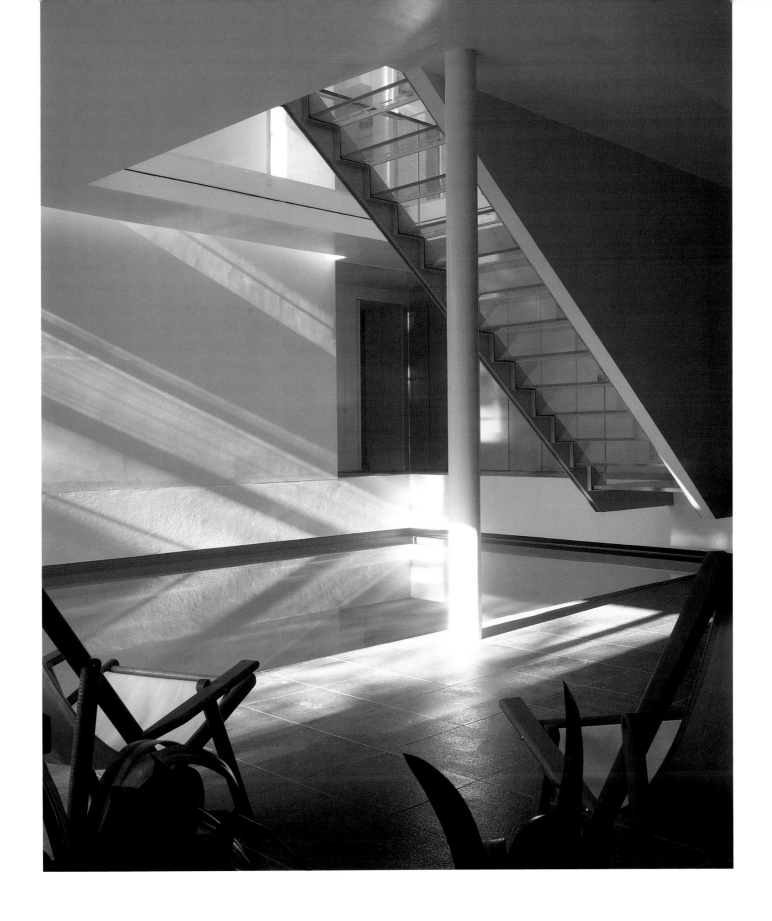

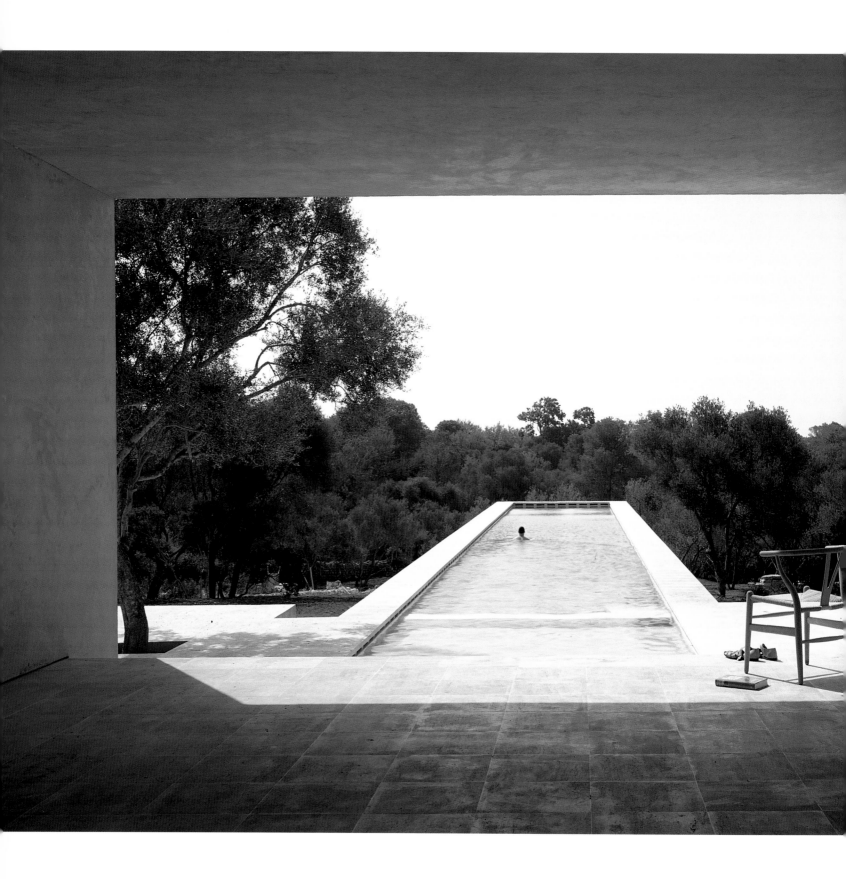

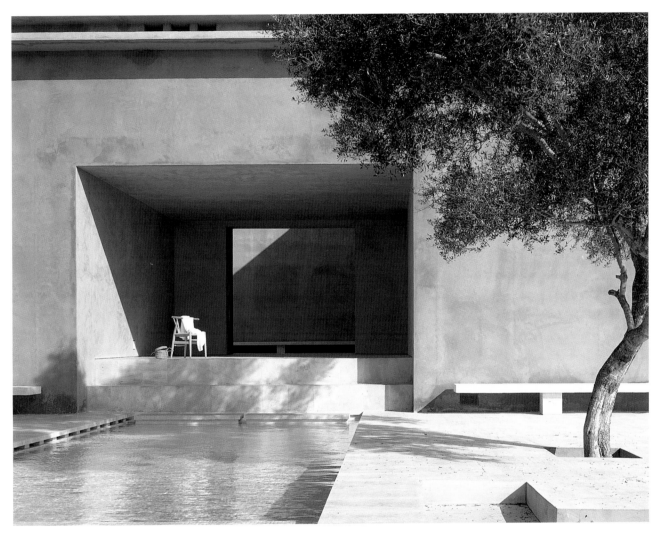

mediterranean calm

A literal extension of the indoors into the outdoors, from man-made space to natural beauty, the pool at this minimal villa in Mallorca designed by John Pawson and Claudio Silvestrin is a seamless plane set into a cubic composition like a jewel. With an off-centre element like an olive tree, essential form and wild nature are inextricably intertwined.

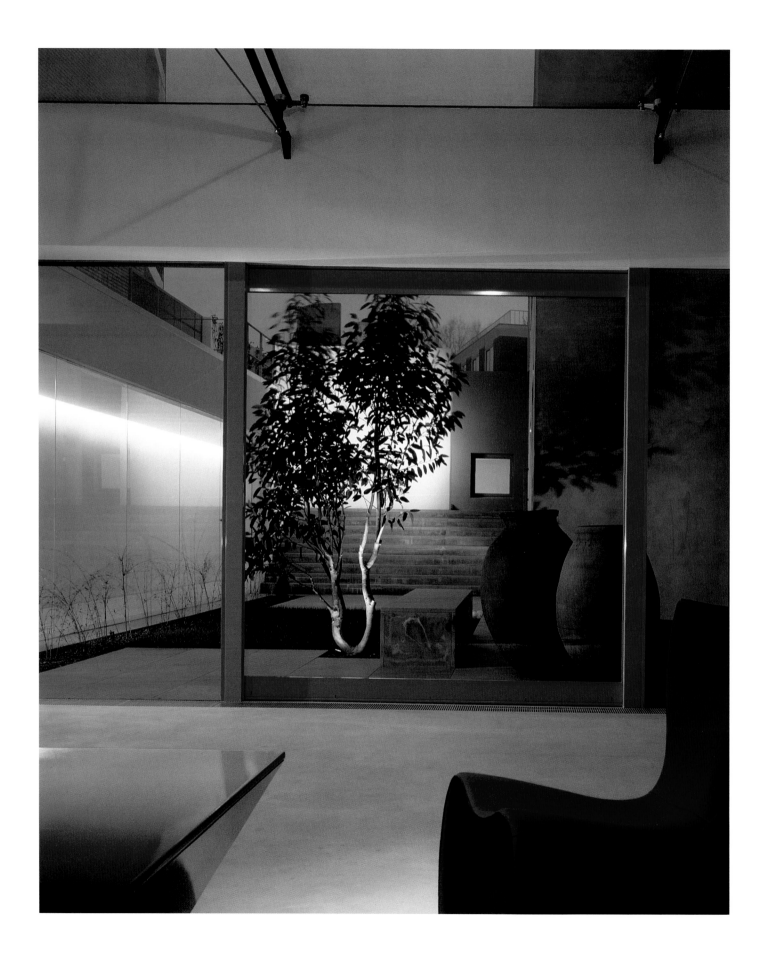

reframing the view [left]

Behind the façade of this London townhouse bold colours, intelligent lighting, oversize pots and concrete flooring combine in what is in effect a single indoor-outdoor space divisible only by a glass wall. Minimal planting and few elements offer the occupant maximum flexibility to compose and recombine furniture and objects in a seamless interaction.

the nature of concrete

Monolithic concrete slabs, set at slightly skewed angles and with slits between them, create the interior courtyard of this Japanese residence designed by Tadao Ando. Apart from obvious outdoor activities, the concrete space is ideal as a template for objects – the simpler the surroundings, the more flexibly one can adorn the space.

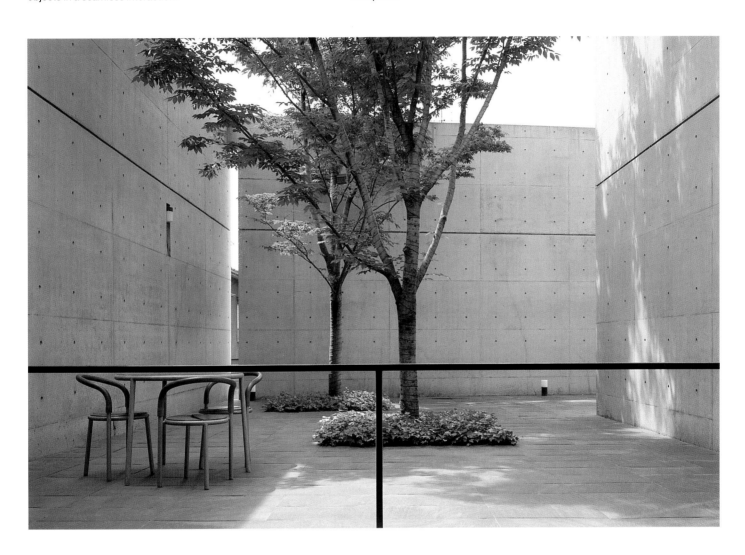

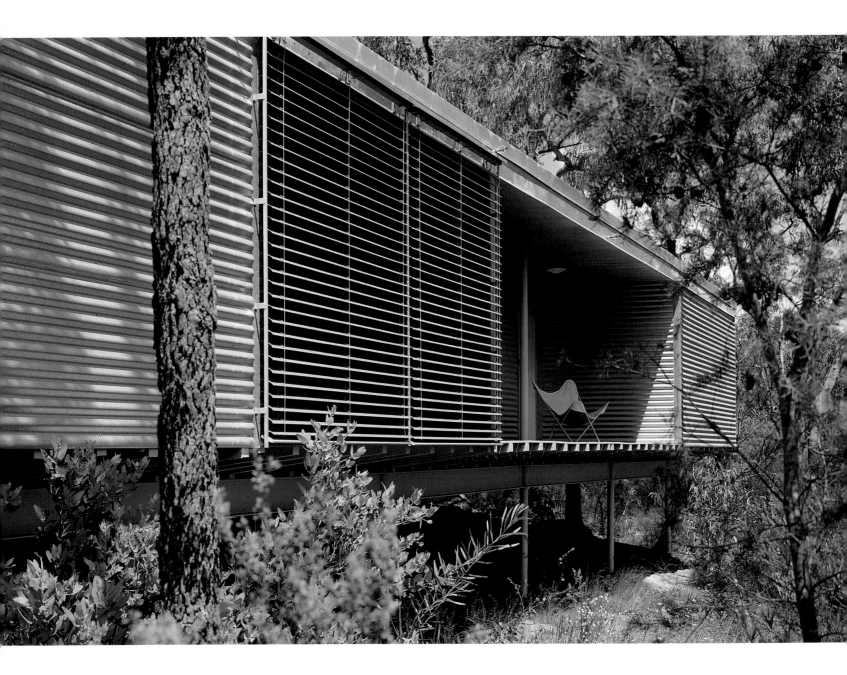

wild lightness

Designed by Glenn Murcutt, this stilted Australian house encased in corrugated steel hovers above the landscape – touching it lightly – to protect itself from unwanted guests and to appreciate its surroundings. Although the building is clearly distinguishable from its context, its minimal form allows nature to speak for itself. The only obvious intrusion is a yellow Butterfly chair – a man-made classic.

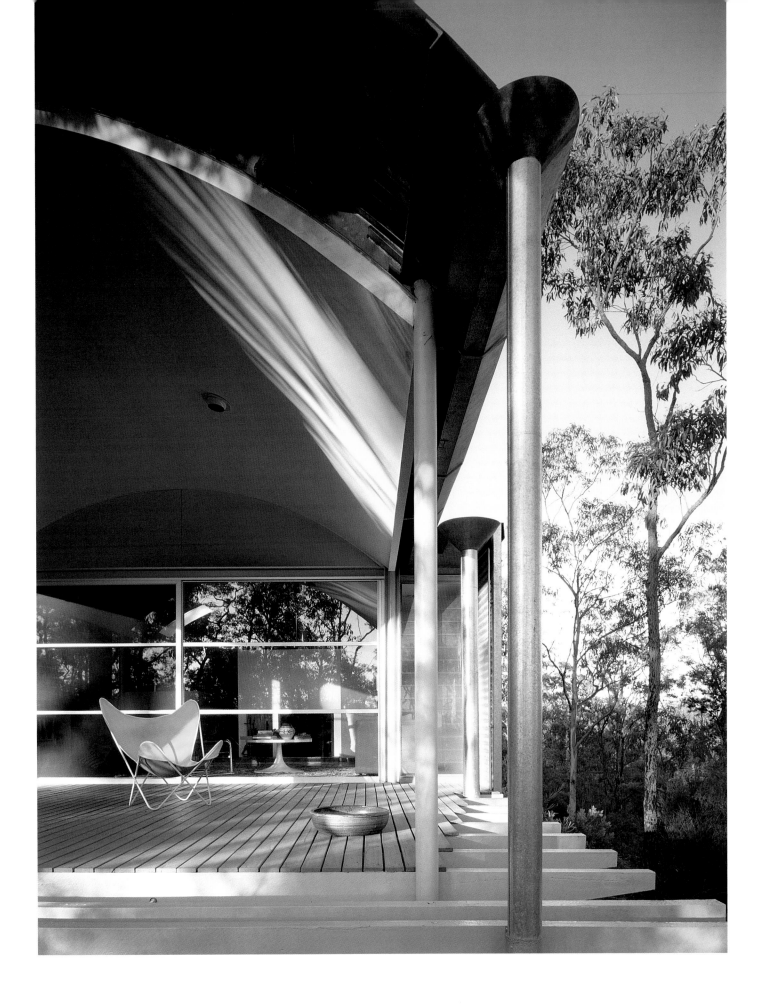

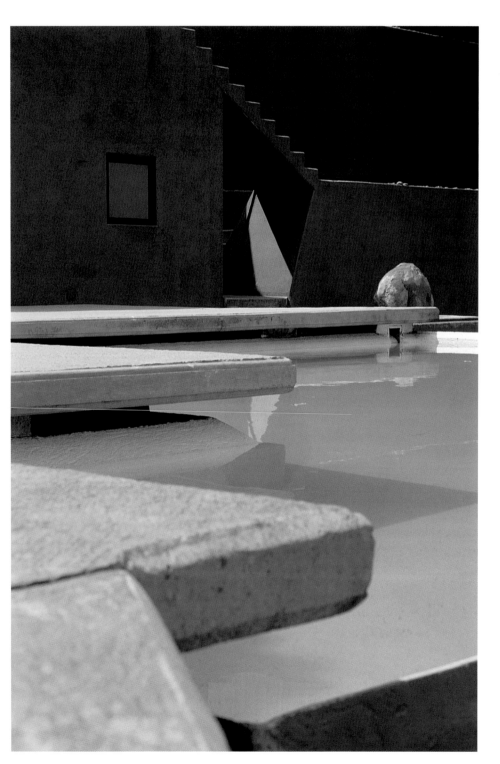

cut from the earth

This irregularly shaped pool at a house in Mexico designed by Agustín Hernández abstracts the language of geology to appear as though carved out of the earth's surface. With water disappearing underneath the stone poolside's lip, the shifting planes of water and rock reveal how humans can borrow the forms of nature for earthly pleasures.

perfectly tuned [right]

Seth Stein's design for a genuine machine for living, which deftly integrates a machine for driving, confuses our perceptions of what belongs to such utilitarian rooms as garages by making a yellow Fiat the centrepiece of this London house. Surrounded by a minimal material vocabulary and restrained colour palette, the car literally brings the outside in.

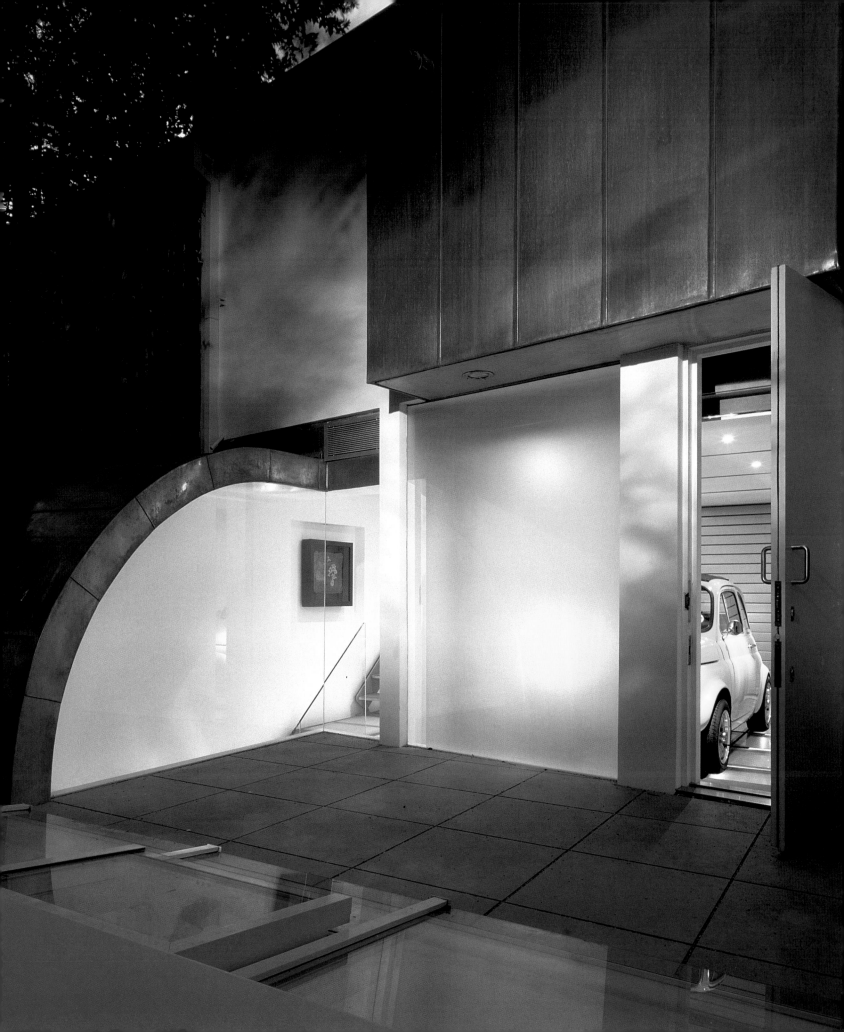

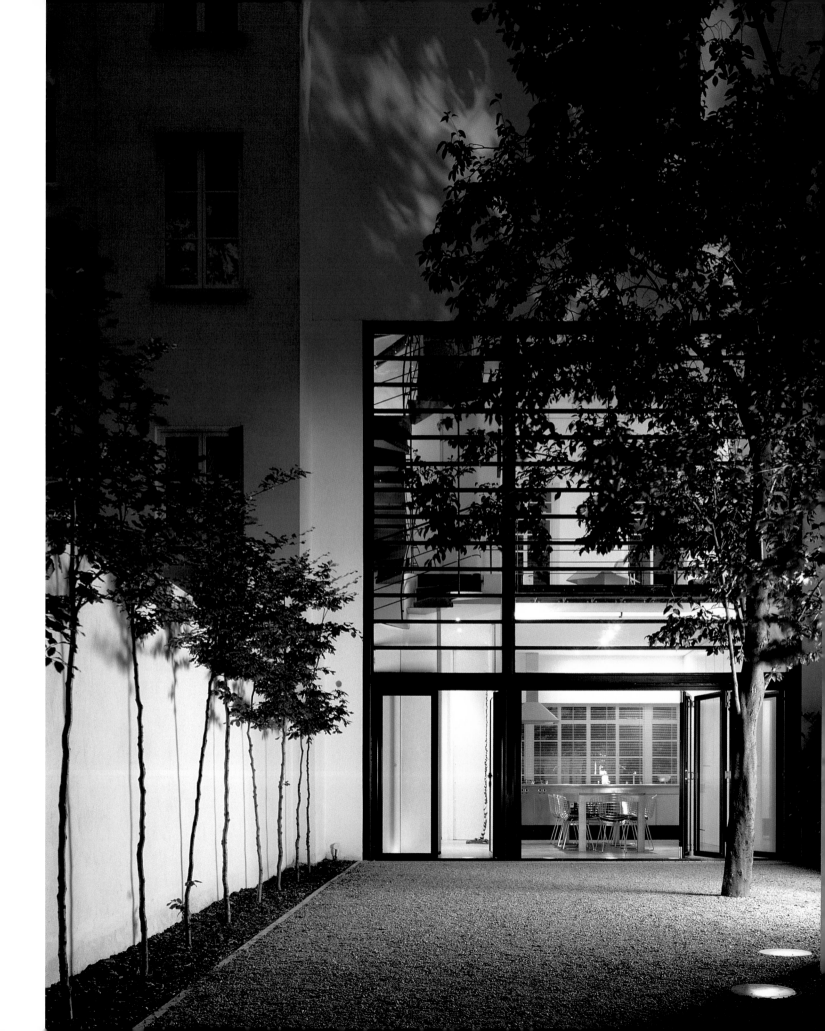

exterior geometries [left]

As landscapes are becoming a hotbed of design, many gardens employ graphic techniques with great success. The elegant extended courtyard in this London house plays host to a well-calculated combination of elements: a regularly spaced line of trees contrasts with the solidity of the existing boundary wall, the rough gravel provides a textured complement to the smooth walls, and the horizontal bars of the double-height façade syncopates with the placement of the trees.

textural boundaries

In the desolate wilds of the California desert is an oasis, demarcated by a breeze-block wall that provides protection and privacy. Apart from evoking the spirit of master Mexican modernist Luis Barragán, the wall's rough texture mediates between human habitation and isolation, between control over earth's natural elements and their control over us.

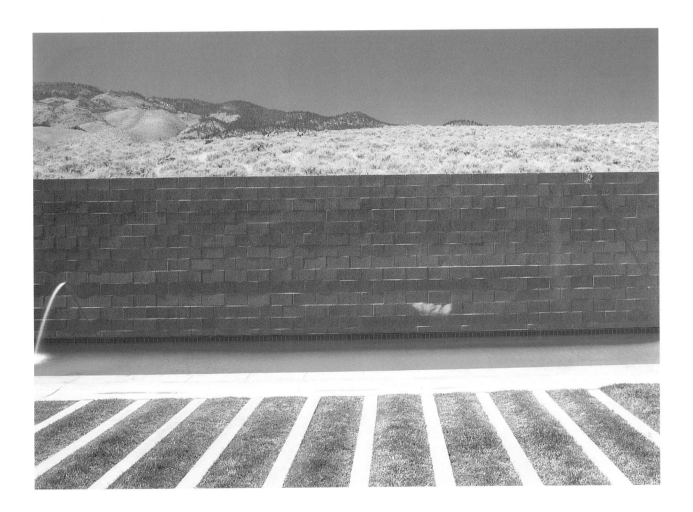

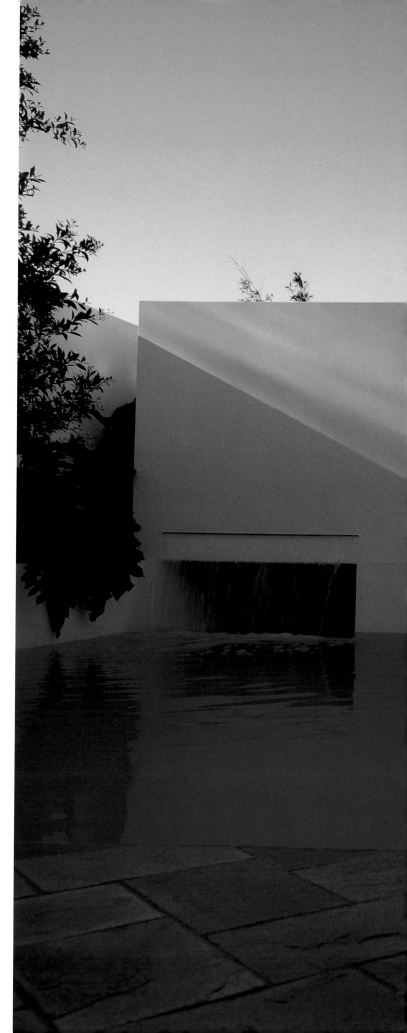

three-dimensional abstraction

The ideal for essential living is to integrate inside and outside spaces as intricately – and openly – as possible. Offering glimpses to the outside from unexpected places on the inside can achieve a thrilling effect. In this sheer house in Sydney, designed by Andrew Nolan, cubic forms define the interior and exterior spaces, but the bold geometrical composition and tight interlocking is softened by the pool, which abuts one side of the house and permits one of the windows to receive refracted light from the undulating water. With sunlight hitting the house and water at the right angle, the entire space is transformed.

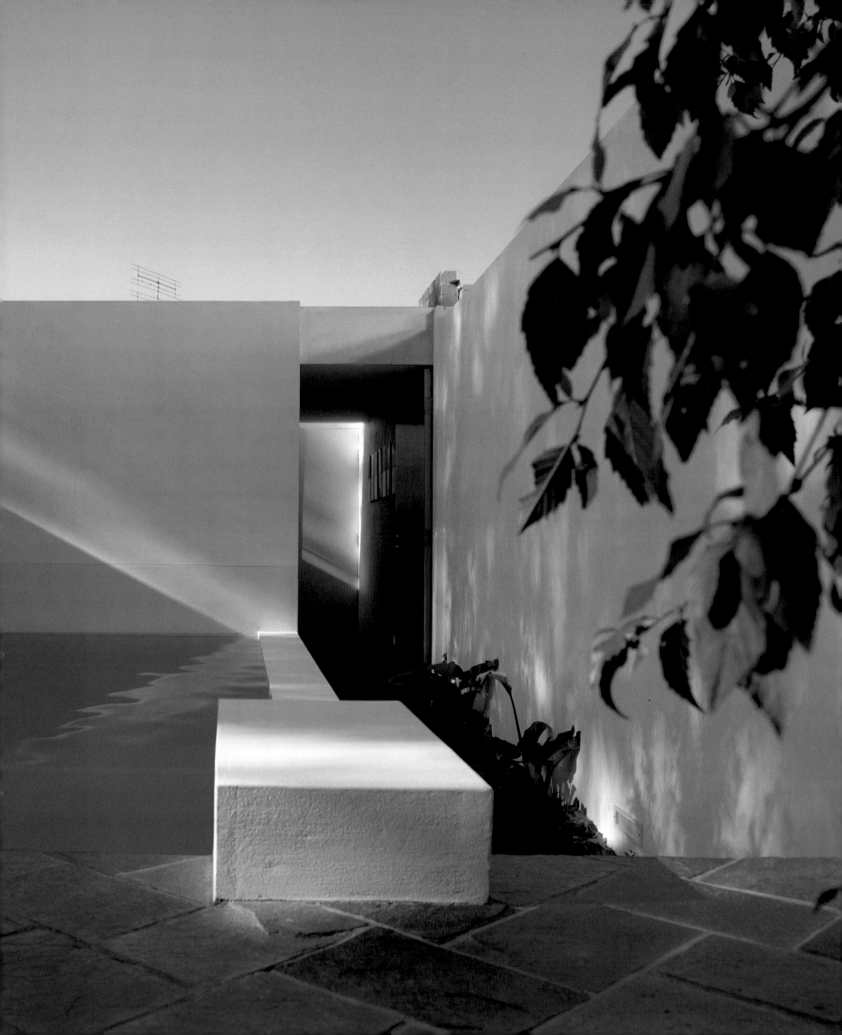

light and shade

In many urban situations, the best solution for an exterior space is an interior courtyard. Such a space has numerous advantages: potted plants can be artfully arranged, single objects – like this oversize pot – and accents of colour can be orchestrated to create numerous effects. Furthermore, the enclosed space is isolated from the fervour outside and serenity is assured.

material mastery [right]

The entrance court to this London townhouse designed by Seth Stein plays several games: frosted glass hints at what awaits inside, a range of textures and materials articulate the space and suggest the abstract forms used within.

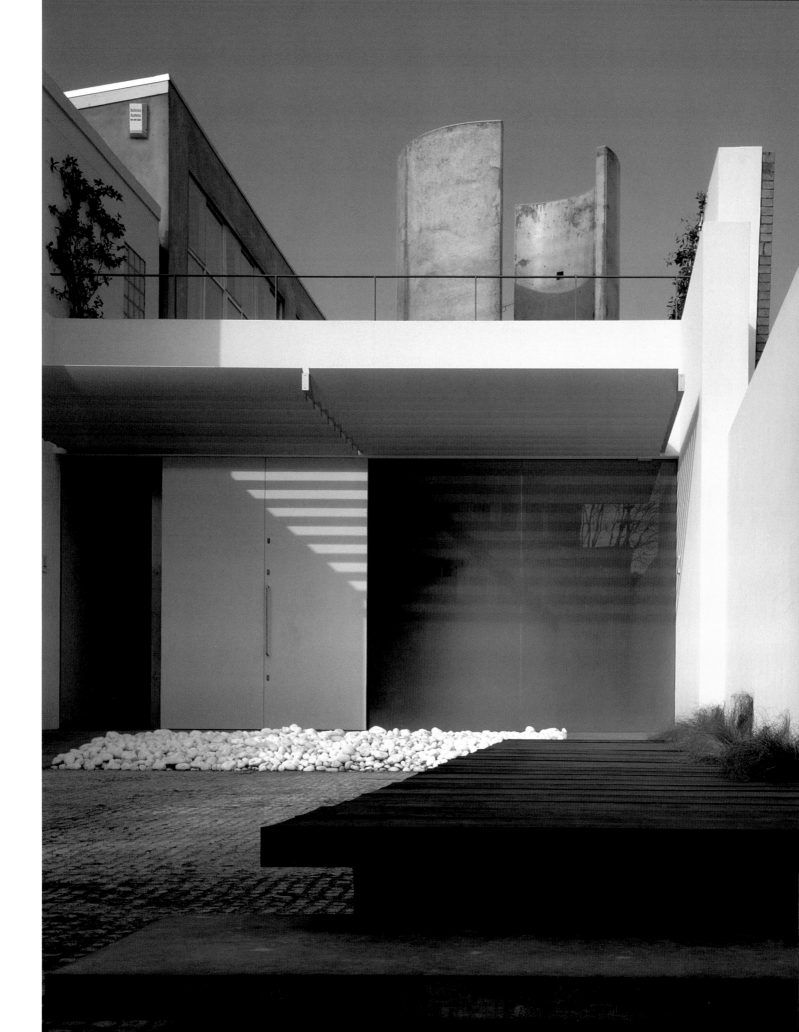

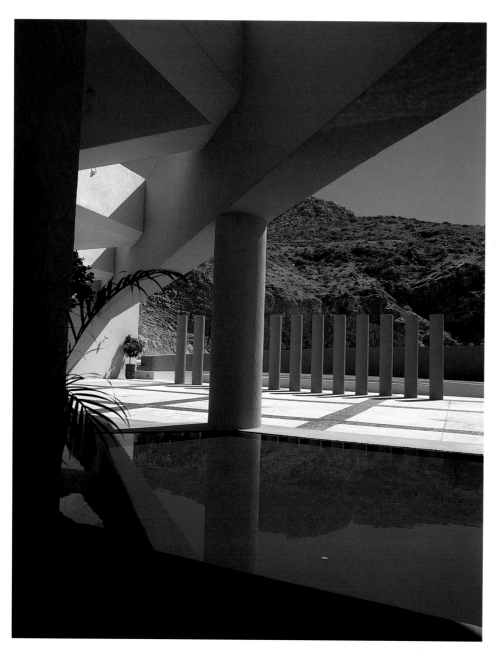

nature tamed

The bold colours and forms created by Ricardo Legorreta for a hotel and its pool area set amid the barren desert nature of Baja California are a delight. Vivid colours and the concrete's confident repetitive geometry contrast with the stillness of the water. 'Windows' incised into the forbidding shapes offer glimpses of the unruly nature beyond, tantalizingly suggesting we have controlled the elements. The building's shapes recall Mexico's pre-Columbian monuments, and the whole combines to give a feast for the senses.

glass skin [spread overleaf]

Only a thin membrane of glass differentiates between the indoor and outdoor areas of this Sydney house. By continuing the stone flooring, wall colour and scale of furnishing and planting, a united space is established that need only be divided when the temperature drops.

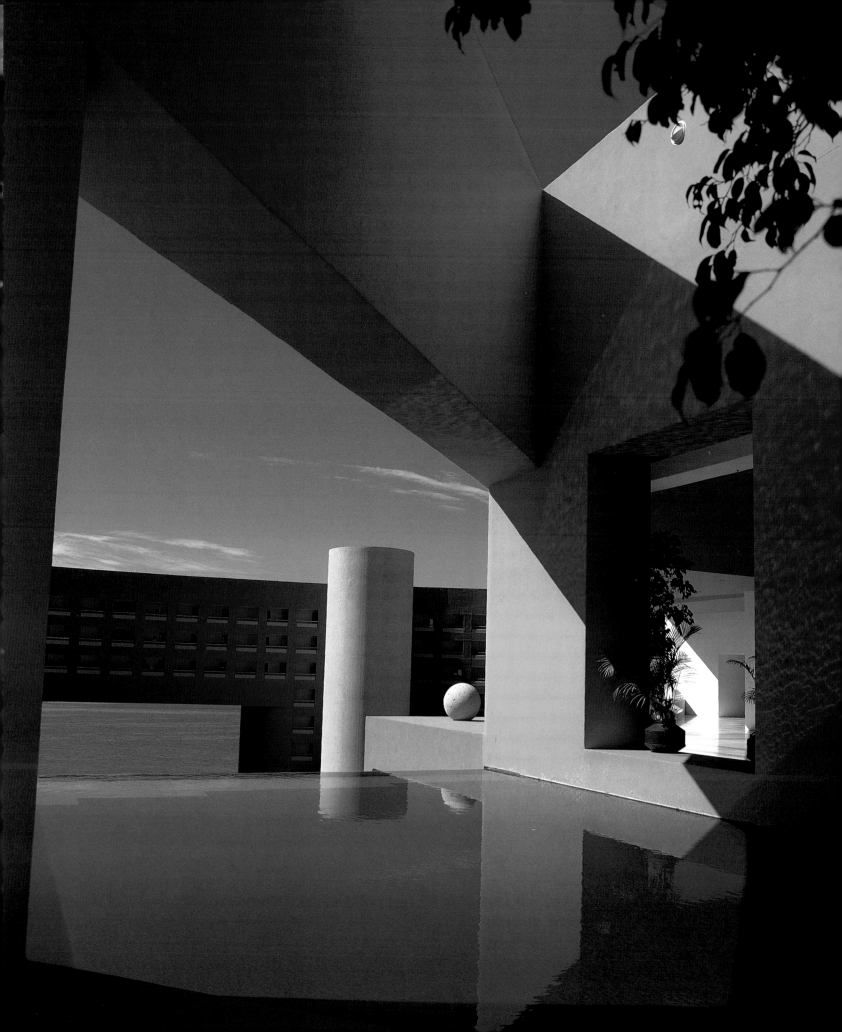

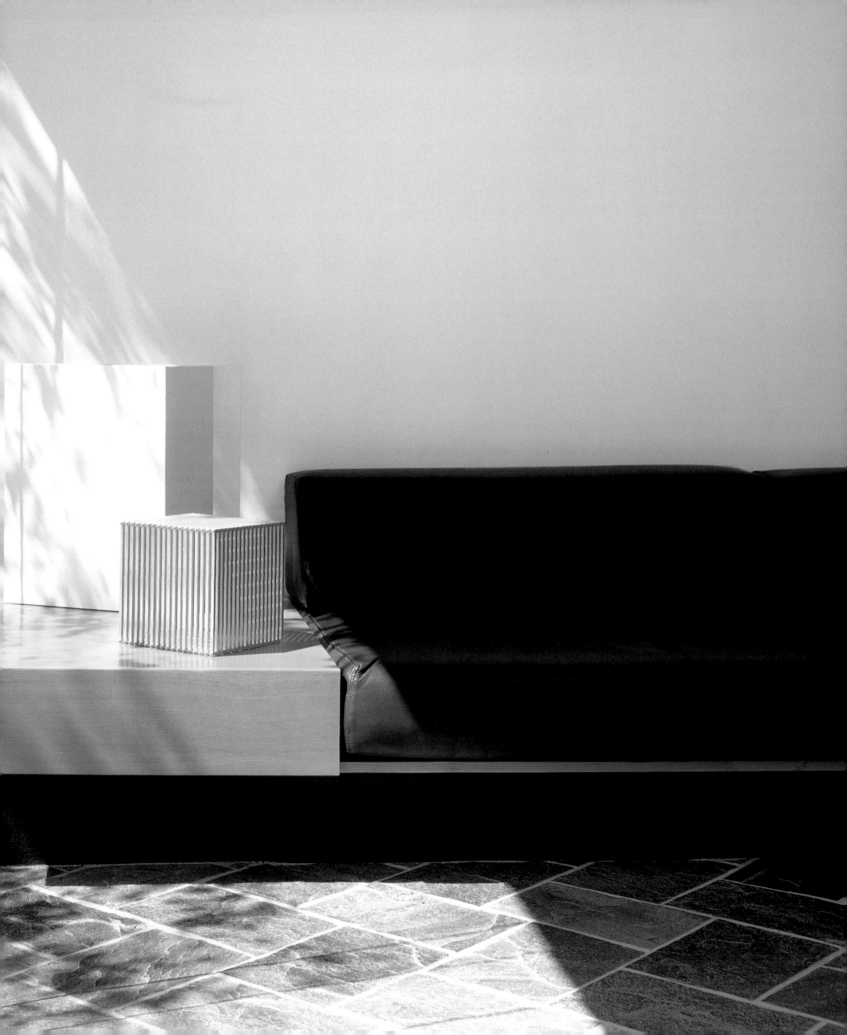

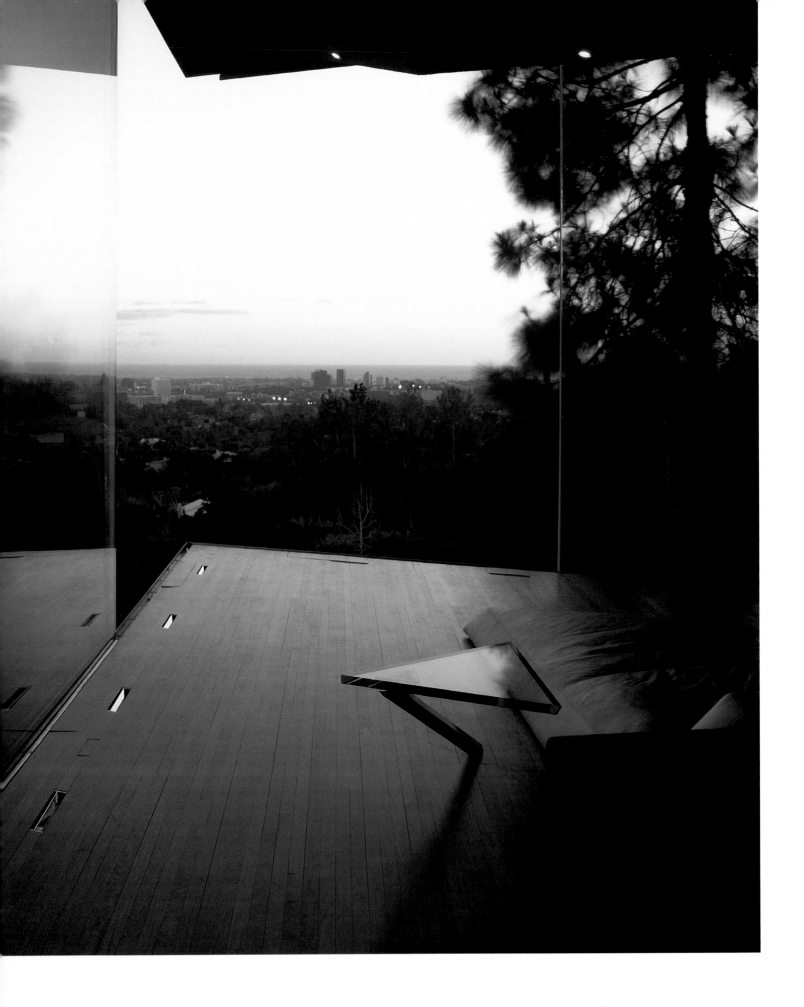

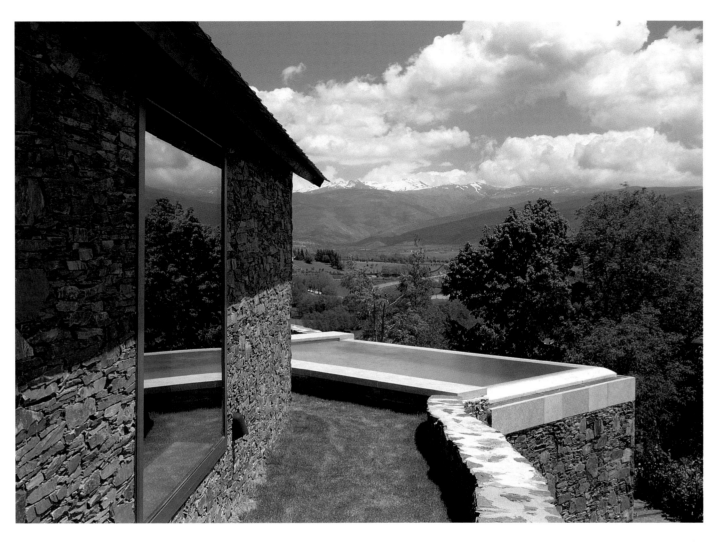

cliffhanger [left]

An 'outdoor' space need not be outside. Dramatically projecting over the vegetation of the hills above Los Angeles, this bedroom redefines the outdoor room. Designed by maverick Californian architect John Lautner, the room feels like a space capsule: launched and held in the air, aloft yet sheltered, with a sense of freedom that is unimaginable.

mountain retreat

Echoing the form and material of the surrounding Pyrenees, a stone house designed by Francisco Rius features an outdoor space that is almost too pristine to inhabit. Like a geological formation, it appears to be a creation of nature itself. One's fellowship with nature – the ultimate minimal experience – is complete.

elements

It's the details that count and add the subtle touches that make a space complete. No object, surface or material should be undervalued.

exteriors

Bearing in mind that the minimal look should be as integrated as possible, the first impression of a house's exterior or an interior's appearance from the outside are important aspects of the overall design.

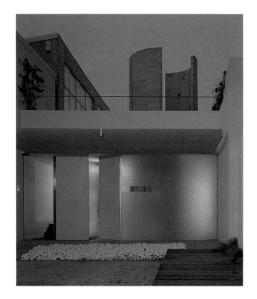

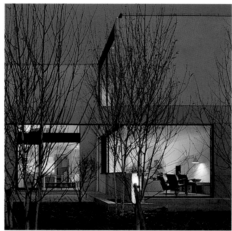

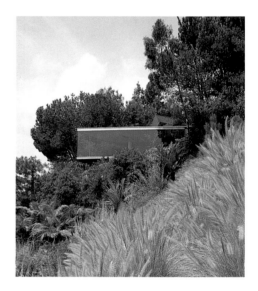

veiled secrets

Frosted or etched glass, which hints at what might be inside, is ideal for an enticing entrance. A sense of expectation is heightened as the visitor crosses the white pebble court over a timber walkway. The discreet materials and sober colours do not prepare the visitor for the vibrant colours within, so the overall impression is doubled.

night moods

How the interior appears from the outside is most relevant at night. The outside-in perception can be enhanced by intensifying the contrast between garden and interior, which becomes more graphic at night when interior illumination acts as backlighting for exterior planting. A low spine wall extends the house's form into the garden, terminating in a shallow pool that functions as a light source to animate the interior.

landed object

Minimal forms, however modern, can fit into just about any natural context – if the contrast is considered carefully. This masterpiece of modern engineering, like a spaceship that has landed by mistake, rests delicately on the hills just outside Los Angeles. Despite the futuristic imagery of the all-glass house, its simple geometry does not disrupt the wildness of the subtropical vegetation.

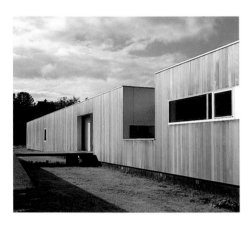

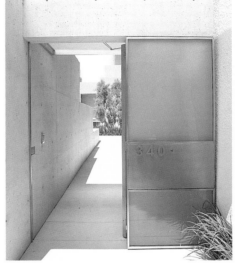

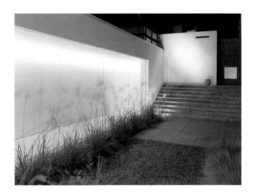

sculptural form building

Whereas the transparency of glass can often serve to break down the conventional boundaries between inside and out, natural materials such as wood, can fit sensitively in the environment. Clad in local wood, the abstract geometric form of this residence set in the woods blends effortlessly into its natural context – despite its striking man-made form. Even the pathways in and around the house are timber, ensuring that the inhabitants and nature coexist harmoniously.

raising expectations

If one is seeking a processional entrance to the interior for added drama, the more anonymous the first impression the better. Access to this northern Californian residence is through a steel-and-glass doorway, leading to a path around a courtyard and along a concrete wall planted with climbers. The visitor has had a complete spatial experience before he has even entered the house.

painting with light

Backlit walls, used as a kind of canvas against which shapes – plants, objects or even images – can be projected, are a magical way to enliven any exterior, whether at the front of the house or in the garden. White-painted surfaces provide the greatest contrast at night, but coloured walls, such as cobalt blue or Tuscan orange, can create striking moods during the day. Tall grasses, like the pampas grass used in this courtyard, blow with the slightest breeze and cast beguilingly intricate shadows at night.

stairs

One of the most exciting aspects of the minimal house – freestanding, floating, sculptural, almost absent – the staircase offers the ideal opportunity to fuse form and function.

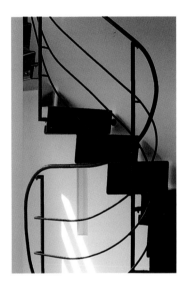 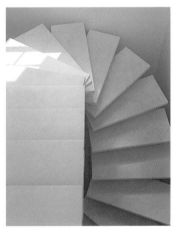 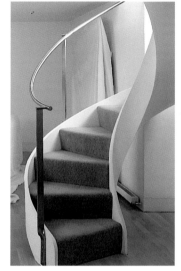 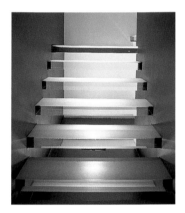

competing geometries

A sinuous metal balustrade seems to be pulled upward by the rectilinear regularity of the steep staircase. Against the white walls, the forms have an effective dynamic tension.

floating down

Like a fanned pack of cards spinning around a fixed point, this extraordinarily simple but effective all-white staircase appears to hover on weightless risers. The steps' planar geometries create the sensation of gliding effortlessly down or up from one level to the next.

perfect curve

This incredible staircase epitomizes elemental elegance. The curvature manages to negotiate a rather steep incline while seeming as though it were designed and built as a single gesture. Freestanding in the middle of the living space with a balcony above, the stairs ultimately become a piece of minimal sculpture.

a light walk

Thick glass treads and artful lighting lend a futuristic effect to these stairs. As the eye encounters the steps, it is tricked into believing that the treads are floating in space, supported only by light. The apparent absence of any structural elements heightens the illusion.

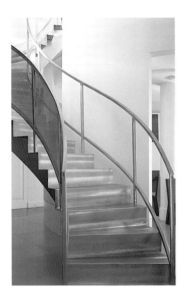 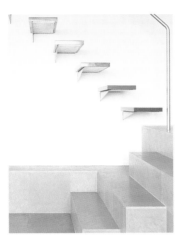 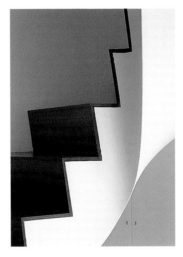 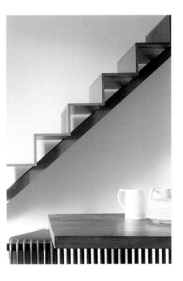

material simplicity

Aluminium was used to create a curved staircase that moves through the space, avoiding rooted structural elements and affording a variety of vantage points around the double-height loft.

graphic effect

Staircases are generally either suspended between two walls or freestanding, but there are other alternatives. Set into the wall, the stairs in this New York apartment transcend function to become purely graphic. At first glance, the treads appear to be a wall-mounted minimalist sculpture.

sculptural purity

The smooth curved surfaces and sharply defined geometry of this staircase are pure sculpture. The exotic dark wood appears to be stretched upward, giving the dynamic sensation of being simultaneously grounded and aloft.

fine lines

Augmenting the vocabulary of the house's linear forms, this 'honest' staircase manifests its structural make-up with a simple beauty. Revealing its economical construction, it abstracts function, resulting in much more than a set of stairs.

built-in furniture

An ideal way to make the most of space is to build pieces into the existing architecture. Tables, seating, countertops – all can be incorporated as bold forms that eliminate the need for furniture.

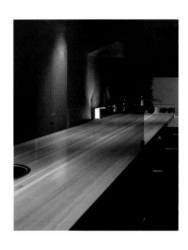 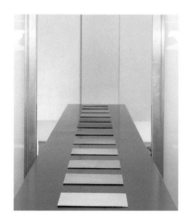 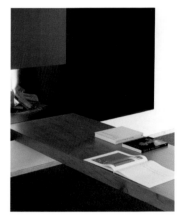

surface continuity

This breathtakingly long work surface encompasses everything from kitchen work-bench to dining table as it projects almost the entire length of the house's central living space. The piece is not only practical, it is a magnet for social interaction. Topped in an inviting wood, it is designed to lead the eye along its long surface to the inviting pool outside.

below grade

Sunken seating arrangements offers a comfortable and unimposing place for informal meeting or dining. Sitting below ground provides an intimate setting, while the surface – in this case stone, but which could be in any material from wood to rubber – is warmed by comfortable and subtly textured cushions.

two in one

Although not easily created in most interiors, a single surface that runs between two separate spaces can incorporate a variety of activities, social and private, and offer unexpected interaction and communication. It could be a cooking work surface on one side, and dining table on the other. Or a desk on side one and an informal coffee bar on side two.

fireside conversion

Reading by the fireside is always a pleasure, which this design takes into the twenty-first century. Smooth planes surround the hearth, and a solid slab of wood projects from the fire on which to read, work or dine.

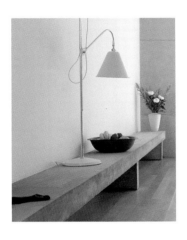 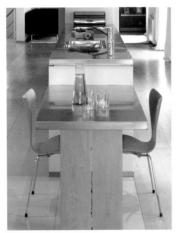 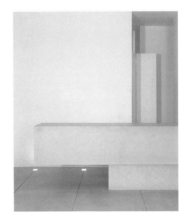 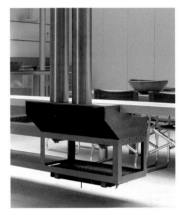

low rider

A long, low concrete slab, whether set against a wall or freestanding, is the perfect multifunctional built-in. Depending on the time of day or year, it might be used for informal sitting or the display of a few precious objects or books.

surface tension

The only feature separating the kitchen preparation zone from the dining area is a change in height of the island's countertop. The basic technique allows the dining table to feel just a little bit more enclosed for a late-night tête-à-tête.

of a piece

The ultimate minimal interior would be created with only built-in furniture. Here, these apparently large slabs of stone are balanced on each other to create a solid and reassuring interior that looks as though it was sculpted out of a single piece of rock. Painted in pastel tones, with subtle lighting effects, it is difficult to imagine a more pure space.

fireside revisited

A high-tech take on the traditional hearth, conventionally built in the chimney breast, this metal fireplace, flues and all, is suspended from the ceiling, allowing the hovering fire to be appreciated from every side.

material effects

The minimal interior should not be reduced to wood floors and white walls. Exciting new materials should be used confidently to heighten the contrasts between hard and soft, smooth and textured.

soft touch

The harder and darker the surface, the more soft materials stand out. This may seem obvious, but the greater the contrast, the greater the appreciation.

velvet delight

Today's contemporary interiors have a preoccupation with overtly natural textiles – cotton, wool, even hemp – but none of these quite captures the quality and comfort of velvet. Richly coloured and used expansively to the exclusion of any other material, velvet offers the ultimate luxuriousness.

mosaic appeal

Mosaic tiles, now widely available in sheets for easy and economical application, have been used for centuries. Today, however, an ever-increasing range of exciting colours and effects are reinventing typically white-tiled bathrooms. Even in a small space like the bathroom, the right selection of a tile can transform it into an oasis of opulence.

canvas tension

Textiles can be used to visually separate rooms throughout an open-plan dwelling, articulating space less rigidly than walls. Using a light-coloured material like stretched cotton or canvas also allows natural light to be maintained and diffused.

 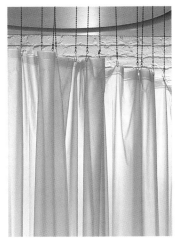 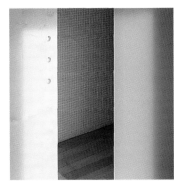

ground zero

Furniture frames, for example, of chairs, tables and beds, get in the way of materials interacting directly with each other. A soft, all-white bed on a white epoxy floor has a much different relationship than it would with a bedframe lifting it aloft. Allow materials and surfaces to communicate directly to most effectively display their essence.

curtain call

Minimalism does not necessarily imply a minimal amount of material. A simple idea – like a circular shower standing in the middle of a bathroom – can be imbued with richness by using a luxurious amount of material.

shifting planes

Sometimes hard-edged material contrasts work best, especially when demarcating more private areas. To enclose rooms, spaces or closets with sliding elements, woods, glass, and steel are easy to obtain and provide a full range of effects. Frosted glass with blond wood is popular and always successful, but don't be afraid to try unconventional combinations.

degrees of light

The control of natural light into the interior is a critical element of design – one of the most vital aspects of the minimal space. Most people tend to use blinds or curtains, but the two can be used together to create a full spectrum of atmospheres. Try perforated metal blinds with airy gauze drapes to create an ethereal mood.

glass

The importance of glass in the minimal environment cannot be understated. The use and usefulness of glass has become so broad that its only restriction today is human imagination.

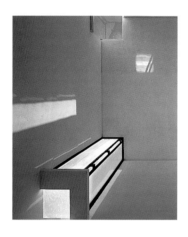 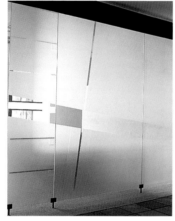 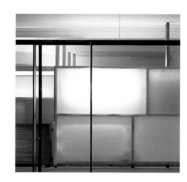 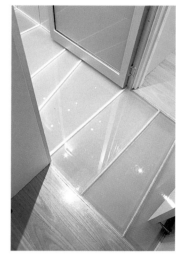

three-dimensional light

Windows don't always have to be merely two-dimensional incisions in walls or occasionally roofs. Treated as three-dimensional devices capable of capturing light and conveying it into an interior, windows can become sculpture. And when used as above, the effect is pure genius.

glass effects

Used as a simple room divider, glass can separate space without enclosing it. With etched glass, however, transparency is blurred, inducing various effects. Combining the best of both transparency and etched glass by using custom-designed patterns can provide a bewildering spectrum of visual games.

colour composition

Coloured bulbs and glass allow the designer to paint with light. Any façade or internal room can be illuminated simply but colourfully with lights behind frosted glass.

walking on air

Structural glass can be prohibitively expensive, but standard glass can be used with off-the-shelf mullions to create ingenious floor surfaces that can be underlit for truly dramatic effect or left transparent for vertiginous views to lower floors. However a glass floor might be used, it allows light of all forms to penetrate difficult-to-light spaces.

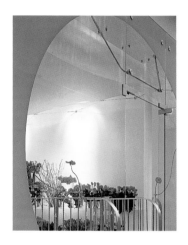

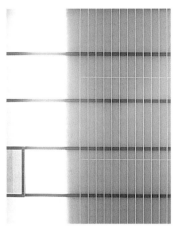

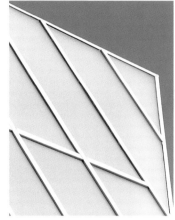

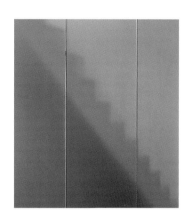

new expression

Glass is almost always used in square sheets and in square windows, but it can be made more expressive and draw attention to a building's forms. This simple egg-shaped window is a pleasingly inventive interpretation of the traditional all-glass shop front.

geometric abstraction

To support its heavy weight, glass must often be used with structural materials, such as wood or steel. This constraint can be turned into a virtue if one abstracts the relationship to create pleasing interior geometric compositions that change character with the light.

diagonal projections

Skylights are common nowadays. Most are transparent and set into existing rooflines. But rather than use conventional fittings, experiment with diagonally set pieces, which will illuminate the interior more dynamically.

frosted reception

The frosted glass wall veiling a staircase casts a ghostly impression to those ascending or descending. Secreting vertical circulation in this way allows greater penetration of natural light through different levels and softens the hard geometries of the staircase.

metal

Stainless steel and aluminium have shaken off their reputation for pure functionality and the modernist aesthetic to become two of the most popular, flexible and beautiful materials of the contemporary home.

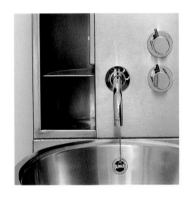 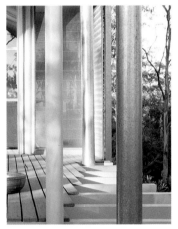 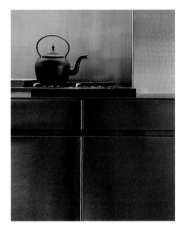 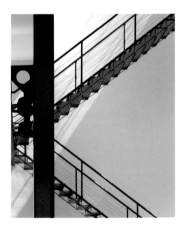

stealing beauty

Until fairly recently, stainless steel was used in bathrooms for fixtures and occasionally for kitchen sinks. Apart from possessing a surface that is easy to clean, stainless steel's industrial and clinical nature is at home in places where messes are frequently made or hygiene is paramount.

pillar of strength

Steel's light weight and strength have long made it one of modern architecture's staple materials. Particularly useful in contexts where large expanses of glass are needed to encourage indoor-outdoor interaction, it can be treated with a variety of finishes and colours to offset its functional appearance.

clean lines

The larger the surface covered by metal, the more dramatic its effect. Used here for kitchen cabinets without handles, the stainless steel will capture movement and light throughout the day and night and accentuate any object.

metal breakthrough

Metal components can be used ingenuously within older buildings to open up spaces. Removing a floor from a traditional townhouse and inserting steel support elements is one way of creating breathtaking spaces within existing architecture.

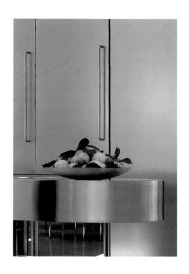

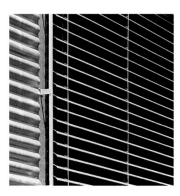

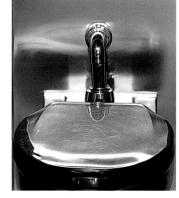

island simplicity

Although stainless steel features throughout this kitchen, the pièce de résistance is the cooking island, which manages to be functional, sculptural and entirely practical. A single metallic component in a large and active space can serve as the perfect magnet for lively social interaction.

light texture

Natural lighting and ventilation can be precisely monitored with metal louvres or shutters. Slat widths can be varied to establish a range of daytime effects, while the slats themselves can be made from many materials – wood, metal, plastic – and be polished, brushed or perforated.

industrial strength

In steel and buffed to a shine, a lavatory can be machined to become the ultimate functional object. Transcending the industrial and nautical aesthetic, metal highlights the object's precise form, thus revealing its true nature.

graphic language

Steel storage racks are no revelation in themselves, but try placing them in configurations as graphic objects on a wall or near windows where daylight will cast playful shadows on the room. There is no item, no matter how utilitarian, that cannot be made to be appreciated on several levels.

wood

More than any other building material, wood is both useful and desirable. In the minimal interior, however, it is often relegated to the floor. Given the varieties and availability, wood offers a world of expression.

 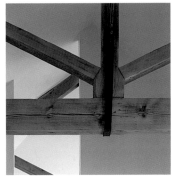 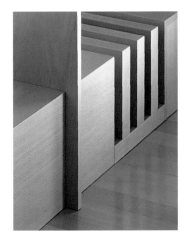 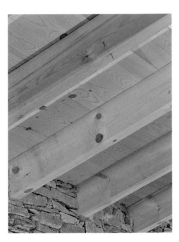

plane intersections

A floor surface composed of regular machined planks of timber may be common, but its appreciation can be heightened with the manipulation of light across it. Over the course of the day, the light and wood change in themselves and in relation to each other in a subtle interplay of patterns.

structural expression

A wooden roof structure that is revealed rather than concealed, particularly when it is the only visible evidence of an older structure that has otherwise been stripped down, offers a poignant reminder of a building's history and simply demonstrates the elegance of wood construction.

smooth groove

Timber is often used 'honestly', that is, in a way that reveals what it is about, where it comes from and how it will be used. Wood can, however, be precisely machined, polished and finished to produce an altogether different effect. This built-in cabinet, for example, becomes a highly refined formal object that almost transcends its material composition.

rustic interplay

Juxtaposing rough-hewn materials, such as stone walls and timber framing, brings out the best in both. Apart from capturing a kind of primeval minimalism, the combination encourages textures and tactility to play off each other – a resonant reminder of the labour involved in the house's construction.

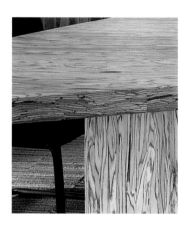

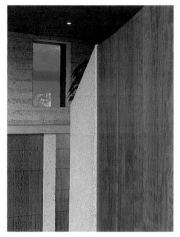

rough character

Unprocessed and perhaps recycled timber, rough and ready, has a strong material impact in any space, but as a single piece of furniture within minimal surroundings it becomes a work of art or object of wonder.

exotic grain

Where budget will allow, the simple use of exotic woods can create a spectacular effect, particularly for bedroom cabinets. Here, West African bubinga is harmonized with the house's poured-concrete construction to create an entirely distinctive dressing area.

finely crafted

A seat made from machined and sanded wood is smooth and wonderful to the touch. The careful craftsmanship is expressed in the seat's simple joint, in which the lightness and warmth of the wood's surface is intensified by its relationship to the metal-framed frosted glass.

with the grain

Stair treads are commonly made of wood and occasionally left unfinished. When the stairs are geometrical abstractions, however, the grain of the wood helps to articulate movement while softening the hardness of their forms.

colour

Until recently, white was the only colour in the minimal home. But attitudes have evolved, and colour has become one of the most exciting – and often least expensive – ways to make a single bold statement.

 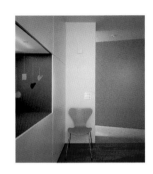

mediating frame

Although the walls of this interior are white and the exterior courtyard plays off muted greys, a single, red, floor-to-ceiling sliding door serves as a dynamic framing device.

furniture accents

Set against a large white space, individual pieces of brightly coloured furniture become playful statements. Rather than use a single colour of the Jacobsen-designed 'Ant' chairs, a range of pastel hues creates a distinctly con-vivial dining environment.

gold-leaf touches

A simple white room is enlivened by an artfully executed, simple idea: gold leaf, used sparingly and in unexpected patterns, is a delightful touch.

colour recess

The use of a single colour need not be restrained; it is the use of many colours that reduces the overall effect. The luminosity of this single fuchsia wall permeates the entire house and defines the space in a novel way.

white light

The appeal of an all-white interior is undeniable, but difficult to maintain in the most active parts of the house. The bedroom is one space where it can succeed – and offer a bright start to each day.

 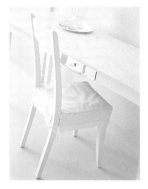 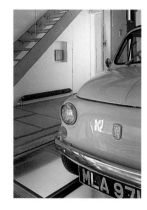 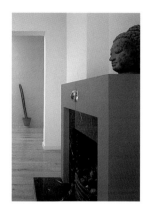

mellow yellow

In rooms where function-
ality and fun intermingle,
work zones can be
articulated and the space
animated with bold colours.
A single yellow recess can
enliven a large expanse
of white cabinets simply
and effectively.

absent presence

Used on floors rather than
walls, a white paint (which
is then epoxyed or heavily
varnished) establishes an
almost surreal ambience –
or a heavenly one, depend-
ing on your mood.

concrete counterpoint

Most people want the
poured-concrete con-
struction of a house
to be covered, but the
material comes into its
own when offset by bold
colours. Concrete often
forms a neutral background
ideal for materials or
objects of character, and
can create the perfect
balance between rough
and smooth, subdued and
charismatic.

spot colour

If you collect colourful
objects, it cannot be denied
that a light-hued backdrop
is best for displaying them.
Against the steel frame and
white walls, this yellow
Mini, the garage for which
was incorporated into the
house's interior, is trans-
formed from an object of
use into one of delight.

bold moves

Designs generally should
avoid more than one
robustly coloured archi-
tectural feature – wall, floor,
fireplace – per room. But
there's no reason why
different colours shouldn't
be used in different spaces
– as long as you compose
your colour palette for the
house as a whole rather
than room by room.

lighting

In the minimal interior, light plays a crucial role. Thought of as a material, it can be sculpted; as an element, it can totally transform the character of a space. Natural or artificial, it is often an afterthought. Try starting with light.

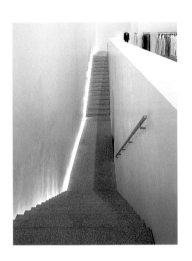 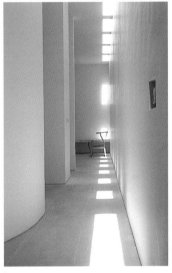 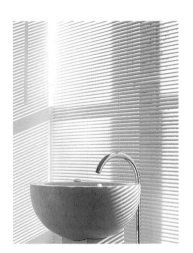 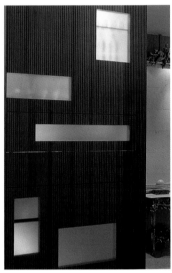

degree of separation

Between the stair and wall a gap has been fitted with lighting to stunning effect. It is as though, dissolved from the wall, the stairs float free of support, inducing in anyone on them the sensation of weightlessness.

beaming down

Directly above the main circulation corridor and carefully calibrated to flood it with natural light, a strip of skylights placed at regular intervals transforms the space with patterns that change with the angle of the sun.

blinding light

If you are fortunate enough to have a bathroom that captures the morning light, make the most of your early-morning rituals with blinds, which permit direct and graphic light to penetrate the space while protecting privacy.

glass works

A cabinet, whether used for display or storage, becomes something much more when lit from within. Illuminating objects from behind completely alters their character. If used for storage, lights behind frosted glass can turn the cabinet into an abstract composition of light and material.

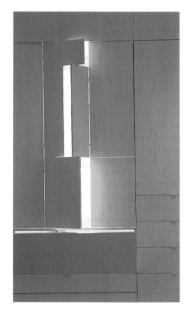

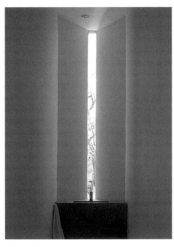

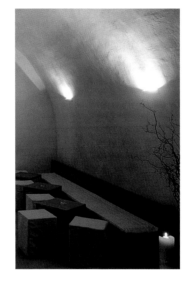

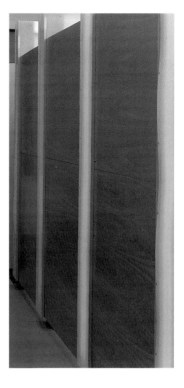

morning breaks

Along one wall of a bedroom, an intricate arrangement of drawers and shutters is conceived as a single piece. As morning sun breaks through the interstices of the shutters' folds, a bright pattern of light suffuses the space.

line of sight

For cost and aesthetic reasons, windows are usually conventional shapes. If possible, every opening in the house where natural light enters should be treated as an ideal opportunity to enhance a space. This narrow bathroom is completely altered by a long, thin window that lets in a shaft of direct sunlight. The effect is simple but powerful.

mood makers

Generally speaking indirect lighting is best for overall lighting purposes, but for the interior that has many uses it is not as desirable as directed natural or artificial light. In the right space, however, such as low-ceilinged or small rooms, uplighting, whether from floor lamps or sconces, establishes a softer, intimate, or even monastic atmosphere perfect for quiet conversation or contemplation.

colour bars

Light can also be used as another material or colour, rather than merely for its capacity for illumination. Coloured artificial lights, whether set behind glass or mounted on walls, are intense accents – to be used in moderation.

storage

Unquestionably the most vital feature of the minimal interior, an exciting and wide variety of storage solutions can be created throughout the space that go well beyond standard cabinets and shelving.

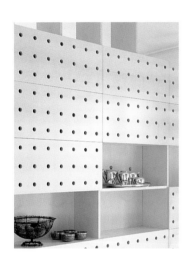
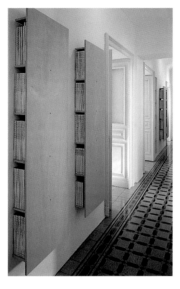

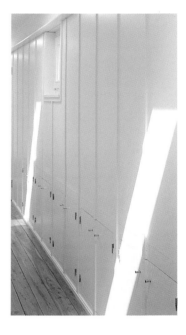

pattern on the wall

Although a bewildering array of materials can be used for storage cabinets, surfaces can also be treated more texturally to give space a graphic complement. The holes incised into the wood cabinets eliminate the need for handles and have a pleasing visual effect.

project planes

Side-mounted shelves contained by a single plane of material – any single piece will do – make the most of restricted areas like corridors and imbue the space with strong material accents.

locked up

Oversize doors can conceal a large number of objects, but placed at the right junction of spaces, they can also help define open areas. This massive set of industrial-strength doors hides and protects an impressive and valuable array of high-fidelity audio equipment. When closed, the doors become part of the wall; when open they are big enough to articulate the large living space.

forward thinking

We tend to add storage units as we accumulate objects, leading to a random or incohesive collection of cabinets or shelves. Whenever possible, think ahead and sacrifice a wall to storage: in the short term the space might feel a bit constrained; over time, however, your foresight will be rewarded.

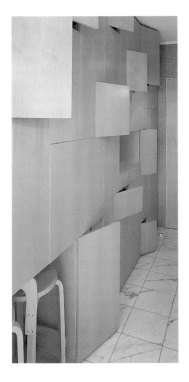

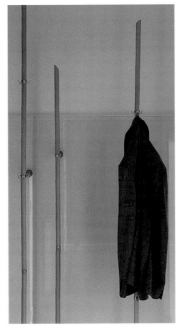

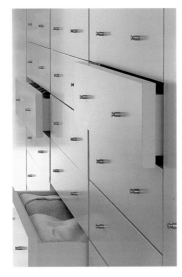

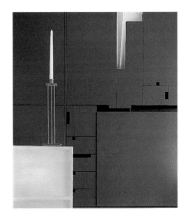

open sesame

Like a well-ordered ship's galley, a single wall of this small kitchen has been transformed into a dynamic surface that conceals storage and a pull-out dining surface. When closed, the wooden cabinets appear as an appealing abstract pattern; when open the entire wall comes alive.

standing order

Storage need not always assume conventional forms to be effective. Coat racks or hangers, for example, often encumber the space in which they are placed. These separate vertical components can be artfully arranged to maximize space and storage while presenting a delight-fully off-beat appearance.

handle with care

Where a large number of drawers are needed, measure the amount of space required, then look at ways of arranging the unit as a geomet-rical composition. Choose handles carefully: they're often more eye-catching than the drawers themselves.

breaking the mould

Regular geometries often fit subtly into the background, which is desirable when other objects in the room are to be foregrounded. In the absence of more striking objects, however, the built-in storage unit itself can become the room's centrepiece, as in this dark-stained jigsawlike cabinet.

object display
abstract form

Creating a unique architectural space is an act few want to engage in or have the means to realize. But lessons can be drawn for any space, new or old, from radical experimentation with form.

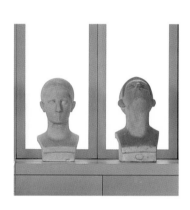 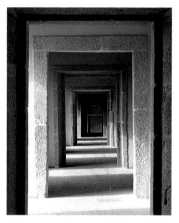 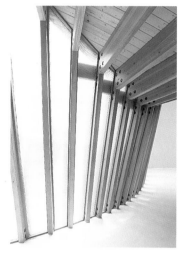 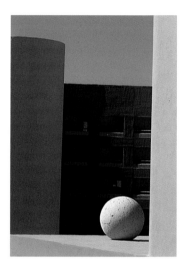

shared ideals

Classicism and minimalism are great partners. Symmetry, rhythm, harmony – all benefit the contemporary interior. Against the right background, even busts, which we often associate with more traditional styles, can work in the minimal context.

infinite jest

Perspective is a crucial component of a successful interior space, and while few are fortunate enough to enjoy infinite spatial regressions, we can employ techniques to augment the *perception* of space. The effect above, for example, can be simulated with mirrors.

sweeping statements

Minimal spaces often emphasize rectilinear components. This approach has its advantages, but curved space can offer a much richer and more surprising environment. The difficulty of mounting objects on walls is overcome by the shape's intrinsic beauty, which becomes the focal point of display or contemplation.

basic geometry

Elemental three-dimensional forms – spheres, cubes, pyramids – set on two-dimensional surfaces have beguiled artists and designers from antiquity to surrealism. With concrete objects widely available today, the same objects of wonder can transform any interior or exterior space – no matter how small – into a space for meditation and aesthetic wonder.

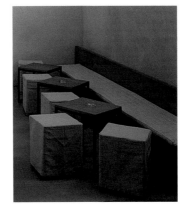

from here to antiquity

White sculpture set against white surfaces conveys an incomparable sense of elegance. With museum shops around the world offering reasonably priced reproductions, there is no need to be an antiquities collector to create the same ambience of sophistication.

dark shape

A bold geometric form exerts a gravitational pull in a minimally adorned environment. Here, stairs are encased in an abstracted spiral that turns an architectural element into an interior object.

moving objects

The line between display and use, between form and function, is blurred when elemental forms of the same size have several uses. Chairs, tables, objects – regardless of their use or arrangement – provide a dynamic setting that can ultimately only be animated by people.

vertical members

A tall, naturally illuminated space is transformed by five wood stilts that rest against the wall. As an artwork, they demand further investigation; as display elements, they heighten the perception of the room by drawing the eye away from the light-coloured floor toward the light entering from above.

planting

As objects featured for their material and textural effects, plants bring the outside inside and add a natural dimension to our man-made habitats. With pots assuming ever new forms, the possibilities are endless.

pointed view

Simple but stark contrasts should be sought out whenever possible. Against the restrained geometric appearance of the exterior, find a single plant whose every idiosyncrasy or exoticism can be fully appreciated.

window display

Using one simple repeated object – the potted plant – on glass shelves to cover a tall expanse of glass is a terrific graphic display technique. Though the idea might be fixed, the scale, pots, plants and their frequency can all be altered to stunning effects for different rooms or at different times of the year.

test-tube treatment

A long work surface is pierced by test tubes. The device is simple, the presentation delightful. A clever idea, minimally executed, offers maximum enjoyment.

high contrast

White concrete is a beautiful building material and acts as a wonderful canvas against which planting can be foregrounded. The regular spacing of the concrete's holes are in pleasing counterpoint to untamed nature.

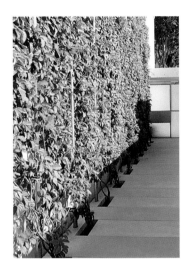

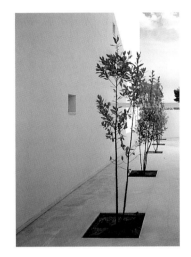

upwardly mobile

Vertical gardening is an ideal solution for constricted spaces. By planting climbers or even an array of potted plants, an outdoor space becomes an outdoor room. In this case the contrast between the green living form and the grey man-made concrete structure intensifies the glorious paradox of minimal form and maximum contrast.

night moves

This backlit exterior wall gives a bright, smooth and glistening backdrop to delicately ornamental pampas grass. There is a joyful sense of movement as the grass's shadows play against the white wall like brushes on a canvas.

four square

Rigour, restraint and order characterize an outdoor area of this stark villa. Sandwiched between the external garden wall and the house are four perfectly square planters cut out of a perfect plane. Although the first impression may be one of austerity, with time the trees' branches will become a canopy over a monastic space, ideal for reflection.

flower focus

The appeal of a single flower, however modest, projecting from a wall or tabletop is an elegantly simple way to adorn a space. There is no room in the house where such a presentation would not bring cheer.

architects and designers

Tadao Ando
5–23 Toyosaki 2-chrome
Kita-ku
Osaka 531
Japan
T +81 6 375 1148
F +81 6 374 6240

Alberto Campo Baeza
Almirante 9
28004 Madrid
Spain
T/F +34 91 521 7061
E campo-baeza@redestb.es

Stéphane Beel
Koningin Astridiaan 7/19
8200 Bruges
Belgium
T +32 50 30 19 50
F +32 50 39 18 97
E stephane.beel@bing.be

Belmont Freeman Architects
110 West 40th Street, suite 2401
New York, New York 10018
U.S.A.
T +1 212 382 3311
F +1 212 730 1229
E bfa@belmontfreeman.com

Deborah Berke Architect
211 West 19th Street, 2nd floor

New York, New York 10011
U.S.A.
T +1 212 229 9211
F +1 212 989 3347

David Chipperfield
1A Cobham Mews
Agar Grove
London NW1 9SB
England
T +44 20 7267 9422
F +44 20 7267 9347
E studio@dchipperfield.demon.co.uk

Arthur Collin Architect
1A Berry Place
London EC1V 0JD
England
T +44 20 7490 3520
F +44 20 7490 3521
E mail@arthurcollin.com

D'Soto Architects
38 Mount Pleasant
London WC1X 0AP
England
T +44 20 7278 5100
F +44 20 7278 5111
E info@dsoto.com

Winka Dubbeldam/
Archi-tectonics
111 Mercer Street, 2nd floor

New York, New York 10012
U.S.A.
T +1 212 226 0303
F +1 212 219 3106
E winka@archi-tectonics.com

Spencer Fung
3 Pine Mews
London NW10 3JA
England
T +44 20 8960 9883
F +44 20 8960 9339
E sfarchs@compuserve.com

Michael Gabellini & Associates
665 Broadway, 7th floor
New York, New York 10012
U.S.A.
T +1 212 388 1700
F +1 212 388 1808

Gluckman Mayner Architects
145 Hudson Street, 11th floor
New York, New York 10013
U.S.A.
T +1 212 925 8967

F +1 212 941 8352

E info@gluckmanmayner.com

Mark Guard Ltd Architects

161 Whitfield Street

London W1P 5RY

England

T +44 20 7380 1199

F +44 20 7387 5441

E mga@markguard.com

Hanrahan Meyers Architects

22 West 21st Street, #1201

New York, New York 10010

U.S.A.

T +1 212 989 6026

F +1 212 255 3776

E hmarchny@aol.com

Hariri & Hariri Design

18 East 12th Street, #1C

New York, New York 10003

U.S.A.

T +1 212 727 0338

F +1 212 727 0479

E gh@haririandhariri.com

Malin Iovino Design

43 St Saviours Wharf

Mill Street

London SE1 2BE

England

T/F +44 20 7252 3542

E iovino@btinternet.com

Janson Goldstein

180 Varick Street, 15th floor

New York, New York 10014

U.S.A.

T +1 212 691 1611

F +1 212 691 2244

E mj@jansongoldstein.com

Jim Jennings Architecture

49 Rodgers Alley

San Francisco, California 94103

U.S.A.

T +1 415 551 0827

F +1 415 551 0829

E office@jjarch.com

Ricardo Legorreta

Palacio de Versalles 285A

11020 Mexico D.F.

Mexico

T +52 5 251 9698

F +52 5 596 6162

E legorett@data.net.mx

Rick Mather Architects

123 Camden High Street

London NW1 7JR

England

T +44 20 7284 1727

F +44 20 7267 7826

E rma@rmather.demon.co.uk

Morris/Sato Studio

219 East 12th Street, 1st floor

New York, New York 10003

U.S.A.

T +1 212 228 2832

F +1 212 505 6160

Souto de Moura Arquitectos

Rua do Aleixo, 53

4150 Porto

Portugal

T +351 2 6187547

F +351 2 6108092

E souto.moura@mail.telepac.pt

Glenn Murcutt

176A Raglan Street

Mosman, New South Wales 2088

Australia

T/F 61 2 9969 7797

Andrew Nolan

98 Surrey Street

Darlinghurst

New South Wales 2010

Australia

T +61 2 9360 1046

Olson Sundberg

108 First Avenue south, 4th floor

Seattle, Washington 98104

U.S.A.

T +1 206 624 5670

F +1 206 624 3730

Pasanella + Klein, Stolzman + Berg

Architects

330 West 42nd Street

New York, New York 10036

U.S.A.

T +1 212 594 2010

F +1 212 947 4381

John Pawson
Unit B, 70–78 York Way
London N1 9AG
England
T +44 20 7837 2929
F +44 20 7837 4949
E email@johnpawson.co.uk

Paxton Locher Architects
15B St George's Mews
London NW1 8XE
England
T +44 20 7586 6161
F +44 20 7586 7171
E pla@paxloch.demon.co.uk

Martin Raffone
10 East 16th Street, #15
New York, New York
U.S.A.
T +1 212 243 2027
F +1 212 243 7478

Resolution 4 Architecture
150 West 28th Street, suite 1902
New York, New York 10001
U.S.A.
T +1 212 675 9266
F +1 212 206 0944
E jtanney@re4a.com

Richard Rogers
Thames Wharf
Rainville Road
London W6 9HA
England
T +44 20 7385 1235

F +44 20 7385 8409
E enquiries@richardrogers.co.uk

Marco Romanelli
via del Caravaggio 2
20144 Milan
Italy
T +390 2 4398 0365
F +390 2 4398 0363

Claudio Silvestrin Architects Ltd
Unit 18
Waterside
44–48 Wharf Road
London N1 7UX
England
T +44 20 7490 7797
F +44 20 7490 7272
E silvestrin@aol.com

Smith-Miller + Hawkinson
305 Canal Street
New York, New York 10013
U.S.A.
T +1 212 966 3875
F +1 212 966 3877

Seth Stein Architects
52 Kelso Place
London W8 5QQ
England
T +44 20 7376 0005
F +44 20 7376 1383
E seth@ssa.ndirect.co.uk

Tsao & McKown
20 Vandam Street, 10th floor

New York, New York 10013
U.S.A.
T +1 212 337 3800
F +1 212 337 0013
E tsao@tsao-mckown.com

Stephen Varady
363A Pitt Street
Sydney, NSW 2000
Australia
T +61 2 9283 6880
F +61 2 9283 6886

manufacturers

living/dining/storage

B&B
Strada Provinciale, 32
22060 Novedrate (COMO)
Italy
T +390 31 795111
F +390 31 791592
www.bebitalia.it

Cappellini spa
Via Marconi, 35
22060 Arosio (CO)
Italy
T +390 31 759111
F +390 31 763322
www.cappellini.it

Cassina
Via Bisnelli 1
20036 Meda (MI)
Italy
T +390 362 372
F +390 34 22 46
E info@cassina.it

De La Espada
60 Sloane Avenue
London SW3
England
T +44 20 7581 4474
F +44 20 7320 8391
www.delaespada.com

Minotti S.p.a.
Via Indipendenza 152
P.O. Box Numero 61
20036 Meda MI
Italy
T +390 362 343499
F +390 362 340319

Poliform
Via Montesanto, 28
22044 Inverigo (CO)
Italy
T +390 31 6951
F +390 31 699444
www.poliform.it

Porro
via per Cantù 35
22060 Montesolaro (CO)
Italy
T +390 31 780237
F +390 31 781529
E info@porro.com
www.porro.com

kitchens

Arc Linea
Viale Pasubio, 50
36030 Caldogno (VI)
Italy
T +390 444 394 100
F +390 444 394 262

Boffi S.p.A.
via Oberdan, 70
22030 Lentate sul Seveso (MI)
Italy
T +390 362 5341
F +390 362 565 077

Balthaup
84153 Aich
Germany
T +49 1802 212 534
www.balthaup.com

Siemens
Grand Union House
Old Wolverton Road
Wolverton
Milton Keynes MK12 5PT
England
T +44 1908 32 84 00
F +44 1908 32 84 99

Strato
Via Piemonte 9
23018 Talamona (SO)
T +390 3426 10869
F +390 3426 10418
E strato@stratocucine.com
www.stratocucine.com

further reading

Aspects of Minimal Architecture (*Architectural Design* magazine, London, 1994)

Aspects of Minimal Architecture II (*Architectural Design* magazine, London, 1999)

Franco Bertoni, *Claudio Silvestrin* (Basel, 1999)

Christopher Bradley-Hole, *The Minimalist Garden* (London, 1999)

Francisco Asensio Cerver, *Exclusive Houses* (Barcelona, 1997)

Bruce Chatwin/Deyan Sudjic, *John Pawson* (Barcelona, 1992)

Terence Conran & Dan Pearson, *The Essential Garden Book* (London, 1998)

Elizabeth Heyert, *Metropolitan Interiors* (New York, 1989)

Charles W Moore, *Water and Architecture* (New York/London, 1994)

John Pawson, *Minimum* (London, 1998)

Mayer Rus, *Loft* (New York, 1998)

Deyan Sudjic, *The House Style Book* (London, 1984)

Philippa Waring, *The Feng Shui of Gardening* (London, 1998)

Herbert Ypma, *London Minimum* (London, 1996)

photography credits

t = top r = right c = centre l = left b = bottom

Richard Glover/Arcaid: 1, 52–53, 57–59, 66–67, 78–79, 169 [cl], 175 [r], 179 [l], 180 [l]
Richard Bryant/Arcaid: 12, 16–17, 20, 22–23, 45–47, 50–51, 55 [tr, br], 56, 60–63, 77, 82–83, 93, 101, 112–13, 116–17, 122, 124, 126, 127 [r], 129–30, 137 [br], 138–50, 154–55, 164 [l, c], 166 [l, cr], 167 [r, cr], 169 [l, r], 171 [r], 172 [l], 173 [cr], 174 [cl, cr, r], 175 [l, cl], 176 [l, cl, cr], 177 [r], 178 [cl, cr], 179 [c, cr], 180 [cl, cr], 181 [cl], 183 [cr, r], 184 [l, cl], 185 [l], 186 [l, cr]
Paul Warchol: 2, 18–19, 21, 26–27, 29–43, 55 [bl], 68–69, 72–73, 80, 86–89, 92, 94, 97, 99–100, 102–08, 118, 119 [r], 123, 128, 166 [cl], 167 [l, cl], 170 [l, cl, r], 171 [l, cl], 177 [l], 181 [l], 182 [cr]
Earl Carter/Belle/Arcaid: 5, 11, 74–75, 110–11, 120, 137 [tl], 152–53, 158–59, 168 [l],178 [r], 179 [cl]
Heidi Grassley/Thames & Hudson: 8–9, 10, 14–15, 64, 98, 114, 133, 165 [r], 166 [r], 168 [cr], 187 [cl]
Alberto Piovano/Arcaid: 24–25, 28, 48–49, 55 [tl], 70–71, 119 [l], 125, 127 [l], 134–35, 137 [tr], 161, 165 [l], 168 [r], 171 [cr], 174 [l], 176 [cr, r], 178 [c], 180 [r], 182 [l, cl, r], 183 [l, cl], 185 [r], 187 [cr]
John Edward Linden/Arcaid: 44, 65, 109, 121, 168 [cl],169 [cr], 185 [cl], 186 [cl]
Nicholas Kane/Arcaid: 76, 81, 172 [cr], 181 [r]
Alan Weintraub/Arcaid: 84–85, 115, 151, 160, 162–63, 164 [r], 165 [c], 172 [cl], 173 [cl, r], 177 [cl], 184 [cr], 186 [r], 187 [l]
Rodney Weidland/Arcaid: 95, 132, 170 [cr]
Paul Raftery/Arcaid: 96
Geoff Lung/Belle/Arcaid: 131, 172 [r]
Natalie Tepper/Arcaid: 137 [bl], 156–57, 184 [r]
Niall Clutton/Arcaid: 173 [l], 187 [r]
Chris Gascoigne/Arcaid: 177 [cr], 188
David Churchill/Arcaid: 179 [r]
Gisela Erlacher/Arcaid: 181 [cr], 185 [cr]